the BiG BANG THEORY™
BOOK OF LISTS

the BiG BANG THEORY

BOOK OF LISTS

THE OFFICIAL GUIDE TO CHARACTERS, QUOTES, TIMELINES, AND MEMORABLE MOMENTS

BRYAN YOUNG

RUNNING PRESS

PHILADELPHIA

Running Press
Hachette Book Group
1290 Avenue of the Americas, New York, NY 10104
www.runningpress.com
@Running_Press

Printed in Italy

First Edition: September 2022

Published by Running Press, an imprint of Perseus Books, LLC, a subsidiary of Hachette Book Group, Inc. The Running Press name and logo are trademarks of the Hachette Book Group.

The Hachette Speakers Bureau provides a wide range of authors for speaking events. To find out more, go to www.hachettespeakersbureau.com or call (866) 376-6591.

The publisher is not responsible for websites (or their content) that are not owned by the publisher.

STOCK PHOTO CREDITS:
Page 109—Viktor Weisskopf: Science History Images / Alamy Stock Photo
The following images are from the Getty Images collection. Pages 148, 154—Stephen Hawking: Karwai Tang/WireImage; page 108 —Enrico Fermi: Bettman Collection, J. Robert Oppenheimer: Corbis Historical Collection, Edward Teller: Corbis Historical Collection, Richard Feynman: Photo 12/Universal Images Group Collection; page 109—Otto Frisch: Corbis Historical Collection, Pief Panofsky: Smith Collection/Gado; Page 140—Beverly (Christine Baranski): CBS Photo Archive.
Stock imagery of folders, papers, labels, toilet paper, tiled wall, kitten, hand drawings provided by Shutterstock.

Superman created by Jerry Siegel and Joe Shuster. By special arrangement with the Jerry Siegel family. Batman created by Bob Kane with Bill Finger.
Print book cover and interior design by Alex Camlin.

Library of Congress Control Number: 2022932630

ISBNs: 978-0-7624-8118-7 (hardcover), 978-0-7624-8119-4 (ebook)

Elco

10 9 8 7 6 5 4 3 2 1

This one is for all the bullied geeks and nerds out there like me.

We tried so hard to be fit in and escape notice, but now we're on top of the world.

We made it.

TABLE OF CONTENTS

4: THE SUPPORTING PLAYER SYMPOSIUM

5: THE CELEBRITY SITUATIONS

6: THE GEEK ANOMALIES

7: THE MINUTIA PROTOCOLS

8: THE APARTMENT ANALYSIS

Observable Roles of The Big Bang Theory on Multiple Variables in the Zeitgeist

Bryan Young, Master of Science in Geek Studies

Salt Lake City Institute of Nerdery

The cultural zeitgeist has been affected indelibly by the television show The Big Bang Theory.[1] It injected nerd culture into the mainstream, bringing it into more than 20 million homes every week during its run. Not only did it bring nerds into the homes of those with little exposure to geek lifestyles, it brought the outsiders of super-intelligence in as well. The jokes and references became standard the world over, and now the geeks rule the pop culture landscape.

Introduction

In the 1980s and 1990s, things for kids into geeky things were in a dark, dense state. In a world dominated by the mainstream, they were relegated to being bullied and shunned for liking the things they liked. Comic books and their conventions.[2] Roleplaying games.[3] Board games.[4] Computers.[5] Video games and their consoles.[6] Reading far too many books.[7] To say one was into *Star Wars* or *Batman* on the playground was likely to make one a pariah. These were the years when the characters of *The Big Bang Theory* grew up and then later shaped the world around them. Sheldon, Leonard, Howard, and Raj grew up in that landscape where being invested in things and able to hang on to childlike wonder were seen as liabilities. Then about fifteen years ago the expansions of minds began and the culture included more and more of our geek interests.

Thanks to the popularization of the world of geeks (in part through the efforts of *The Big Bang Theory*) kids today have a lot less to worry about when it comes to bullying and being made fun of. Though bullying might not be reduced on a per instance average, being a nerd fast became less and less of a reason to be bullied.

Figure 1 Season 1 DVD cover

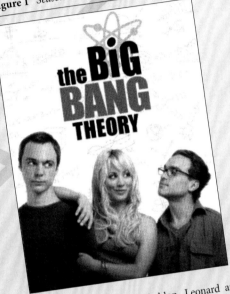

Watching the exploits of Sheldon, Leonard and the gang head to the comic book store and play roleplaying games with the likes of Wil Wheaton made such activities become more popular than they've ever been.[8] Their attempts to get tickets to San Diego Comic-Con are a nightmare many have lived through, and the actors behind the characters appeared at the show as well, nerds like all of us.[9]

More than anything, they made being smart *cool* in the minds of so many people who hadn't considered

1 Running for 279 episodes from September 24, 2007 through May 16, 2019 on CBS, making it the longest running and most popular multi-camera television program of all time.
2 Most notably, San Diego Comic-Con, held annually since 1970
3 Although *Dungeons & Dragons* might be the most popular, there are hundreds of roleplaying games to choose from.
4 Everything ranging from *Settlers of Catan* (The Speckerman Recurrance) to *Campaign for North Africa: The Desert War 1940-43* (The Neonatal Nomenclature).
5 How many kids in the '80s died of dysentery on an Apple II at lunch, getting in extra time on the library computer?
6 Just like all of the vintage consoles Sheldon had stolen from his apartment during the break in "The Bozeman Reaction" (see page 209)
7 You don't accumulate as much knowledge as Leonard or Sheldon without spending significant time reading books
8 In 2017 sales figures, publisher Wizards of the Coast reported that *Dungeons & Dragons* had an estimated 12-15 million players, the most in the game's history, just six years after the guys first played on the show in "The Wiggly Finger Catalyst."

Figure 2 *Season 4 cast*

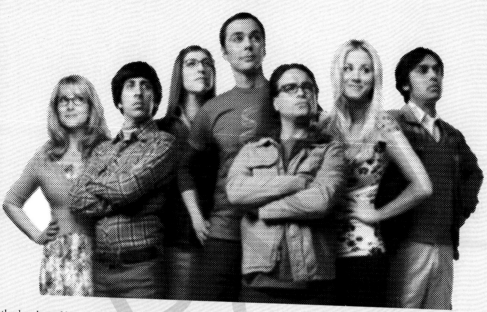

the burden of being one of the four-eyed poindex-ters in school. *The Big Bang Theory* made the smart kids the stars and made it easier for the book worm to exist and the kid with an inordinately large vocab-ulary to fit in and the little girl who wanted to be a scientist feel like it was possible. It made superstars out of people known for being brilliant, making sci-entists into gods. Neil de Grasse Tyson.[10] Bill Nye the Science Guy.[11] George Smoot.[12] Frances H. Arnold.[13] Kip Thorne.[14] Richard Feynman.[15] And many more.

The culture has changed in favor of the geeks thanks to factors like *The Big Bang Theory*. Comic book movies dominate the box office. *Star Wars* movies and television shows come out with regularity.

Roleplaying games are mainstream. You can buy fun, complex board games and RPGs at any local depart-ment store. And *The Big Bang Theory* added to the pop culture as well,[16] adding to the vocabulary of geekiness and the acceptability of being a nerd.

This book intends to document the spirit of the characters that audiences fell in love with,[17] track the absurdities of their nerdery,[18] catalogue the minutiae of trivia that any devoted fan would want, and cele-brate the show for the achievement it was. I hope it brings a smile and, perhaps, a tear.[19]

The geek inherited the cultural zeitgeist.

And one could argue that it all started with a *Big Bang...*[20]

9 In 2013, Johnny Galecki, the actor behind Leonard Hofstadter, appeared in costume as Bouush (Princess Leia's disguise to rescue Han from Jabba's palace) at San Diego Comic-Con, crashing a *Big Bang Theory* panel. Coincidentally, the costume he wore was borrowed from the author's *Full of Sith* podcast then-co-host Consetta Parker. It was the costume she got married in.
10 (The Apology Insufficiency)
11 (The Proton Displacement)
12 (The Terminator Decoupling)
13 (The Laureate Accumulation)
14 Ibid.
15 (The Zazzy Substitution)
16 Bazinga!
17 ...and Stuart.
18 ...which was, indeed, absurd.
19 With apologies to Charlie Chaplin.
20 With my sincerest apologies to The Barenaked Ladies

(1.)

THE
BIG BANG
THEORY

The Dramatis Personae Cohort

Life on THE BIG BANG THEORY revolved around the colorful cast of characters that populate the world. At the center are the original tenants of Apartment 4A, Dr. Sheldon Cooper and Dr. Leonard Hofstadter.

THE NUCLEUS

Dr. Leonard Hofstadter
EXPERIMENTAL PHYSICIST

The shy and incredibly flappable Dr. Leonard Hofstadter is an experimental physicist at Caltech. He's madly in love with Penny, whether or not they can be together, and is the peacemaker among his friends.

Interesting facts: Is lactose intolerant, plays the cello, once posed as an employee at the Apple Genius Bar to pick up women and was subsequently sent to the little jail at the mall.

Dr. Sheldon Cooper
THEORETICAL PHYSICIST

The neurotic but lovable Dr. Sheldon Cooper is a senior theoretical physicist at Caltech, focusing on string theory. Leonard Hofstadter is his best friend and roommate.

Interesting facts: Loves trains, learned to swim via the internet, once led an aggressive letter-writing campaign to get several movie theaters to add Icee machines to their concession stands.

Penny Hofstadter
PHARMACEUTICAL SALES REP
(former Cheesecake Factory server)

The classic "girl next door," Penny Hofstadter was born on a farm near Omaha, Nebraska, and moved to California to be an actress. Her on-again, off-again relationship with Leonard was a result of her belief that she wasn't ready for the commitment, but eventually they married.

Interesting facts: Has a tattoo of Cookie Monster, wants to be an actress, has so many points on her license that she has to get her car insurance from an outfit in the Caymans.

Dr. Amy Farrah Fowler
NEUROBIOLOGIST

Hailing from Glendale, California, Dr. Amy Farrah Fowler is a successful neurobiologist who got her doctorate degree at Harvard University. She went to work at Caltech and found her way into the friend group by matching with Sheldon on a dating website.

Interesting facts: Loves Neil Diamond, her gynecologist says she often overstays her welcome, at the age of fourteen, she severed the webbing between her own toes using nothing but nitrous oxide from cans of whipped cream as anesthesia.

Howard Wolowitz
ASTRONAUT AND ENGINEER

The model of a good Jewish son, Howard Wolowitz loves his mother a little too much. He studied engineering at MIT and studied hairstyles from the Beatles, circa 1960. His work as an engineer allowed him to visit the International Space Station in 2012.

Interesting facts: Loves Neil Diamond, is known by the nickname "Froot Loops" to his fellow astronauts, has a belt buckle collection numbering in the hundreds.

Dr. Rajesh Koothrappali
ASTROPHYSICIST

Born into an incredibly wealthy family in India, Dr. Rajesh Koothrappali is an astrophysicist who has very little luck with women—when he can even speak to them. According to a psychiatrist, he has an ersatz same-sex marriage with Howard to fulfill his need for intimacy.

Interesting facts: Calls his apartment the "Raj Majal," finds cows both sacred and delicious, once paid a kid on eBay $25 for a handcrafted wand from Harry Potter and received nothing but an ordinary stick in return.

Dr. Bernadette Rostenkowski-Wolowitz
MICROBIOLOGIST

The diminutive but feisty Dr. Bernadette Rostenkowski-Wolowitz put herself through school to get her PhD by waitressing at the Cheesecake Factory. She fell in love with Howard Wolowitz and had two children with him, all while maintaining a successful career.

Interesting facts: Competed in the Miss California Quiznos 1999 pageant, owns a parabolic microphone for eavesdropping, can no longer watch movies with melting faces after she accidentally dropped a vial of flesh-eating bacteria into a rhesus monkey lab.

SUPPORTING CAST

Stuart Bloom
ARTIST AND OWNER, THE COMIC CENTER OF PASADENA

Stuart is the owner of the Comic Center of Pasadena, the comic book store frequented by the entire gang. When the comic book store suffers a fire, Howard is able to hire Stuart to take care of his ailing mother as a live-in nurse and, with few exceptions, he really doesn't leave the Wolowitz house again.

Interesting facts: Gets 45 percent off comic books, has impeccable handwriting, once had a gnawing feeling in his stomach that turned out to be a tapeworm.

Priya Koothrappali
LAWYER

The younger sister of Raj Koothrappali, Priya is an accomplished lawyer and acts as an attorney for one of the largest automobile manufacturers in India. Despite her brilliance and attractiveness, she insists on maintaining a romantic relationship with Leonard for almost a year.

Interesting facts: Doesn't particularly like trains, can practice law in three different countries, once tore Sheldon's roommate agreement with Leonard to legal shreds.

Wil Wheaton
ACTOR AND GAMER

Wil Wheaton, the famous actor from *Stand By Me* (1986) who played Wesley Crusher on *Star Trek: The Next Generation* (1987), circles in the orbit of Sheldon and his friends. He's buddies with Stuart and is unscrupulous enough to lie to win at a card game.

Interesting facts: Hates auditioning, uses his celebrity to get special treatment, hosts a celebrity game of *Dungeons & Dragons*.

Denise
ASSISTANT MANAGER, THE COMIC CENTER OF PASADENA

After Neil Gaiman tweeted about the Comic Center, its popularity skyrocketed and Denise was hired as an assistant manager to keep up with demand. She quickly ingrained herself in the lives of the group and eventually began dating Stuart.

Interesting facts: Is an accomplished *Fortnite* player, has an uncanny ability to recommend comics to Sheldon, only decided to date Stuart in the first place based on the notion that she might get to meet *Star Wars* actor Mark Hamill.

Mary Cooper
WOMAN OF GOD

A devout born-again Christian hailing from East Texas, Mary Cooper couldn't be more different from her atheist-scientist son, Sheldon. She invokes the Lord's name and wisdom as often as she can and loves her son deeply despite their differences.

Interesting facts: Has a mild addiction to Dr Pepper, used to secretly be a smoker, likes cooking Italian food because "that's what the Romans made Jesus eat."

Dr. Beverly Hofstadter
NEUROSCIENTIST, PSYCHIATRIST, AND AUTHOR

One would assume that the author of a nonfiction book titled *The Disappointing Child* would be an ice-queen of a mother, and one would be right. Dr. Beverly Hofstadter is Leonard's mother, and made his entire childhood a miserable research experiment for her own gains.

Interesting facts: Is divorced, is polyamorous, only had sex with Leonard's father, Alfred, for the purpose of reproduction (and she wrote a paper on the topic).

Dr. Bert Kibbler
GEOLOGIST AND MACARTHUR GENIUS GRANT RECIPIENT

The lumbering, soft-spoken, and eternally lonely Dr. Bert Kibbler is a geologist working at Caltech. Dr. Sheldon Cooper has an aversion to geologists, but even he was forced to admit that Bert's work in the field was remarkable.

Interesting facts: Is known as a gentle giant, frequently makes rock puns, once appeared in Leonard's nightmares.

Dr. Arthur Jeffries
PROFESSOR PROTON

As a children's science show host, Dr. Arthur Jeffries was never taken seriously as a scientist, so the last years of his life were spent entertaining kids at birthday parties instead of working on research. He befriended Sheldon and Leonard, who idolized him before he passed away in 2014.

Interesting facts: His wife left him for the puppeteer on his show, sued Bill Nye the Science Guy for stealing his act, appears in Sheldon's dreams as a Force ghost in Obi-Wan Kenobi's robes.

Dr. Leslie Winkle
EXPERIMENTAL PHYSICIST

Dr. Leslie Winkle works at Caltech and has no qualms about using or misusing school property or men. Manipulative and cunning, she dangles sex over Howard Wolowitz's head for a time to control him.

Interesting facts: Plays the violin, refers to Sheldon Cooper as "dumbass," once flash-froze a banana with liquid nitrogen in her lab to shatter it with a hammer and sprinkle on her cereal.

Debbie Wolowitz
MOTHER

With a hoarse, shrieking voice, Debbie Wolowitz had no bigger priorities than her own bowel movements and the care of her son, Howard. A devoted mother to the end, she didn't live long enough to see her grandchildren born.

Interesting facts: Would watch *Wheel of Fortune* with Howard on the Sabbath, she would cut Howard's meat for him (but only when it was fatty), accompanied her son to astronaut training to take care of him.

Zack Johnson
VICE PRESIDENT OF HIS FATHER'S MENU DESIGNING COMPANY

Penny's on-again, off-again boyfriend before she married Leonard, Zack was the dopiest nice guy anyone had ever met. He ended up getting married, selling his father's company, and retiring to live on a yacht.

Interesting facts: Dressed as Superman to help the guys win a costume contest, barely comprehends his native tongue, wanted Leonard to be the father of his children.

Dr. Barry Kripke
THEORETICAL PHYSICIST

Barry Kripke is the Elmer Fudd to Sheldon Cooper's Bugs Bunny, engaging in more than a decade of rivalry with the Nobel prize–winning physicist.

Interesting facts: Builds killer robots, hasn't watched a single episode of *Star Trek* since he discovered that the strip club near his house has a free buffet.

Dr. Emily Sweeney
DERMATOLOGIST

A resident at Huntington Hospital, Dr. Emily Sweeney has a dark sense of humor and a taste for the macabre, making her an unlikely match as Raj's longtime girlfriend.

Interesting facts: Has a tattoo of Sally from *The Nightmare Before Christmas* (1993), likes cutting people with knives, was a nanny for a few years, qualifying her to change Raj's diapers.

Dr. Stephen Hawking
THEORETICAL PHYSICIST

Legendary theoretical physicist Dr. Stephen Hawking is a friend of Sheldon's and finds his work fascinating. At times, he's worked closely with Howard on his wheelchair, and he also picked Leonard for a scientific mission to the North Sea.

Interesting facts: A ridiculous prankster, hates losing, once asked what Sheldon Cooper and a black hole have in common (Answer: They both suck).

THE APARTMENT BUILDING

GRIFFITH OBSERVATORY

APARTMENT 4A

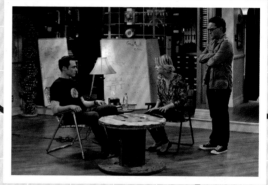

ZANGEN

APARTMENT 4B

THE RAJ MAHAL

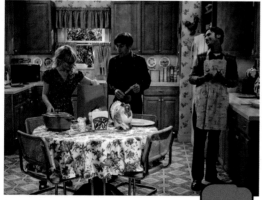

HOWARD'S HOUSE

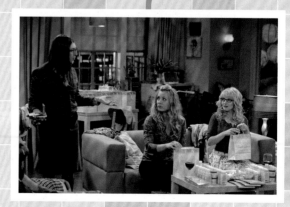

AMY'S APARTMENT

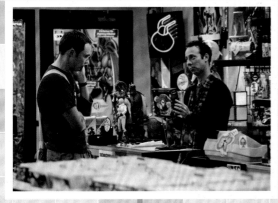

THE COMIC CENTER OF PASADENA

THE CAFETERIA

AMY'S OFFICE

THE CALIFORNIA INSTITUTE OF TECHNOLOGY

SHELDON'S OFFICE

RAJ'S OFFICE

THE ATHENAEUM CLUB

OTHER HANGOUTS

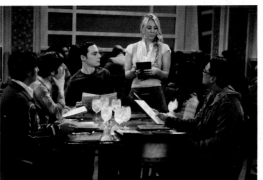

HOWARD'S LAB

THE MOVIE THEATER

THE CHEESECAKE FACTORY

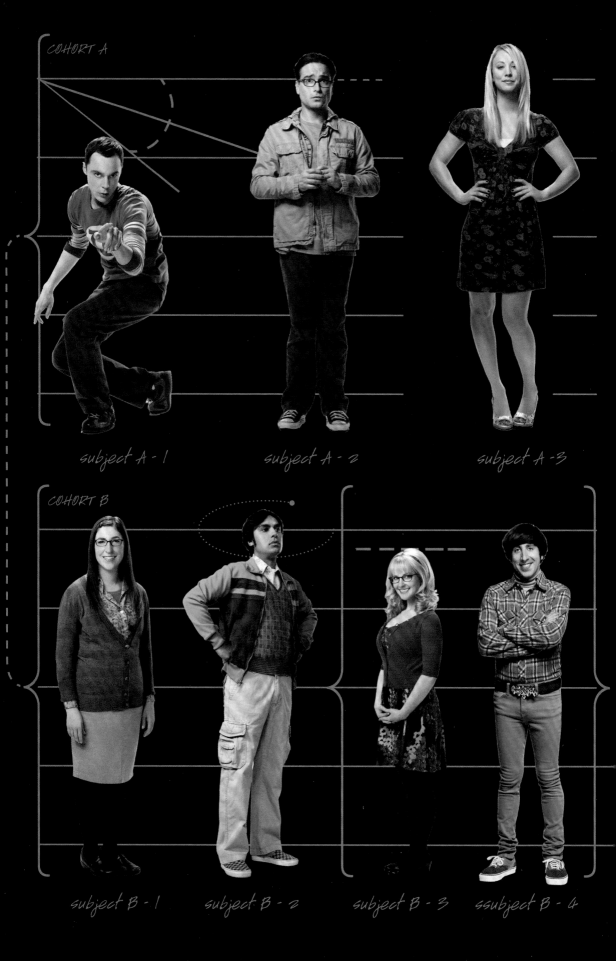

COHORT A

subject A - 1

subject A - 2

subject A -3

COHORT B

subject B - 1

subject B - 2

subject B - 3

ssubject B - 4

THE CHARACTER CONUNDRUM

A Brief History of Sheldon Cooper

Sheldon Cooper
The Nobel Prize in Physics, 2019

Born: February 26, 1980, Galveston, Texas

Affiliation at the time of the award: The California Institute of Technology

Prize Motivation: "For the discovery of super-asymmetry as a provable model for quantum string theory"

Prize share: 1/2, alongside Dr. Amy Farrah Fowler

Work:

Where supersymmetry is a proposed type of space-time symmetry, super-asymmetry as developed by Drs. Cooper and Fowler posits that the world is asymmetrical and full of symmetry, clearly dependent on observer position. They rebuilt string theory, taking super-asymmetry into account from the beginning of their equations.

Biography:

Born in an East Texas Kmart in 1980, Sheldon Cooper was brought up in a conservative and deeply religious family. His mother, Mary Cooper, worked for her local church, and his father, George Cooper Sr., worked as a football coach. Many would argue that his parents weren't equipped to deal with a child as intelligent as Sheldon, but they made every sacrifice to ensure the young prodigy had the tools he needed to succeed with his intellect.

As a child, he set out to complete many experiments that often landed him, or his family, in trouble. These ranged in absurdity from an attempt to create a pet griffin using techniques involving recombinant DNA, which failed because his parents refused to acquire the required eagle eggs and lion semen, to the time he tried to build his own CAT scanner, sending him to the hospital with radiation burns.

Despite setbacks like these, Sheldon first set foot in the halls of higher education at the age of 11 and received his first doctor of philosophy degree (PhD) at the age of 16. His extreme intelligence manifesting at such a young age, combined with an eidetic memory that enabled him to remember every moment of his life since his mother stopped breastfeeding him one drizzly Tuesday meant Sheldon always had a hard time fitting in with those around him.

Consistently the youngest and smallest in every class he attended as a child, he was constantly bullied. At the age of 5, class bully Billy Sparks shoved a Mexican peso up Sheldon's nose, causing problems with airport security to this day. At the age of 8, he attempted to fight back against the bullies using a Vulcan neck pinch. The bully in question retaliated by breaking the young genius's collarbone. According to Sheldon's own recollections, he spent much of the 5th grade with his head in a toilet. Many of his childhood inventions were conceived to fend off his bullies. A death ray he designed didn't slow them down, but it did annoy dogs.

That didn't stop him from trying to better his community, though. At the age of 13, he tried building a nuclear reactor to power his hometown, but that plan was stopped after the government informed him that it was illegal for him to obtain and store yellowcake uranium.

After his schooling was complete, Sheldon decided to go into the field of theoretical physics and landed a job at the California Institute of Technology. His early work there centered on bosonic string theory, but he eventually changed his focus to heterotic string theory. It was always his goal to win a Nobel Prize in Physics, and many early hypotheses and experiments took him in that direction. One notable grant he received was from the National Science Foundation to detect slow monopoles at the magnetic North Pole. He led an expedition there, accompanied by experimental physicist Dr. Leonard Hofstadter, astrophysicist Dr. Rajesh Koothrappali, and MIT-trained engineer Howard Wolowitz. Though their findings were inconclusive, they did get to spend months in the freezing cold.

Though his physics experiments were sound, some of his social experiments bordered on unethical. Once, he engaged his then-roommate, the above-mentioned Dr. Hofstadter, as a test subject to discover at what point food starts tasting "mothy," spending months grinding moths into his subject's food.

Another hypothetical road he took was the alleged discovery of a method for synthesizing a new stable super-heavy element. Though it landed him on NPR's *Science Friday* and on the cover of *Physics Today,* his hypothesis was eventually disproven. He made strides with his work alongside Dr. Hofstadter as they postulated an idea where space should actually be calculated as a super-fluid.

His fame, though, came through his longtime partnership with neuroscientist Dr. Amy Farrah Fowler. As they dated, the pair combined their fields and developed a hypothesis of string theory using super-asymmetry. Though they faced numerous setbacks in their research, their wedding proved to be the breakthrough they needed. Writing in lipstick on the mirror of the bridal suite, Drs. Cooper and Fowler hashed out the equations that made the paper publishable. They expected it to take years to prove, but two scientists out of the Fermi National Accelerator Laboratory in Illinois accidentally proved the paper correct, putting the theory of super-asymmetry on the fast track to the Nobel committee.

Together, Cooper and Fowler became the 2019 Nobel laureates in the field of physics, accepting the award in Sweden under the watchful eyes of their closest friends, including the three who accompanied him to the ends of the Earth for his failed research there. In his speech, Cooper thanked those friends for their help in his work that had gone unacknowledged for far too long.

Anyone who knows him would admit that Sheldon Cooper is a difficult man, but at the same time one who inspires a fierce loyalty. Hofstadter, whom Cooper considers his best friend, would describe the brilliant scientist as "judgmental, sanctimonious, obnoxious," but would (and has) defended him vociferously in all aspects of his life. Fowler, his wife, might be the most patient person in his life, waiting years to cultivate their intimacy, first emotionally, then physically. Even she would admit his difficulty, but underneath it all, she sees him for the brilliant, kind-hearted man he truly is.

Sheldon's Pictorial Record

SUBJECT

Dr. Sheldon Cooper is the sort of man who stands out in a crowd. Constantly wearing a pair of shirts and the twinkle of superiority, he's created a fashion that belongs entirely unto himself.

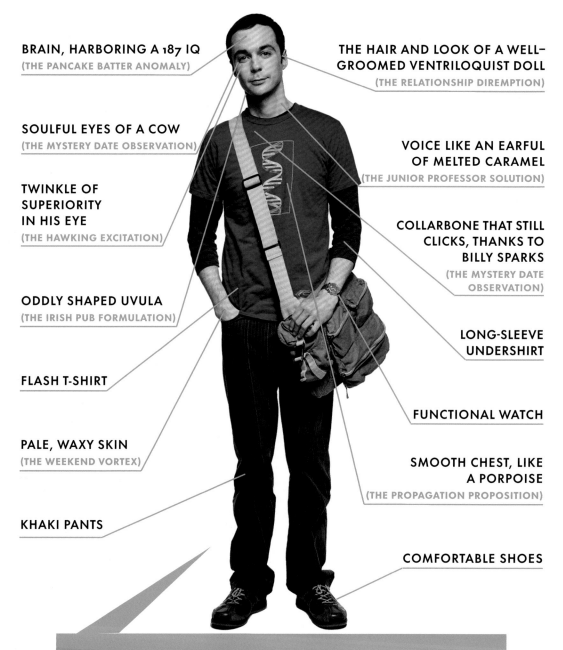

BRAIN, HARBORING A 187 IQ
(THE PANCAKE BATTER ANOMALY)

THE HAIR AND LOOK OF A WELL-GROOMED VENTRILOQUIST DOLL
(THE RELATIONSHIP DIREMPTION)

SOULFUL EYES OF A COW
(THE MYSTERY DATE OBSERVATION)

VOICE LIKE AN EARFUL OF MELTED CARAMEL
(THE JUNIOR PROFESSOR SOLUTION)

TWINKLE OF SUPERIORITY IN HIS EYE
(THE HAWKING EXCITATION)

COLLARBONE THAT STILL CLICKS, THANKS TO BILLY SPARKS
(THE MYSTERY DATE OBSERVATION)

ODDLY SHAPED UVULA
(THE IRISH PUB FORMULATION)

LONG-SLEEVE UNDERSHIRT

FLASH T-SHIRT

FUNCTIONAL WATCH

PALE, WAXY SKIN
(THE WEEKEND VORTEX)

SMOOTH CHEST, LIKE A PORPOISE
(THE PROPAGATION PROPOSITION)

KHAKI PANTS

COMFORTABLE SHOES

"For the record, I do have genitals. They are functional and aesthetically pleasing." (The Skank Reflex Analysis)

Sheldon's Timeline

SUBJECT

For a complete timeline of Sheldon's relationship with Dr. Amy Farrah Fowler, see page 100.

S.01

PILOT
Sheldon and Leonard meet Penny as she moves into apartment 4B.

THE LUMINOUS FISH EFFECT
Sheldon is fired by Dr. Eric Gablehauser, the new chair of the physics department, but quickly gets his job back.

Invents a bioluminescent fish.

THE COOPER-HOFSTADTER POLARIZATION
The Institute of Experimental Physics asks Sheldon and Leonard to present their paper on the properties of super solids at the Topical Conference on Bose-Einstein Condensates, much to Sheldon's dismay.

THE PANCAKE BATTER ANOMALY
Sheldon catches a cold, a disaster for all his friends.

THE PORK CHOP INDETERMINACY
Refocuses research from bosonic string theory to heterotic string theory.

S.02

THE BAD FISH PARADIGM
Attempts to move out of apartment 4A because he can't stand keeping Penny's secret about quitting community college.

THE EUCLID ALTERNATIVE
Is forced to take a driving test to finally get his driver's license, but fails to acquire one.

THE COOPER-NOWITZKI THEOREM
"Dates" postgraduate student Romona Nowitzki.

THE BATH ITEM GIFT HYPOTHESIS
After receiving Penny's gift of Leonard Nimoy's signature and DNA on a Cheesecake Factory napkin, Sheldon hugs Penny.

THE FRIENDSHIP ALGORITHM
Sheldon tries to befriend Barry Kripke in order to gain access to the open science grid computer.

THE WORK SONG NANOCLUSTER — Sheldon helps Penny build a successful Penny Blossom business.

THE VEGAS RENORMALIZATION — Locked out of his apartment, Sheldon is forced to sleep at Penny's apartment and convinces her to sing "Soft Kitty" for him.

THE MONOPOLAR EXPEDITION — First use of the term "Bazinga!"

THE ELECTRIC CAN OPENER FLUCTUATION — While in the North Pole, Sheldon sleeps naked with Howard, Raj, and Leonard when the heating breaks.

Sheldon resigns from the university and runs away following the debacle with the falsified data from his North Pole experiments. He quickly returns.

THE VENGEANCE FLUCTUATION — Sheldon appears on NPR's Science Friday with Ira Flatow, but is foiled by Barry Kripke, who pumps helium into his office during the interview.

THE GORILLA EXPERIMENT — As an experiment, Sheldon tries to teach Penny the basics of physics. He dubs the project "Operation: Gorilla," after the work done teaching Koko the gorilla more than 2,000 words in sign language.

THE BOZEMAN REACTION — Sheldon moves briefly to Bozeman, Montana, after apartment 4A is broken into. He believes it's safer, but comes back home immediately after having his bags stolen.

THE EINSTEIN APPROXIMATION — Sheldon gets a job at the Cheesecake Factory to activate his frontal cortex to figure out a physics problem. He modeled this solution on Albert Einstein's menial work in a patent office.

THE EXCELSIOR ACQUISITION — Despite not having a driver's license, Sheldon is thrown in jail for contempt of court after insulting the judge in a routine traffic court. This causes him to miss Stan Lee's signing at the comic book store.

THE LUNAR EXCITATION — Is blackmailed by Howard and Raj with a hidden dirty sock into going on a first date with Amy Farrah Fowler.

THE ROBOTIC MANIPULATION

First official date with Amy.

THE CRUCIFEROUS VEG AMPLIFICATION

In a bid to live long enough to have his consciousness implanted in a robot, effectively making him immortal, Sheldon builds a Mobile Virtual Presence Device.

THE APOLOGY INSUFFICIENCY

After blowing Howard's chance of getting a top-secret clearance from the FBI, Sheldon apologizes by giving Howard his spot on the couch for a total of 94 seconds.

THE TOAST DERIVATION

When the friend group relocates to Raj's house because Leonard is dating Priya, Sheldon invites new friends over. This group includes Barry Kripke, Stuart from the Comic Center, and Penny's ex-boyfriend Zack Johnson.

THE ENGAGEMENT REACTION

When wandering through the hospital, Sheldon takes a wrong turn and needs to undergo a two-week quarantine for exposure to a deadly disease.

THE INFESTATION HYPOTHESIS

Poses as a self-appointed member of the CDC street team in a vain effort to condemn Penny's apartment to rid the building of a new chair she found on the street.

THE WIGGLY FINGER CATALYST

Decides to let a pair of polyhedral *Dungeons & Dragons* dice decide all his most trivial decisions to free up brain power.

THE FLAMING SPITTOON ACQUISITION

After Amy starts dating Stuart, an inexplicably jealous Sheldon asks Penny on a date.

THE WEREWOLF TRANSFORMATION

After his regular barber, Mr. D'Onofrio, goes to the hospital, Sheldon has a crisis when his hair gets too long, but he decides to embrace the chaos.

THE HIGGS BOSON OBSERVATION

Sheldon looks to hire an assistant to go through his early work to see if he might have done anything that would yield him a Nobel Prize.

THE LOCOMOTION REVERBERATION

Sheldon wants to leave physics to be an engineer. A train engineer. Not the goofy kind Howard is.

THE ALLOWANCE EVAPORATION

Reveals that he got his driver's license two years prior.

THE RELAXATION INTEGRATION

Sheldon tries to wear flip-flops for the first time and it all goes south.

THE PROTON REGENERATION

Sheldon auditions for the role of Professor Proton.

THE TESLA RECOIL

Sheldon goes back to work for the military and doesn't tell Howard and Leonard.

THE SEPARATION TRIANGULATION

Sheldon rents his old room from Leonard and Penny in order to get some work done on string theory.

THE TENANT DISASSOCIATION

Angry about the smells from the food truck below his apartment, Sheldon complains to the tenant association, angering all his friends, who love the truck's pastrami sandwiches. But he's the president of the association and its only member.

THE SIBLING REALIGNMENT

Sheldon brings Leonard to Texas to reconcile with his brother, Georgie.

THE TAM TURBULENCE

Sheldon tries to drop Leonard as his best friend because Leonard takes the side of his old best friend. They all reconcile.

THE VCR ILLUMINATION

After Amy and Sheldon's theory seems to be proven wrong, Sheldon has an existential crisis and reevaluates everything in his life.

Beverly Hofstadter suggests they give the paper a funeral to help them mourn, so they give it a Viking funeral in the bathtub.

Sheldon uses his first sports metaphor.

THE CONFERENCE VALUATION

Gets excited to hang out with Halley and Neil Michael because he found a book about doing science experiments on babies.

THE STOCKHOLM SYNDROME

During his Nobel acceptance speech, Sheldon honors his friends instead of giving the self-centered speech he had prepared.

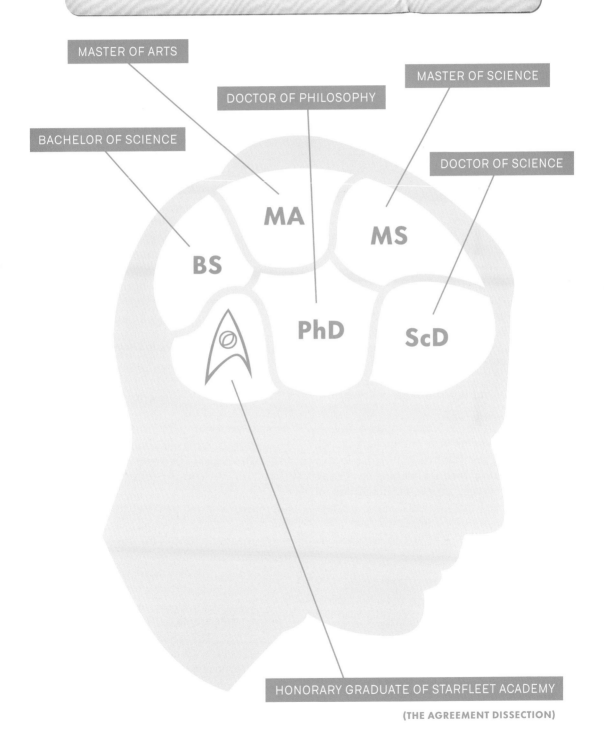

The Educational Assortment

SUBJECT

Dr. Sheldon Cooper is, perhaps, the most learned man among his friend group and has an assortment of degrees and honors.

MASTER OF ARTS

DOCTOR OF PHILOSOPHY

MASTER OF SCIENCE

BACHELOR OF SCIENCE

DOCTOR OF SCIENCE

MA

MS

BS

PhD

ScD

HONORARY GRADUATE OF STARFLEET ACADEMY

(THE AGREEMENT DISSECTION)

The Publication Paradigm

SUBJECT

Over the years, Dr. Sheldon Cooper has racked up an impressive number of published papers in peer-reviewed journals the world over. He's also tinkered with ideas across space and time. Here is just a sampling of his work, his successes, his failures, and the journeys along the way.

Wrote a paper at age five called "A Proof that Alge-braic Topology Can Never Have a Non-Self-Contradictory Set of Abelian Groups."

(THE HIGGS BOSON OBSERVATION)

Wrote another paper at age five called "A Rederivation of Maxwell's Equations Regarding Electromagnetism," but changed the title to "Magnets, What Do They Stick To?" because the more religious folks in town were starting to say Sheldon was a witch.

(THE HIGGS BOSON OBSERVATION)

At 16, Sheldon was too busy to get a driver's license because he was otherwise engaged in examining perturbative amplitudes in N=4 supersymmetric theories leading to a reexamination of the ultraviolet properties of multi-loop N=8 supergravity using modern twister theory.

(THE EUCLID ALTERNATIVE)

> **@carynlarrinaga:** Dr. Cooper has taken a relatively boring subject and managed to make it completely insufferable. Plus, he looks like a giant insect.
>
> **(THE THESPIAN CATALYST)**

Published a paper on the properties of super solids, coauthored with Leonard Hofstadter.

(THE COOPER-HOFSTADTER POLARIZATION)

Wrote a paper on grand unification using string-network condensates.

(THE COOPER-NOWITZKI THEOREM)

In a paper, included a footnote that likens mirror-symmetry to The Flash playing tennis with himself.

(THE COOPER-NOWITZKI THEOREM)

Wrote a paper on astrophysical probes of M-theory effects in the early universe. He planned to give this paper to George Smoot.

(THE TERMINATOR DECOUPLING)

Submitted a grant proposal to the National Science Foundation to detect slow monopoles at the magnetic North Pole. He went, but his hypotheses were not proved correct.

(THE MONOPOLAR EXPEDITION)

Wrote a paper on the decay of highly excited massive string states.

(THE ADHESIVE DUCK DEFICIENCY)

Worked feverishly for days without sleep to unravel the mystery of why electrons behave as though they have no mass when traveling through a graphene sheet.

(THE EINSTEIN APPROXIMATION)

Once did an experiment without the consent of the subject (Leonard) to determine at what point food starts tasting "mothy." He spent a month grinding moths into Leonard's food to determine that point.
(THE IRISH PUB FORMULATION)

Worked on time-dependent backgrounds in string theory, specifically quantum field theory in "D-dimensional" de Sitter space.
(THE ENGAGEMENT REACTION)

Unburdened by the need to make trivial decisions thanks to rolling dice, Sheldon published two papers in notable peer-reviewed journals.
(THE WIGGLY FINGER CATALYST)

Sheldon figured out a method for synthesizing a new stable super-heavy element. This got him on the cover of *Physics Today*. He has a meltdown because he made a mistake in his calculations, even though they still worked out.
(THE ROMANCE RESONANCE)

Sheldon retracted his paper on the method for synthesizing a new stable super-heavy element after Leonard published a paper disproving it.
(THE DISCOVERY DISSIPATION)

Sheldon and Leonard's paper on space as a super-fluid took them on a road trip to present the paper at Berkeley.
(THE COLONIZATION APPLICATION)

Sheldon and Leonard tried buying helium on the black market in order to conduct their experiment before a Swedish team could scoop them. They weren't successful in acquiring it from the black market.
(THE HELIUM INSUFFICIENCY)

Wrote a paper on super-singular prime numbers that only took him about an hour and a half while on a date with Amy.
(THE MYSTERY DATE OBSERVATION)

Raj and Sheldon discovered a medium-sized asteroid. They named it Amy.
(THE SALES CALL SUBLIMATION)

Sheldon, Leonard, and Howard were about to field test a quantum gyroscope, but the military took over the project.
(THE GYROSCOPIC COLLAPSE)

Sheldon asked for $500,000,000 for an experiment to create a microscopic black hole in order to prove his theories about string theory. When the university declined, he ended up heading to Las Vegas to try to win some money. Unfortunately, he got tossed out.
(THE MONETARY INSUFFICIENCY)

Sheldon hit upon the idea of super-asymmetry just before he got married.
(THE BOW TIE ASYMMETRY)

Despite the fact that they thought the paper has been disproven, Sheldon and Amy came up with another way to tackle their super-asymmetry paper and rewrite it.
(THE VCR ILLUMINATION)

Sheldon and Amy's paper on super-asymmetry got published.
(THE PAINTBALL SCATTERING)

Scientists from Fermilab in Chicago accidentally proved Amy and Sheldon's paper on super-asymmetry.
(THE CONFIRMATION POLARIZATION)

Sheldon and Amy were informed they won the Nobel Prize in Physics for their paper on super-asymmetry. Leonard smacked Sheldon across the face.
(THE CHANGE CONSTANT)

Sheldon's future memoirs were tentatively titled *You're Welcome, Mankind*.
(THE FRIENDSHIP CONTRACTION)

The Rules Expectancy

Sheldon Cooper is a stickler for the rules. He has rules for everything, both for himself and the people around him. His list is nothing short of extensive.

1. **People cannot be in Sheldon's bedroom.**

 (THE BARBARIAN SUBLIMATION)

2. **No one touches food on Sheldon's plate.**

 (THE PANTY PIÑATA POLARIZATION)

3. **Sheldon has a rule against forwarding email humor. He explains this after scolding Penny for forwarding him a LOLcat.**

 (THE PANTY PIÑATA POLARIZATION)

4. **Must sit in the acoustic sweet spot of movie theaters. He'll use his voice or toy xylophone to locate it.**

 (THE WHITE ASPARAGUS TRIANGULATION)

5. **Guests in emotional distress must receive a hot beverage for consolation. It's not optional.**

 (THE COHABITATION FORMULATION)

6. **Will not drink from the glass of another.**

 (THE ENGAGEMENT REACTION)

7. **Will not use public restrooms in a hospital.**

 (THE ENGAGEMENT REACTION)

8. **Guests "drunk as a skunk" must get coffee as their consolation hot beverage. And it must be gotten with a smile.**

 (THE RHINITIS REVELATION)

9. **Sheldon's hot cocoa requires half–and–half instead of whole milk, heated to precisely 183 degrees Farenheit, with 7 little marshmallows, no more, no less.**

 (THE SPECKERMAN REOCCURRENCE)

10. **Sheldon doesn't like buying things at night.**

 (THE HELIUM INSUFFICIENCY)

11. **Sheldon must cut the crust off his toast.**

 (THE EUCLID ALTERNATIVE)

SUBJECT

Dr. Sheldon Cooper is an anxious ball of fear and phobias. He knows it. Everyone knows it. But how low do the depths of his fear go? The compiled list of fears is more extensive than even Sheldon himself would guess.

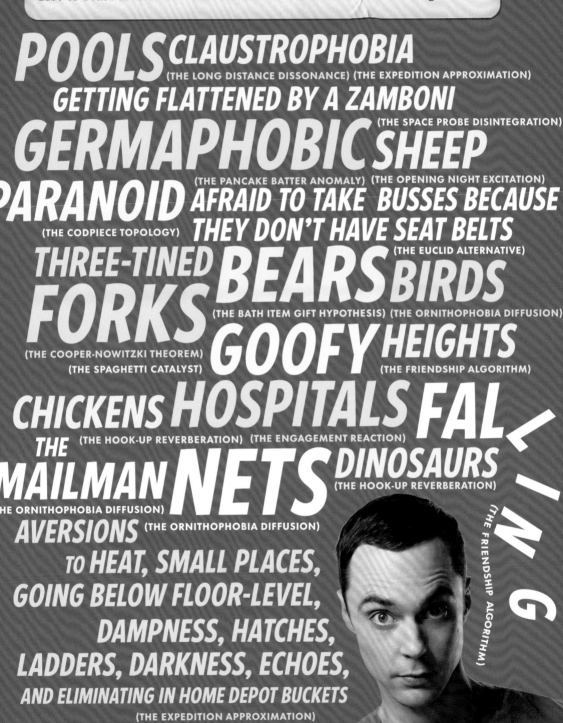

POOLS (THE LONG DISTANCE DISSONANCE) **CLAUSTROPHOBIA** (THE EXPEDITION APPROXIMATION)

GETTING FLATTENED BY A ZAMBONI (THE SPACE PROBE DISINTEGRATION)

GERMAPHOBIC (THE PANCAKE BATTER ANOMALY) **SHEEP** (THE OPENING NIGHT EXCITATION)

PARANOID (THE CODPIECE TOPOLOGY) **AFRAID TO TAKE BUSSES BECAUSE THEY DON'T HAVE SEAT BELTS** (THE EUCLID ALTERNATIVE)

THREE-TINED FORKS (THE COOPER-NOWITZKI THEOREM) **BEARS** (THE BATH ITEM GIFT HYPOTHESIS) **BIRDS** (THE ORNITHOPHOBIA DIFFUSION)

GOOFY (THE SPAGHETTI CATALYST) **HEIGHTS** (THE FRIENDSHIP ALGORITHM)

CHICKENS (THE HOOK-UP REVERBERATION) **HOSPITALS** (THE ENGAGEMENT REACTION) **FALLING** (THE FRIENDSHIP ALGORITHM)

THE MAILMAN (THE ORNITHOPHOBIA DIFFUSION) **NETS** (THE ORNITHOPHOBIA DIFFUSION) **DINOSAURS** (THE HOOK-UP REVERBERATION)

AVERSIONS TO HEAT, SMALL PLACES, GOING BELOW FLOOR-LEVEL, DAMPNESS, HATCHES, LADDERS, DARKNESS, ECHOES, AND ELIMINATING IN HOME DEPOT BUCKETS (THE EXPEDITION APPROXIMATION)

The Sheldonian Calendar

Dr. Sheldon Cooper is a creature of habit and, as such, has a number of strict routines. Each one has been settled into with scientific rigor, tested and retested by Sheldon to create the most comfortable situation for himself as he can. Many of these are for Sheldon to automate his decisions, freeing up brain power for his eidetic memory and to explore the theoretical sciences that he finds so utterly fascinating.

Everyone at the university knows that Sheldon eats breakfast at 8:00 a.m. and moves his bowels at 8:20 a.m. (THE MONOPOLAR EXPEDITION)

Sheldon shaves once every 11 days. (THE POSITIVE NEGATIVE REACTION)

On Tuesday nights, Sheldon claims to do a live web chat called "Apartment Talk." (THE ROOMMATE TRANSMOGRIFICATION)

On Wednesdays, Sheldon goes to the comic book store for new comic book day, then Soup Plantation for creamy tomato soup, and then caps his evening off at Radio Shack. (THE EUCLID ALTERNATIVE)

On Mondays, Sheldon eats Thai food: mee krob and chicken satay with extra peanut sauce from Siam Palace. (THE COOPER-NOWITZKI THEOREM)

On Tuesdays, Sheldon eats a cheeseburger at the Cheesecake Factory at 6:00 p.m. (THE WORK SONG NANOCLUSTER & THE LOVE CAR DISPLACEMENT)

Every workday at 2:45, Sheldon leaves the lunchroom to go to a small room in the basement to recharge and play hacky sack. (THE 43 PECULIARITY)

Sheldon doesn't eat desert on Tuesdays. (THE HOT TROLL DEVIATION)

Sheldon awakens at 6:15 a.m., pours himself a bowl of cereal, adds a quarter cup of 2 percent milk, sits in his spot on the couch, and watches *Doctor Who*. **(THE DUMPLING PARADOX)**

Sheldon uses the bathroom from 7:00 to 7:20 a.m. **(THE DUMPLING PARADOX)**

Sheldon's normal urination time is 7:10 a.m. **(THE EAR-WORM REVERBERATION)**

Wednesdays are also *Halo* night. **(THE COOPER-NOWITZKI THEOREM)**

Sheldon goes to the bathroom at 8:00 a.m. with an optional follow-up at 1:45 p.m. and 7:10 p.m. on high-fiber Fridays. **(THE 43 PECULIARITY)**

Sheldon showers twice a day. **(THE GRASSHOPPER EXPERIMENT)**

On Fridays, it's Chinese food and vintage video game night. **(THE HOFSTADTER ISOTOPE)**

On Thursdays, Sheldon eats pizza from Giacomo's. Sausage, mushrooms, light olives. **(THE COOPER-NOWITZKI THEOREM)**

He also wears shirts featuring The Flash on Fridays. **(THE CRUCIFEROUS VEGETABLE AMPLIFICATION)**

Saturday night at 8:15 is for laundry. **(THE PANTY PIÑATA POLARIZATION)**

In a bid to extend his lifetime to reach the singularity where man can implant consciousness in robots and achieve immortality, Sheldon replaces Thursday pizza night with Thursday cruciferous vegetable night. **(THE CRUCIFEROUS VEGETABLE AMPLIFICATION)**

As a college student, his bedtime was 9:00 p.m. **(THE COOPER-NOWITZKI THEOREM)**

The Council of Sheldons Reflection

In the eleventh-season episode "The Relaxation Integration," Sheldon's dreams convene a Council of Sheldons to determine who will have access to Sheldon's mind and body. This was after he felt betrayed to discover that Laid-Back Sheldon even existed and was presenting himself in his sleep. The council votes to boot out Laid-Back Sheldon and call a vote to get rid of Humorous Sheldon, too. Each aspect of Sheldon is unique and holds a different key to the doors of his total persona.

SHELDON

This is the Sheldon that loves all things science and operates the math portions of his brain.

TEXAS SHELDON

Sheldon's folksy attitude, occasional Texas drawl, and love of his mother all fit in here.

HUMOROUS SHELDON

Bazinga!

FANBOY SHELDON

Want to know the difference between Jay Garrick and Wally West, or which Green Lantern got punched in the face by Batman? This is the Sheldon that would know. It contains his enthusiasm and childlike wonder.

GERMAPHOBE SHELDON

Would there be any other personality so capable of weathering a pandemic with his constant supply of Purell and worry?

LAID-BACK SHELDON

Well, you know, man, he just wants to get along and get by and be cool, just like everyone else.

The Public Restroom Kit Analysis

SUBJECT

In "The Skywalker Incursion," Sheldon reveals the contents of his Public Restroom Kit (or PRK). He doesn't like using the restroom in public and to help, this kit has been put together to ease his mind and soothe his anxiety.

1. Toilet paper
2. Hand sanitizer
3. Rubber gloves
4. Air freshener
5. Noise-canceling headphones
6. Danger whistle
7. Pepper spray
8. Multi-language "occupied" sign
9. Seat protectors
10. Booties for shoes
11. Clothespin for nose
12. A mirror on a stick so he can make sure the person in the stall next to him isn't some sort of weirdo

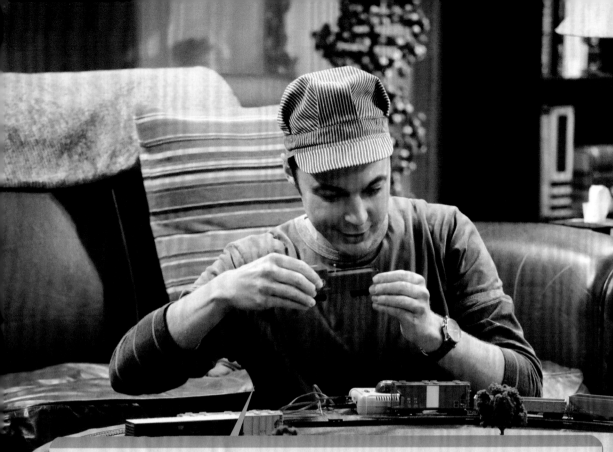

The Locomotive Cartography Situation

SUBJECT

When Sheldon suffers a breakdown because everything around him is changing, so he decides to ride the rails in the eighth-season premiere of the show (The Locomotion Interruption). He spent more than a month aboard trains and in train stations. In that time, he never left the train stations or ate a single piece of fruit. His trip crisscrossed the country and ended at a police station in Kingman, Arizona, sans pants. He'd been robbed.

"Why would I leave a train station? That's where all the cool trains are."—Sheldon Cooper

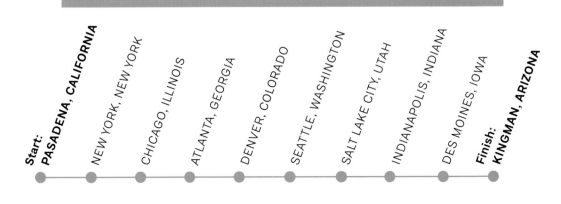

Start:
PASADENA, CALIFORNIA

NEW YORK, NEW YORK

CHICAGO, ILLINOIS

ATLANTA, GEORGIA

DENVER, COLORADO

SEATTLE, WASHINGTON

SALT LAKE CITY, UTAH

INDIANAPOLIS, INDIANA

DES MOINES, IOWA

Finish:
KINGMAN, ARIZONA

SUBJECT

In "The Wiggly Finger Catalyst," Sheldon decides to let a set of polyhedral dice decide all of his most trivial decisions, to hilarious effect. What were those decisions, and how did they play out?

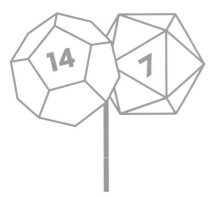

At the Cheesecake Factory, a roll of 14 and 7 on the dice yield Sheldon a side of corn succotash for dinner.

Another roll directs him to wash the succotash down with a pitcher of margaritas.

Dessert is a hot fudge sundae.

The dice direct Sheldon to grow a mustache by telling him what percentage of his face to shave.

The dice had him free ball it, chafing his testicles.

After a roll of the dice, Sheldon refuses to believe that Raj has a girlfriend.

Rolling doubles prevents Sheldon from revealing information about Raj to the group. After Penny has him roll again, he tells them that the Koothrappalis are vastly wealthy. Like, Richie Rich rich. Halfway between Bruce Wayne and Scrooge McDuck.

Wondering if he should go to the bathroom or not, the dice told Sheldon to stay in his spot.

Like a Magic 8 Ball, Sheldon asks the dice if he should use the restroom at the Cheesecake Factory or wait until he gets home. The dice don't roll in his favor.

SUBJECT

Let it never be said that Dr. Sheldon Cooper didn't have a creative side.
There were many times he revealed his love of poetry:

POEM FOR HOWARD

(THE APOLOGY INSUFFICIENCY)

H is for honesty,
 for which he has much.
O's for outstanding,
 which he is such.
W's for witty,
 he's quick with a joke.
A's for artistic ability . . .

He never got to finish reading it, but had entries for every letter of HOWARD JOEL WOLOWITZ.

POEM TO COMMEMORATE DR. SEUSS'S DEATH

(THE FOCUS ATTENUATION)

Why die?
Why did he die?
Old, told.
I was told he was old.

POEM FOR LEONARD'S ASHES URN

(THE SEPTUM DEVIATION)

Here lie the ashes of
Leonard Hofstadter.
He thought he was right,
but his roommate knew better.

MNEMONIC FOR CLEAN BATHROOMS AT THE SCHOOL (THE TAM TURBULENCE)

If it's number one,
the library's fun.
If it's number two,
the basement's for you.

NAME: Dr. Leonard Leakey Hofstadter

BIRTHDAY: May 17, 1980

HEIGHT: 5'5"

BUILD: Medium

HAIR: Brown

EYES: Brown

GLASSES: Thick

EYEBROWS: Thicker

HEAD: Thickest

FUN FACT: Capable of producing an actual pheromone-based stink of desperation

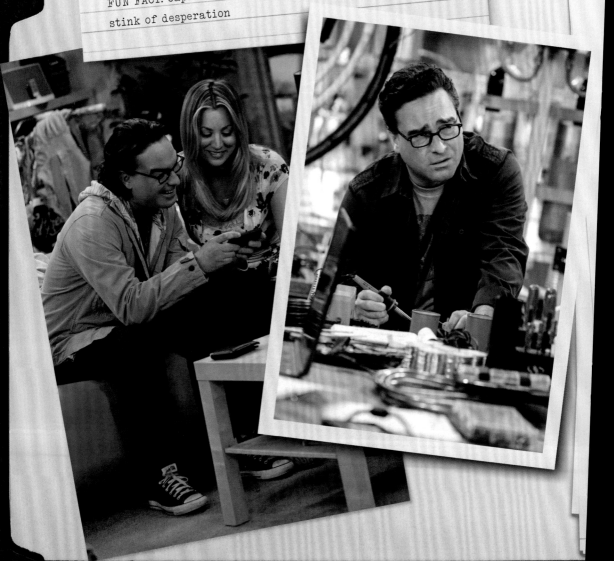

THE HOFSTADTER ASSESSMENT

For the man known as the Jar Jar Binks of the Hofstadter family,[1] Dr. Leonard Hofstadter was forced to learn to take that as a compliment. Like the lovable Gungan warrior, general, and representative, Hofstadter is loyal, if not clumsy, brave, though terrified, and often in situations far over his head. Like the much-maligned Binks, Leonard suffered through bullying at the hands of people who didn't understand his good nature and the value of his existence. Like the beleaguered amphibian, Leonard grew up an outcast in his family. Once, at ten years old, Hofstadter even built a hugging machine out a dress-maker's mannequin, stuffed with an electric blanket, and two radio-controlled arms.[2]

Born in New Jersey the same month *Star Wars: Episode V—The Empire Strikes Back* was released to theaters, he spent his formative years as more of a psychology experiment than a child. His mother, the renowned psychiatrist and author Dr. Beverly Hofstadter, used his childhood as the grist for a nonfiction study called *The Disappointing Child*. That would have an effect on anyone growing up in that environment.

Despite the brutal frigidity of his upbringing, both from bullies and his home life, Leonard went to nearby Princeton University and ended up getting his Doctorate in Physics before moving to Pasadena to work at the California Institute of Technology alongside folks who would become his good friends like Dr. Sheldon Cooper, Dr. Rajesh Koothrappali, and Howard Wolowitz. Seeking a place to live, he answered an ad that brought him to apartment 4A and the place that he would call home for the next 20 years.[3]

History was made there. In apartment 4A, Leonard would establish himself as the bedrock of a friend group that would eventually expand to include everyone from Stuart Bloom, his purveyor of comics, to *Star Trek: The Next Generation* actor and table-top gamer Wil Wheaton.

His life was changed forever when he met Penny, though. She moved in across the hall in apartment 4B and he was smitten completely. They dated briefly and he had his already reduced level of confidence shattered when she broke up with him. He dated on and off, but it was never the same without Penny. Eventually, they reconciled, dated, got married in a quick ceremony in Las Vegas, and are expecting parents.[4]

Aside from his romantic relationship with Penny, his most important connection would be with his best friend, Dr. Sheldon Cooper. When asked about their relationship, Leonard once replied, "Look, I know he can be aggravating, but what you have to remember is that he is not doing it on purpose. It's just how he is. He is also loyal and trustworthy, and we have fun together . . . You know what? Sheldon is the smartest person that I have ever met. He's a little broken and he needs me. I guess I need him, too."[5]

Leonard spent his time as an experimental physicist working primarily with lasers and doing his best to prove and disprove hypotheses. He was a valuable asset to the California Institute of Technology and to the field of physics in general. He published prolifically in the field, on his own, and as a part of teams and partnerships (some of the most notable include Dr. Sheldon Cooper).

Even Dr. Stephen Hawking called the work Leonard and Sheldon did on spacetime as a super-fluid intriguing, but that didn't stop Hawking from trolling the pair of them out of boredom.

Additionally, Leonard served an important part of Sheldon and Dr. Amy Farrah Fowler's Nobel prize win. He chased down the citations for them, finding the Russian paper they thought disproved the theory of super-asymmetry, forcing them to bolster their work and come up with something even better.

Ultimately, Leonard is a competent scientist, devoted husband, and a terrific friend.

1 (The Maternal Capacitance)
2 (The Barbarian Sublimation)
3 (The Staircase Implementation)

4 (The Stockholm Syndrome)
5 (The Proton Displacement)

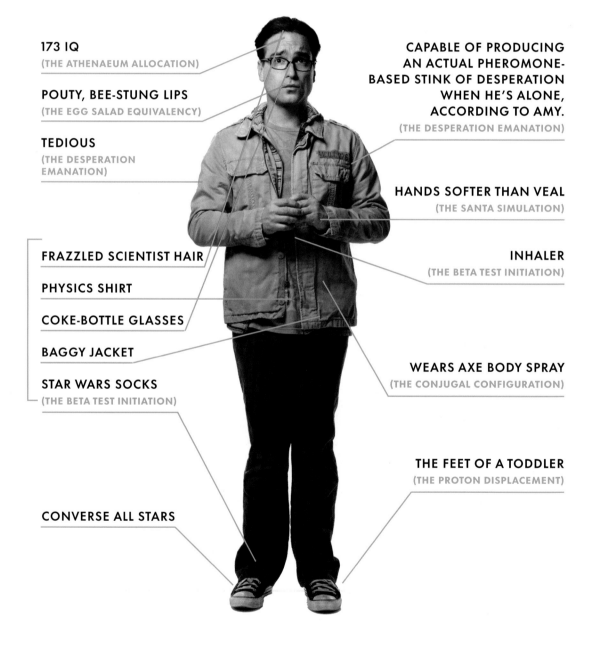

Leonard's Pictorial Record

SUBJECT

Dr. Leonard Hofstadter does his best to blend in and avoid notice, wearing big baggy hoodies and jackets covering nerdy physics shirts. He's as likely to be staring at his shoes as he is to be looking at someone. A brilliant scientist and deep thinker, Leonard is more impressive than his looks might imply.

173 IQ
(THE ATHENAEUM ALLOCATION)

POUTY, BEE-STUNG LIPS
(THE EGG SALAD EQUIVALENCY)

TEDIOUS
(THE DESPERATION
EMANATION)

FRAZZLED SCIENTIST HAIR

PHYSICS SHIRT

COKE-BOTTLE GLASSES

BAGGY JACKET

STAR WARS SOCKS
(THE BETA TEST INITIATION)

CONVERSE ALL STARS

CAPABLE OF PRODUCING
AN ACTUAL PHEROMONE-
BASED STINK OF DESPERATION
WHEN HE'S ALONE,
ACCORDING TO AMY.
(THE DESPERATION EMANATION)

HANDS SOFTER THAN VEAL
(THE SANTA SIMULATION)

INHALER
(THE BETA TEST INITIATION)

WEARS AXE BODY SPRAY
(THE CONJUGAL CONFIGURATION)

THE FEET OF A TODDLER
(THE PROTON DISPLACEMENT)

Leonard's Timeline

SUBJECT

For a complete timeline of Leonard's relationship with Penny, see page 93.

S.01

PILOT
Sheldon and Leonard meet Penny. For Leonard, it's love at first sight.

THE FUZZY BOOTS COROLLARY
On Leonard and Penny's first date, Leonard demonstrates centrifugal force with an olive and injures himself retrieving it from under the table.

THE HAMBURGER POSTULATE
Leonard sleeps with Leslie Winkle.

THE MIDDLE EARTH PARADIGM
Penny's first kiss with Leonard, though they later decide this kiss doesn't count.

THE COOPER-HOFSTADTER POLARIZATION
The Institute of Experimental Physics asks Sheldon and Leonard to present their paper on the properties of super solids at the Topical Conference on Bose-Einstein Condensates.

THE TANGERINE FACTOR
Leonard asks Penny out for the first time and she says yes.

S.02

THE CODPIECE TOPOLOGY
Leonard starts dating Leslie Winkle after Penny brushes him off for a second date.

Leslie Winkle breaks up with Leonard over his belief that string theory is superior to loop theory.

THE VARTABEDIAN CONUNDRUM
Leonard dates Dr. Stephanie Barnett.

S.03

THE ELECTRIC CAN OPENER FLUCTUATION
While in the North Pole, Leonard sleeps naked with Howard, Raj, and Sheldon when the heating breaks.

Leonard, along with Howard and Raj, interfere with the data of Sheldon's North Pole experiments in order to keep him happy.

THE ADHESIVE DUCK DEFICIENCY
Leonard gets stoned on weed cookies while waiting for the Leonid meteor shower.

THE EINSTEIN APPROXIMATION
Leonard changes the ringtone on his phone to the Joker's creepy laugh.

THE LARGE HADRON COLLISION
Leonard is sent to attend a conference in Switzerland to see the CERN supercollider.

THE EXCELSIOR ACQUISITION
Leonard changes the ringtone on his phone to the '60s Spider-Man theme song, and Stan Lee takes him out for gelato.

THE DESPERATION EMANATION
Tired of being alone and without Penny, Leonard invokes the girlfriend pact with Howard. Bernadette hooks him up with a meathead named Joy. He agrees to a second date when she mentions an open bar and easy sex.

THE BUS PANTS UTILIZATION
Leonard devises an idea for an app to recognize handwriting and solve equations. The guys help him try to realize it. They call it the Lenwoloppali Differential Equation Scanner after Leonard fires Sheldon.

THE PRESTIDIGITATION APPROXIMATION
In a bid to impress Priya Koothrappali, Leonard replaces his glasses with contacts. He also lets her change his wardrobe.

THE ROOMMATE TRANSMOGRIFICATION
Leonard breaks it to Priya's parents that they're dating after he discovers she was planning on moving back to India without telling him.

THE INFESTATION HYPOTHESIS
Leonard tries having cybersex with Priya, but the entire enterprise is awkward and gets even worse when the picture freezes.

THE FRIENDSHIP CONTRACTION
Leonard nullifies his friendship with Sheldon in order to negate the roommate agreement and get out of taking Sheldon to the dentist. This plan is met with disastrous results.

THE SPOILER ALERT SEGMENTATION
Leonard finally starts reading Harry Potter. As he gets into the sixth book, Sheldon spoils the fact that Dumbledore dies. After another disagreement, Sheldon spoils the death of Dobby the house-elf. As Leonard commiserates with Penny, she spoils the fact that Harry and Ginny get together.

THE CONTRACTUAL OBLIGATION IMPLEMENTATION
Leonard is contractually obligated to serve on a committee with the university and elects to serve on one encouraging women to take up the sciences.

Leonard goes to Howard's middle school to give a speech to the young women there, encouraging them to get into science.

THE BON VOYAGE REACTION
Leonard joins a mission to the North Sea as part of a Stephen Hawking expedition.

THE HOFSTADTER INSUFFICIENCY
Leonard has a lot of fun partying on his science mission to the North Sea.

THE PROTON DISPLACEMENT

Leonard reveals to Professor Proton that Sheldon is the smartest person he's ever met and he's a little broken. "He needs me. And I guess I need him, too."

THE ITCHY BRAIN SIMULATION

When Leonard finds a *Super Mario Brothers* (1993) DVD that he failed to return seven years previous on Sheldon's account, he is forced to wear an itchy sweater for days until he can return it. Little does he know that Sheldon paid for the DVD years ago and waited seven years for this revenge.

THE DISCOVERY DISSIPATION

Leonard disproves Sheldon's latest major discovery in the lab.

THE TABLE POLARIZATION

Leonard causes consternation in the apartment when he wants to replace the loft desk with a dining room table.

THE HOOK-UP REVERBERATION

Leonard suggests that he and the guys buy a stake in Stuart's comic book store to help him reopen after a fire.

THE SEPTUM DEVIATION

Leonard has his deviated septum straightened, much to Sheldon's consternation. When an earthquake happens during the procedure and the power goes out, Sheldon breaks his nose.

THE CHAMPAGNE REFLECTION

Leonard cleans out their colleague Dr. Abbot's office after his death and finds a bottle of champagne Abbot's mother gave him, to be opened in the event of a great success or scientific breakthrough. Leonard, Raj, and Howard vow to drink it when they have one of their own breakthroughs and toast to Dr. Abbot. Sheldon opens it instead to celebrate the un-cancellation of *Fun with Flags*.

THE GRADUATION TRANSMISSION

Leonard is asked to give the commencement speech at his old high school, but his flight to New Jersey is canceled. Penny arranges for him to give it via Skype.

THE 2003 APPROXIMATION

Leonard signs an agreement that lets him move out of the apartment.

THE MATRIMONIAL METRIC

Leonard embarks on writing a book about a brilliant physicist who solves crimes using science.

THE ATHENAEUM ALLOCATION

Leonard is caught in a lie to Sheldon about the Athenaeum Club near Caltech being extremely exclusive. He's been a member for years.

THE GRANT ALLOCATION DERIVATION

Leonard gets put in charge of allocating extra grant money at the university. He worries about angering people by not funding their projects but ends up using the remaining money to buy a new laser for his lab.

THE CITATION NEGATION

Leonard finds a paper that seems to disprove Amy and Sheldon's theory of super-asymmetry.

THE PROPAGATION PROPOSITION

After going back and forth with Penny about it, Leonard donates his sperm to Penny's ex-boyfriend Zack so Zack and his wife can conceive a child.

THE CONFIRMATION POLARIZATION

Leonard has a fever dream where he cuts open a meteorite with a laser and unleashes something that forces him to eat Raj, Bert, and Penny.

THE CONFERENCE VALUATION

When Sheldon does social experiments with Howard's kids, Leonard has a crisis about his own childhood, giving him flashbacks. His sleepaway camp cabin was even named "Control Group."

THE DECISION REVERBERATION

Sick of being a "satisficer," a person who makes decisions based on everyone else's happiness rather than their own, Leonard starts making decisions to make himself happy rather than satisfying others. He orders BBQ on Chinese night, sits in Sheldon's spot, and doesn't take the well-worn route to work. He then demands control of a project at work and is rejected. He gets to be co-lead on a photon entanglement team, though.

THE MATERNAL CONCLUSION

Beverly Hofstadter comes to visit and is unnaturally nice to Leonard. He's shocked to discover that it's for research for a book and not an attempt to be nice. Leonard forgives her for her bad parenting and forgives himself for taking so long to do it.

SUBJECT

Dr. Leonard Hofstadter dedicated his life to the world of experimental physics and published prolifically over the years. Everything from quantum mechanics and super-solids to cosmic radiation and dark matter are represented on his widely varied CV.

Published a paper on the properties of super solids, coauthored with Sheldon.

(THE COOPER-HOFSTADTER POLARIZATION)

Designed experiments to measure cosmic radiation at sea level.

(THE JERUSALEM DUALITY)

Became proficient in use of a free-electron laser for an X-ray refraction experiment.

(THE EUCLID ALTERNATIVE)

Reconciled the black hole information paradox with his theory of string-network condensates.

(THE COOPER-NOWITZKI THEOREM)

Worked with Dr. David Underhill on an experiment to examine the radiation levels of photomultiplier tubes for a new dark matter detector.

(THE BATH ITEM GIFT HYPOTHESIS)

His anti-decay experiment yielded no results after 20,000 data runs.

(THE FRIENDSHIP ALGORITHM)

Worked on replicating the dark matter signal found in sodium iodide crystals by the Italians.

(THE MATERNAL CAPACITANCE)

His Work on fundamental tests of quantum mechanics and tests of the Aharonov-Bohm quantum interference effect reached an interesting point, where he tested a phase shift due to electric potential.

(THE GORILLA EXPERIMENT)

At age 8, won a ribbon at the science fair for his project "Do Lima Beans Grow Better to Classical Music."

(THE PANTS ALTERNATIVE)

Received a "Dissertation of the Year" award for experimental particle physics.

(THE BENEFACTOR FACTOR)

Got a big government contract to see if his high-powered lasers could be used to knock out ballistic missiles. Leonard was confident his lasers couldn't do the job, but the money was good, and he was able to use the leftover parts to make his own Bat-Signal.

(THE RECOMBINATION HYPOTHESIS)

Leonard designed a front-projected holographic display combined with laser-based finger tracking.

(THE HOLOGRAPHIC EXCITATION)

Grew isotopically pure crystals for neutrino detection.

(THE 43 PECULIARITY)

Built a particle detector using superfluid helium.

(THE TROLL MANIFESTATION)

While talking to Penny at dinner, Leonard has a significant breakthrough in the idea of spacetime as a superfluid and talked to Sheldon about it. Sheldon finished the calculations and they published the paper. Eventually, they're trolled in the forums by an anonymous Stephen Hawking.

(THE TROLL MANIFESTATION)

Sheldon and Leonard tried buying helium on the black market in order to conduct their experiment before a Swedish team scooped them.

(THE HELIUM INSUFFICIENCY)

Sheldon, Leonard, and Howard readied their quantum gyroscope for field testing, but the military took it over.

(THE GYROSCOPIC COLLAPSE)

The Black Sheep Diagnosis

SUBJECT

Except for his younger brother, a law professor at Harvard, every member of Leonard's immediate family is an accomplished scientist. Despite all his successes in physics, Leonard might be the least accomplished member of his family, who set the bar pretty high for his levels of achievement.

FATHER

Dr. Alfred Hofstadter
Anthropologist

MOTHER

Dr. Beverly Hofstadter
Psychiatrist and neuroscientist

AUNT EDNA

One of the hairiest women one would ever meet.
(THE CODPIECE TOPOLOGY)

SISTER

[Name Unknown]
Medical researcher

She successfully grew a human pancreas in an adolescent gibbon, putting her on the road to curing diabetes.

(THE MATERNAL CAPACITANCE)

BROTHER

Michael Hofstadter
Harvard Law professor

He married the youngest appellate court judge in New Jersey's history and once argued a case in front of the Supreme Court.

NIBLINGS

Nephews, all by way of Leonard's sister.

(THE PROCRASTINATION CALCULATION)

NEIL JEFFREY SCOTT WILLIAM RICHARD

GRANDFATHER

[Name Unknown]

Passed away on Leonard's birthday as a child. His funeral made Leonard feel like he was getting a real birthday party.

(THE PEANUT REACTION)

GRANDMOTHER

[Name Unknown]

She suffered from Alzheimer's and once visited Sheldon and Leonard in their apartment, then stripped naked.

(PILOT)

AUNT NANCY

She was devoured by cats after she died.

(THE ZAZZY SUBSTITUTION)

AUNT

[Name Unknown]

Knit Leonard an itchy red sweater with t"Lenny" emblazoned across the front.

(THE ITCHY BRAIN SIMULATION)

UNCLE FLOYD

The only person kind to Leonard during his youth, he passed away of a heart attack in 2009.

(THE MATERNAL CAPACITANCE)

NAME: Penny Hofstadter
BIRTHDAY: December 2, 1985

SIGN: Sagittarius
HEIGHT: 5'6"
BUILD: Alluring
HAIR: Blond
EYES: Green

CURRENT OCCUPATION:
Pharmaceutical Sales
Representative
FORMER OCCUPATION:
Waitress
ASPIRING OCCUPATION:
Actress

BEST KNOWN FOR:
SERIAL APE-IST 2: MONKEY SEE, MONKEY KILL
BEST FRIENDS:
Dr. Amy Farrah Fowler, Dr. Bernadette Rostenkowski-
Wolowitz, Dr. Sheldon Cooper
TATTOOS:
Cookie Monster and the Chinese character for "soup" on
her right buttock

THE LUCKY PENNY PARADIGM

Penny's biography is the classic Hollywood story: A beautiful girl-next-door from a small farming community moves to Los Angeles to be an actress and immediately takes a topless role in a Z-list horror film.[1] Turning to screenwriting and working at the local Cheesecake Factory while she auditioned for parts, this was Penny's life when she moved into apartment 4B, right across the hall from Doctors Sheldon Cooper and Leonard Hofstadter. This would put her on a trajectory that would forever change her life for the better.

Before meeting the two doctors, Penny's life was full of misadventure, missed opportunities, and mis . . . something. Her upbringing in the land of cow-tipping and beers for breakfast left much to be desired. Her father, Wyatt, wanted a boy more than anything else and forced her to play sports and be "one of the guys." He called her "Slugger" consistently until she got her first training bra,[2] and after that only occasionally.

Though she seems to hang out with a group of doctors and college graduates, Penny never graduated from community college, something she's sensitive about. In fact, her entire career at school was fraught with too much dating and bullying,[3] and not enough paying attention. She even ditched pre-school to date a second grader.[4] Through elementary and middle school, she had similar experiences and it got worse over the years as she dated numbskull after numbskull looking for something she'd never find. Her father thought the men she brought home might have been her way to punish him until she met Leonard.

Leonard was everything she didn't know she could deserve: a man who would worship and love her and treat her well. Granted, Leonard had his problems including being jealous and possessive, but gradually they became equal partners in their relationship.

While working at the Cheesecake Factory and hanging out with Sheldon and Leonard, Penny also worked hard on her acting career. Because of her memorable roles in *Serial Ape-ist,* she was offered the lead in the sequel, starring opposite Wil Wheaton, *Star Trek* actor and nemesis-turned-friend of Sheldon Cooper. When the low-budget B-horror film *Serial Ape-ist 2: Monkey See, Monkey Kill* became a cult hit for its cheesy absurdity, it gave Penny the opportunity to make use of her fifteen minutes of fame and sell her autograph at conventions.[5] Aside from the small notoriety earned from the gorilla pictures and a hemorrhoid commercial,[6] not much came of Penny's acting career and eventually she gave it up.

Thanks to her friend, Dr. Bernadette Rostenkowski-Wolowitz, Penny found a second career in the fast-paced world of pharmaceutical sales. She thrived in that career, coming to a point where she began to be more successful and make more money than her husband, commanding teams and playing elaborate games of office politics that cast her as Cersei Lannister in her very own cutthroat *Game of Thrones.*

Penny's relationship with Leonard was never something she used to define her, though she pined for him in quiet moments when they were apart. She stayed her own delightful person and never apologized for her past, her present, or her intended future.

Where the tale of Penny and Leonard Hofstadter leaves off, their best friends are winning Nobel prizes when she discovers she's pregnant. It's a situation she never thought she'd find herself in, but the glow of motherhood ends up suiting her just fine, giving her and Leonard a happily ever after they could both write home about.

5. (The Fetal Kick Catalyst)
6. (The Skank Reflex Analysis)

1. Serial Ape-ist (2006)
2. (The Maternal Capacitance)
3. Usually, she was the one doing the bullying.
4. (The Proton Displacement)

Penny's Headshot Approximation

SUBJECT

Every actress needs to be aware of her looks and physicality, and Penny was no exception. She had to have a headshot for every audition and she needed every hair to be in place. Lucky for her, she was cute as a button, and her eventual husband, Leonard Hofstadter, worshipped the ground she walked on.

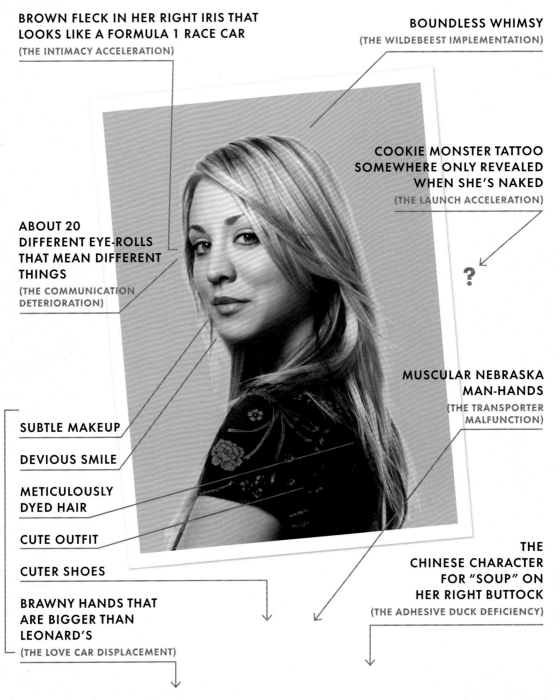

BROWN FLECK IN HER RIGHT IRIS THAT LOOKS LIKE A FORMULA 1 RACE CAR
(THE INTIMACY ACCELERATION)

BOUNDLESS WHIMSY
(THE WILDEBEEST IMPLEMENTATION)

COOKIE MONSTER TATTOO SOMEWHERE ONLY REVEALED WHEN SHE'S NAKED
(THE LAUNCH ACCELERATION)

ABOUT 20 DIFFERENT EYE-ROLLS THAT MEAN DIFFERENT THINGS
(THE COMMUNICATION DETERIORATION)

MUSCULAR NEBRASKA MAN-HANDS
(THE TRANSPORTER MALFUNCTION)

SUBTLE MAKEUP

DEVIOUS SMILE

METICULOUSLY DYED HAIR

CUTE OUTFIT

CUTER SHOES

BRAWNY HANDS THAT ARE BIGGER THAN LEONARD'S
(THE LOVE CAR DISPLACEMENT)

THE CHINESE CHARACTER FOR "SOUP" ON HER RIGHT BUTTOCK
(THE ADHESIVE DUCK DEFICIENCY)

Penny's Timeline

SUBJECT

For a complete timeline of Penny's relationship with Dr. Leonard Hofstadter, see page 93.

see page 93

S.01

PILOT	Penny moves into apartment 4B, right across the hall from Sheldon and Leonard.
THE MIDDLE EARTH PARADIGM	Penny's first kiss with Leonard, though she'd rather forget it.
THE GRASSHOPPER EXPERIMENT	Penny gets promoted to bartender and, in her new role, encourages Raj to speak to a woman for the first time.
THE LOOBENFELD DECAY	Penny gets a part in a one-night showcase of *Rent*.
THE PEANUT REACTION	Penny blackmails Sheldon into helping throw Leonard a surprise birthday party by threatening to ruin his mint-condition comic books.
THE TANGERINE FACTOR	Because her boyfriend Mike wrote about their sex life on his public blog, Penny breaks up him.
	Penny has her first date with Leonard.

S.02

THE BAD FISH PARADIGM	Penny brushes Leonard off, worried she's not smart enough for him.
THE BARBARIAN SUBLIMATION	Penny locks herself out of her apartment and accidentally gets into the *Age of Conan* MMORPG with Sheldon's encouragement.
THE GRIFFIN EQUIVALENCY	Penny goes on a date with Raj, accompanying him to the party to celebrate his appearance in *People* magazine's "30 Under 30."
THE BATH ITEM GIFT HYPOTHESIS	Penny dates Dr. David Underhill, then discovers he's married after finding nude pictures of his wife on his phone ... after he tried taking nude pictures of her.
THE KILLER ROBOT INSTABILITY	Howard tries to kiss Penny, so Penny breaks his nose.
THE FINANCIAL PERMEABILITY	Penny takes out a loan from Sheldon to catch up on rent and car repairs.
THE MATERNAL CAPACITANCE	Penny almost sleeps with Leonard but kicks him out of bed after he brings up his mother.
THE CUSHION SATURATION	The entire apartment is thrown into upheaval when Penny shoots Sheldon's spot on the couch with a paintball.

THE WORK SONG NANOCLUSTER

Penny starts a business selling Penny Blossoms.

THE DEAD HOOKER JUXTAPOSITION

Penny gets into a fight with upstairs neighbor Alicia after being threatened by her. She also makes her first *Star Trek* reference.

THE HOFSTADTER ISOTOPE

Penny visits the comic book store for the first time and ends up going on a date with Stuart, the comic shop owner.

THE CLASSIFIED MATERIALS TURBULENCE

On a second date with Stuart, Penny says Leonard's name while they're making out.

THE ADHESIVE DUCK DEFICIENCY

After Penny dislocates her shoulder in the shower, She needs Sheldon to dress her and drive her to the emergency room.

THE GORILLA EXPERIMENT

In order to please Leonard, Penny asks Sheldon to teach her a little bit about physics. Sheldon agrees, fashioning it into an experiment he dubs "Operation: Gorilla."

THE 21-SECOND EXCITATION

Amy and Bernadette ask Penny to explain why she's no longer dating Leonard in a game of truth or dare, but she can't come up with a reason and quits playing, retreating to her room.

THE BOYFRIEND COMPLEXITY

When Penny's dad comes to visit, she pretends she's still dating Leonard.

THE COHABITATION FORMULATION

Penny drives out to Van Nuys to audition for a cat food commercial, which turns out to be an adult film. She doesn't get the part. Or, at the very least, turns it down . . . ?

THE SKANK REFLEX ANALYSIS

Embarrassed she "slept" with Raj, Penny sleeps over at Amy's because she doesn't want to show her face. She later discovers she didn't really sleep with Raj, she was just too drunk to remember what happened.

Penny gets a part in a commercial for "rose-scented Preparation H."

THE TRANSPORTER MALFUNCTION

As a thank-you to the guys for eating all their food, Penny uses residuals from her commercial to buy Sheldon and Leonard each a mint-in-box 1975 Mego *Star Trek* transporter.

THE RE-ENTRY MINIMIZATION

Penny beats Sheldon in a wrestling contest and then kisses him to taunt him. Amy joins in and his face gets covered in lipstick.

S.06

THE EXTRACT OBLITERATION

In hopes of maybe finishing her degree, Penny goes back to school.

THE PARKING SPOT ESCALATION

In the ever-escalating war over Howard's parking spot, Penny's nose is broken by Amy, who accidentally hits her with a coffee can full of change she meant to take to the bank. Amy meant to hit Bernadette with it.

THE FISH GUTS DISPLACEMENT

Penny teaches Howard how to fish so he can go on a fishing trip with his father-in-law.

THE CONTRACTUAL OBLIGATION IMPLEMENTATION

Penny accompanies Amy and Bernadette to Disneyland, where they get princess makeovers.

S.07

THE LOVE SPELL POTENTIAL

After her Vegas trip is canceled, Penny plays *Dungeons & Dragons* for the first time.

THE HESITATION RAMIFICATION

Penny gets a part on *NCIS* as a waitress opposite Mark Harmon. She's devastated when the scene is cut and she doesn't find out until the broadcast.

THE OCCUPATION RECALIBRATION

Penny quits her job at the Cheesecake Factory to focus on her acting career.

THE INDECISION AMALGAMATION

Though the script is terrible, Penny takes the lead in *Serial Ape-ist 2: Monkey See, Monkey Kill*.

THE PROTON TRANSMOGRIFICATION

The funeral of Professor Proton is the first funeral Penny ever goes to.

THE STATUS QUO COMBUSTION

Penny briefly takes a job taking care of Howard's mom, but quits almost immediately.

THE LOCOMOTION INTERRUPTION

Penny applies for a job at Bernadette's pharmaceutical company as a sales rep.

S.08

THE HOOK-UP REVERBERATION

In her new job as a pharmaceutical rep, Penny tries her pitch out on Emily, Raj's girlfriend.

THE TROLL MANIFESTATION

Serial Ape-ist 2 hits streaming services and Penny is forced to suffer through it while Bernadette and Amy laugh.

THE COMMUNICATION DETERIORATION

Penny goes to an audition for Kevin Smith's *Clerks 3*. Naturally, she doesn't get the part.

THE HOT TUB CONTAMINATION

Penny is asked to sign autographs at the Van Nuys Comic-Con for *Serial Ape-ist*.

THE EXPLOSION IMPLOSION

Penny intercepts a call from her mother-in-law, Dr. Beverly Hofstadter. The two of them bond over "girl things."

THE CONFERENCE VALUATION

Penny lets the power of her new promotion to work on Bernadette's anti-inflammatory drug go to her head and becomes a tyrant to her team.

THE CHANGE CONSTANT

Penny goes to a conference with Bernadette, where she's asked to come work for the competition, angering Bernadette.

Penny discovers that she and Leonard have conceived and she is pregnant.

THE STOCKHOLM SYNDROME

Proud of her friends Sheldon and Amy, Penny stands to be recognized as they thank her for their Nobel Prize win.

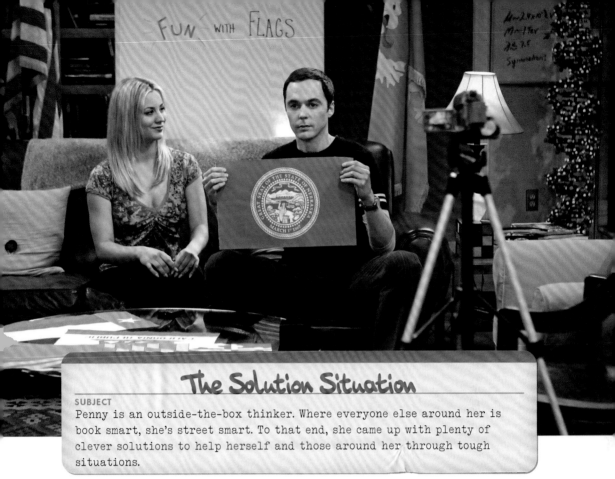

The Solution Situation

SUBJECT

Penny is an outside-the-box thinker. Where everyone else around her is book smart, she's street smart. To that end, she came up with plenty of clever solutions to help herself and those around her through tough situations.

Penny has emails from Howard sent directly to her spam folder.

(THE FRIENDSHIP ALGORITHM)

Penny gets Beverly Hofstadter drunk.

(THE MATERNAL CONGRUENCE)

When Sheldon has a hard time being excited for Amy, Penny suggests he pretend to be excited by thinking of koalas instead.

(THE SHINY TRINKET MANEUVER)

She suggests that Sheldon buy Amy jewelry to get her to forgive him for his lack of tact and enthusiasm. He buys Amy a tiara. It works.

(THE SHINY TRINKET MANEUVER)

"Don't take your shirt off just because the director says so."

(THE SPOCK RESONANCE)

Penny tells Sheldon to face her during their taping of *Fun with Flags* in order to get a less robotic performance out of him. And it works.

(THE MONSTER ISOLATION)

In order to make the guys more well-rounded, Penny teaches Leonard and Sheldon about pop culture.

(THE BAT JAR CONJECTURE)

Penny gives Sheldon acting classes to help make him a better teacher.

(THE THESPIAN CATALYST)

Penny teaches Howard to fish in order to prepare him for a fishing trip with his father-in-law, Mike.

(THE FISH GUTS DISPLACEMENT)

When Sheldon is nervous about giving a speech, Penny suggests that a new suit will boost his confidence and takes him suit shopping.

(THE PANTS ALTERNATIVE)

"No one ever bought me drinks at a bar because my brain just popped out of my shirt."

(THE MYSTERY DATE OBSERVATION)

Penny's Relationship Admonitions

Since Penny is so much more experienced at relationships than anyone else in her friend group, it stands to reason that she'd have the best relationship advice to offer.

Relationships should move at a pace both parties are comfortable with.

(THE VARTABEDIAN CONUNDRUM)

If it's meant to be, it'll be.

(THE VARTABEDIAN CONUNDRUM)

"If you're really Leonard's friend, you will support him no matter who he wants to be with."

(THE CODPIECE TOPOLOGY)

The best place to give bad news to a guy is in bed with them. "That's how I told my high school boyfriend I slept with his brother. That's how I told his brother the same thing."

(THE VACATION SOLUTION)

After realizing that withholding sex won't work with Sheldon until he reaches puberty, Penny advises Amy to give Sheldon the silent treatment in order to get him to treat her better. When Amy says he would enjoy that, too, Penny suggests that she make a scene.

(THE WEEKEND VORTEX)

"Don't take advice from a man who threw his shoe at a crow."

(THE MYSTERY DATE OBSERVATION)

"Instead of worrying about pain you might cause in the future, worry about fixing the pain you're causing right now."

(THE HOT TUB CONTAMINATION)

"Is that all you have? Shop-worn tidbits like 'talk to her' and 'let it go'? Gee, Penny, life's given me lemons, what should I do?"—Sheldon

"Well, you could shove them somewhere."—Penny

(THE COMIC BOOK STORE REGENERATION)

"Do as I say, not as I do."

(THE BITCOIN ENTANGLEMENT)

To Amy: "Looks don't matter to Sheldon, because he only has eyes for you."

(THE LONG DISTANCE DISSONANCE)

To Sheldon, distraught about everything changing, Penny tells him "The only thing that stays the same is that things are always changing."

(THE CHANGE CONSTANT)

"Keep your mouth off of other women."

(THE COMMITMENT DETERMINATION)

When Howard is considering breaking up with Bernadette because of her request that he sign a prenuptial agreement, Penny tells him, "All right, Howard Wolowitz, listen up! You sign anything she puts in front of you because you are the luckiest man alive. If you let her go, there is no way you can find anyone else. Speaking on behalf of all women, it is not going to happen, we had a meeting."

(THE VACATION SOLUTION)

"Compromise is key."

(THE COHABITATION EXPERIMENTATION)

Penny's Home Hijinx Anomalies

SUBJECT

If there's one thing Penny experienced, it was an unusual childhood with a colorful family. From unusual nicknames and cow-tipping to unsuitable boyfriends, Penny had a lot of experiences at home before moving to Los Angeles.

Penny: Can I ask you a question?
Sheldon: Given your community college education, I encourage you to ask me as many as possible.

(THE ROBOTIC MANIPULATION)

Penny's Thanksgiving was once canceled because of her brother's court trial. She said it was a big misunderstanding and he's "sort of a chemist." (He deals drugs.)

(THE PIRATE SOLUTION)

Penny: Look, I'm telling you I've done it. I clearly remember the cow standing up and then a cow on its side.
Leonard: Were you drunk?
Penny: I was sixteen and in Nebraska, what do you think?
Leonard: I think you're the one who fell over.
Penny: Well, that would explain why the sky was also on its side.

(THE THANKSGIVING DECOUPLING)

Penny made a pact with her friend Rosie in first grade to marry Bert and Ernie. When they both wanted Ernie, they didn't speak again until middle school.

(THE CREEPY CANDY COATING COROLLARY)

Penny: What kind of teenager did you think I was?
Bernadette: Slutty.
Amy: Easy.
Penny: The word is "popular."

(THE PROM EQUIVALENCY)

Penny's dad taught her all about how to catch, gut, and clean fish.

(THE FISH GUTS DISPLACEMENT)

She rebuilt a tractor all by herself.

(THE BIG BRAN HYPOTHESIS)

"I grew up on a farm. From what I heard, they're either having sex or Howard's caught in a milking machine."

(THE DUMPLING PARADOX)

Penny started dating at the age of 14.

(THE ROBOTIC MANIPULATION)

Penny dropped out of community college.

(THE EXTRACT OBLITERATION)

Penny implies that she engaged in post-prom mating rituals because her prom date drove a van with an air mattress.

(THE PROM EQUIVALENCY)

Amy: Did you know the iconic heart shape isn't based on an actual human heart, it's based on what a woman's rear end looks like bending over?
Penny: So in eigth grade, I was dotting my i's with little asses? That's cool.

(THE ALIEN PARASITE HYPOTHESIS)

Howard Wolowitz,
The Frightened Little Astronaut

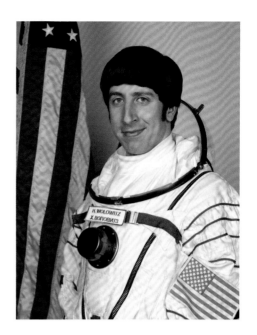

BIOGRAPHICAL DATA

Lyndon B. Johnson Space Center

Houston, Texas 77058

Howard Joel Wolowitz (M.Eng)

Nasa Astronaut (Former)

Pronunciation: HOW-ard WALL-uh-witz

Nickname: Froot Loops

PERSONAL DATA: Born in Pasadena, California, in 1981. Married to Dr. Bernadette Rostenkowski. Two children, Halley and Neil Michael. Enjoys comic books, model rockets, family activities, and paintball. Allergic to peanuts.

PHYSICAL CHARACTERISTICS: 5'4", brown hair, blue eyes. Constant bowl cut, ever-present dickey, ostentatious belt buckle.

OFFICIAL BIOGRAPHY: Though his friends might describe him as a minor league engineer with an Oedipus complex,[1] Howard Wolowitz is an accomplished aerospace engineer with a master's degree from the Massachusetts Institute of Technology (MIT). Even before he became an astronaut for NASA, heading up the International Space Station as a payload specialist, he saw success in numerous engineering feats that were sent to space. Most notable among them was a toilet designed for implementation on the space station.

Howard's early life was marked by the departure of his father at the age of eleven,[2] and was made even worse by his overreliance on his overbearing helicopter mom, Debbie Wolowitz. He had trouble connecting with friends and meeting girls. His school years never ran smoothly and he even got kicked out of Hebrew school at one point for putting on a suggestive shadow-puppet show.[3] In the sixth grade, he dated a pen.[4] And, as long as one doesn't count the serial killer who ate all of those prostitutes, Howard is still the most famous alumnus of his middle school.[5]

After graduating from high school, Howard planned to study medicine,[6] hoping that would make his mother proud, but a weak stomach and the violent retching he did at the sight of stitches and wounds sent him looking for somewhere else to apply his intellect and skills. Despite his lonely upbringing and need to change majors, Howard eventually made it to Massachusetts to study engineering at MIT.

1. As a matter of fact, Dr. Sheldon Cooper did. (The Apology Insufficiency)
2. (The Precious Fragmentation)
3. (The Collaboration Contamination)
4. (The Champagne Reflection)
5. (Contractual Obligation Implementation)

Howard carried this loneliness into his adult life, desperately seeking female companionship any way he could. In order to fill this void in his life, he entered a hetero-life-mate-style relationship with astrophysicist Dr. Rajesh Koothrappali. The pair became inseparable and worked through all their troubles, even going to couples counseling at one point,[7] and would often go to any length to meet girls.[8] However, that all ended when Howard met the love of his life: Dr. Bernadette Rostenkowski.

Howard and Bernadette met while she was still working toward her PhD. After a rocky courtship,[9] Howard eventually proposed to Bernadette. They got married in a simple rooftop ceremony officiated by their friends just before Howard was sent to space by NASA. Thanks to his work as a superior engineer,[10] Howard was chosen as a payload specialist to deploy a deep field telescope aboard the International Space Station.

After the death of his beloved mother, Howard and Bernadette moved into his childhood home and promptly had two children, Halley[11] and Neil Michael,[12] one more step in their quest for a happily ever after.

6. (The White Asparagus Triangulation)

7. (The Septum Deviation)

8. Howard and Raj once dressed up in goth attire and fake tattoos to pick up goth women. (The Gothowitz Deviation)

9. They once broke up because Bernadette caught Howard having an affair in *World of Warcraft* with a character named Glissinda the Troll under the Bridge of Souls. Bernadette never discovered that Glissinda was actually Steve Patterson, the greasy old guy in facilities management at Caltech. (The Hot Troll Deviation)

10. Just don't tell Sheldon that.

11. Named for Halley's Comet. (The Birthday Synchronicity)

12. Named for Neil Armstrong, Gaiman, and Diamond, and Michael for Bernadette's father. (The Neonatal Nomenclature)

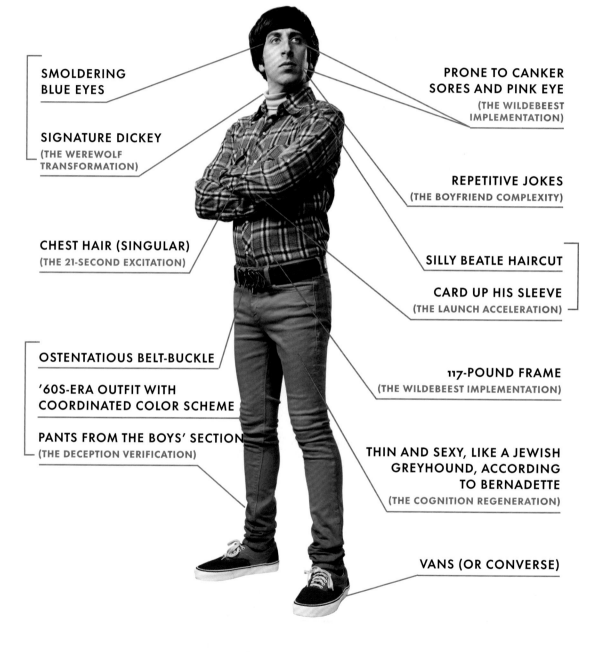

Howard's Pictorial Record

SUBJECT

The shortest of his group of friends, Howard Wolowitz is unmistakable in a lineup. Though he thinks he has the suavest style-sense of all his friends, he dresses quite loudly.

SMOLDERING BLUE EYES

SIGNATURE DICKEY
(THE WEREWOLF TRANSFORMATION)

CHEST HAIR (SINGULAR)
(THE 21-SECOND EXCITATION)

OSTENTATIOUS BELT-BUCKLE

'60S-ERA OUTFIT WITH COORDINATED COLOR SCHEME

PANTS FROM THE BOYS' SECTION
(THE DECEPTION VERIFICATION)

PRONE TO CANKER SORES AND PINK EYE
(THE WILDEBEEST IMPLEMENTATION)

REPETITIVE JOKES
(THE BOYFRIEND COMPLEXITY)

SILLY BEATLE HAIRCUT

CARD UP HIS SLEEVE
(THE LAUNCH ACCELERATION)

117-POUND FRAME
(THE WILDEBEEST IMPLEMENTATION)

THIN AND SEXY, LIKE A JEWISH GREYHOUND, ACCORDING TO BERNADETTE
(THE COGNITION REGENERATION)

VANS (OR CONVERSE)

Howard's Timeline

SUBJECT
For a complete timeline of Howard's relationship with Dr. Bernadette
Rostenkowski-Wolowitz, see page 113.

S.02

THE LIZARD-SPOCK EXPANSION — Howard sleeps with Leslie Winkle, making her the fifth woman he's ever slept with.

THE MATERNAL CAPACITANCE — Leslie Winkle breaks up with Howard.

THE VEGAS RENORMALIZATION — Raj and Leonard hire a woman to pretend to be Jewish and seduce Howard in Las Vegas.

THE ELECTRIC CAN OPENER FLUCTUATION — While in the North Pole, Howard sleeps naked with Sheldon, Raj, and Leonard when the heating breaks.

S.03

THE JIMINY CONJECTURE — Howard bets his copy of *Fantastic Four* #48 (the first appearance of Silver Surfer) against Sheldon's *The Flash* #123 (the classic "The Flash of Two Worlds" issue) that Sheldon has not correctly identified a snowy tree cricket.

THE GOTHOWITZ DEVIATION — Howard and Raj dress up as goths to pick up "freaky chicks" at a nightclub.

THE EXCELSIOR ACQUISITION — Stan Lee takes Howard and the guys (minus Sheldon) out for gelato.

THE APOLOGY INSUFFICIENCY — Howard makes it onto the team for the Defense Department's new laser-equipped surveillance satellite, but needs to get security clearance from the government first. Thanks to Sheldon telling them about the Mars rover incident, he fails his background check, setting his career back at least two years.

THE BOYFRIEND COMPLEXITY — Howard and Raj kiss.

THE PRESTIDIGITATION APPROXIMATION — Howard nearly drives Sheldon mad by stumping him with a simple card trick.

THE RUSSIAN ROCKET REACTION — Howard is chosen to be a payload specialist on a mission to the International Space Station to install a telescope his team designed.

S.04

THE SHINY TRINKET MANEUVER — The idea of Howard going into space freaks Bernadette out and she tries to keep him from going.

THE WEREWOLF TRANSFORMATION — Howard performs at a child's birthday party as "The Great How-dini."

THE LAUNCH ACCELERATION

Howard goes to astronaut training, where he throws up and soils himself repeatedly. His check-ins with Bernadette via webcam are dire.

THE COUNTDOWN REFLECTION

The timeline for Howard's space trip is accelerated, forcing him to cancel his wedding with Bernadette.

THE DATE NIGHT VARIABLE

After a last-minute wedding to Bernadette prior to the launch, Howard is shot into space on a Russian rocket.

THE HIGGS BOSON OBSERVATION

Howard blasts to the International Space Station in a Soyuz rocket.

THE RE-ENTRY MINIMIZATION

Howard's return to Earth is delayed, driving him mad. It gets to the point where he's sending Bernadette messages in code to build him a rocket to retrieve him herself.

Howard returns to Earth.

THE HABITATION CONFIGURATION

Howard finally moves out of his mother's house.

THE PARKING SPOT ESCALATION

Howard gets a car and parks in Sheldon's spot at work, upsetting Sheldon.

THE FISH GUTS DISPLACEMENT

Howard is forced to go fishing with Bernadette's father in an effort to get to know him better. Penny teaches him to fish. When Howard and his father-in-law both decide the trip isn't for them, Bernadette's father suggests they go to a casino and learn to play craps instead.

THE COOPER/KRIPKE INVERSION

Howard is taken off the joint bank account with Bernadette until he can learn the value of money. He goes hungry at lunch because he blew all his money on Pokémon cards.

THE CONTRACTUAL OBLIGATION IMPLEMENTATION

Howard returns to his middle school to give a speech to the young women there, encouraging them to get into science.

THE PROTON RESURGENCE

Raj asks Howard and Bernadette to dog-sit his Yorkshire terrier, Cinnamon. They take her to the park and promptly lose her.

THE DECEPTION VERIFICATION

Howard gets a high dose of estrogen from putting medicated cream on his mother and gets incredibly moody as a result.

THE WORKPLACE PROXIMITY

Howard and Raj get a couples massage.

THE CONVENTION CONUNDRUM

Howard gets an advance on his allowance from Bernadette to buy scalped tickets for Comic-Con.

THE TABLE POLARIZATION — NASA requests that Howard go back into space again to repair the telescope mount he installed on his first trip. He purposely blows his physical so he doesn't have to go back.

THE FRIENDSHIP TURBULENCE — Howard tries to bury the hatchet with Sheldon so they can be better friends. He offers to take Sheldon to Houston with him, where he's giving a talk at NASA.

S.08

THE JUNIOR PROFESSOR SOLUTION — Howard takes Sheldon's class as the first step toward getting his doctorate. He drops the class after Sheldon tries to humiliate him.

THE FIRST PITCH INSUFFICIENCY — Howard is asked to throw out the first pitch at a Los Angeles Angels game. Bernadette teaches him how to throw so he's not embarrassed. He ends up using a Mars rover to throw the pitch, but it's so slow he gets booed anyway.

THE COMIC BOOK STORE REGENERATION — Howard's mom, Debbie, passes away in Florida.

THE 2003 APPROXIMATION — Creates the band Footprints on the Moon with Raj.

THE VALENTINO SUBMERGENCE — On Valentine's Day, Howard finds a drowning rabbit in the hot tub. He and Bernadette rescue it and name it Valentino. It promptly bites Howard and distracts Bernadette from her moment to tell him she's pregnant.

THE POSITIVE NEGATIVE REACTION — Bernadette tells Howard that she's pregnant.

THE BIG BEAR PRECIPITATION — Howard is almost poisoned when the sub he's eating has pistachios on it. He has to get to the hospital fast.

S.09

THE CONJUGAL CONJECTURE — Howard gets a $500 traffic ticket after driving like a lunatic, thinking government agents are chasing him.

THE EXPLOSION IMPLOSION — Howard stresses out about being a father to a boy. He builds model rockets with Sheldon as a trial run, but their Saturn V replica rocket explodes along with his emotions.

THE PROTON REGENERATION — In an effort to prevent any more unwanted pregnancies, Howard gets a vasectomy.

THE MONETARY INSUFFICIENCY — The kids, Halley and Neil Michael, give Howard pinkeye.

THE VCR ILLUMINATION — Bernadette encourages Howard to fulfill his lifelong dream of becoming a member of the Magic Castle, an elite magical society.

S.10

THE DONATION OSCILLATION

With Raj and Anu's wedding canceled or postponed, Howard decides to go through with some of the bachelor party plans anyway, and invites Raj, Anu, and Bernadette to ride the Vomit Comet.

S.11

THE CONFERENCE VALUATION

Howard stays home and watches the kids so Bernadette can go to a work conference with Penny.

THE INSPIRATION DEPRIVATION

Howard buys a new, red scooter. Bernadette immediately makes him sell it.

THE MATERNAL CONCLUSION

Howard buys a $1,300 plane ticket to get into the airport and convince Raj not to move to London. The pair profess their love to each other.

S.12

THE STOCKHOLM SYNDROME

The kids are left at home while Howard and Bernadette head to Sweden to watch their friends, Drs. Sheldon Cooper and Amy Farrah Fowler receive the Nobel Prize in Physics.

Howard's Language Codex

SUBJECT

Howard is a brilliant linguist and knows an array of languages and methods of communication beyond the math he requires for his work in engineering.

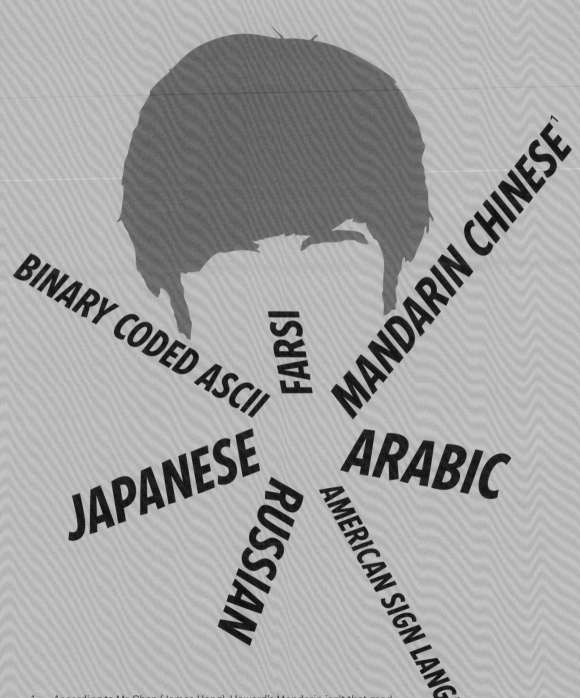

MANDARIN CHINESE [1]

BINARY CODED ASCII

FARSI

ARABIC

JAPANESE

RUSSIAN

AMERICAN SIGN LANGUAGE

1. According to Mr. Chen (James Hong), Howard's Mandarin isn't that good.
 (THE DUMPLING PARADOX)

The Wolowitz Engineering Initiative

SUBJECT

Though Dr. Sheldon Cooper might disagree, Howard is a brilliant engineer and built or designed some pretty amazing things. The list of things he's designed, built, or created is nothing to laugh at.

Howard built a small payload support structure for a small European experimental science package going up on the space shuttle.

(THE JERUSALEM DUALITY)

Designed a telescope mounting bracket that Raj used to help discover a trans-Neptunian planetoid.

(THE GRIFFIN EQUIVALENCY)

Designed a car-driving simulator for Sheldon use to learn how to drive inside apartment 4A. In the amazingly detailed simulator, Sheldon kills a pedestrian and crashes into a pet store.

(THE EUCLID ALTERNATIVE)

Codesigner of the International Space Station's Liquid Waste Disposal System.

(THE CLASSIFIED MATERIALS TURBULENCE)

Built a killer robot dubbed MONTE (Mobile Omnidirectional Neutralization and Termination Eradicator).

(THE KILLER ROBOT INSTABILITY)

Howard creates the sexist Wolowitz Coefficient equation, "neediness times dress size squared," giving him an estimate of 5,812 potential sexual partners in a 40-mile radius.

(THE HOFSTADTER ISOTOPE)

Designed a three-stage model rocket engine that impresses Leonard and Raj when they first come to his house.

(THE STAIRCASE IMPLEMENTATION)

Designed the Wolowitz Programmable Hand, a robot hand for extravehicular repairs for the International Space Station. He uses it to unload Chinese food from the table. And then uses it to pleasure himself, with disastrous consequences. Twice.

(THE ROBOTIC MANIPULATION)

Builds a machine for long-distance kissing for Priya and Leonard. Raj and Howard French kiss each other with it.

(THE INFESTATION HYPOTHESIS)

NASA chose Howard's team's design for the deep field space telescope that's going on the International Space Station. They need someone to go up with the telescope and Howard is chosen.

(THE RUSSIAN ROCKET REACTION)

Created the Lisatronic 3000, a robotic girlfriend.

(THE HOLOGRAPHIC EXCITATION)

Howard buys a 3D printer for his office; the first thing he makes is a whistle, but then he designs custom action figures of himself, Raj, and Amy.

(THE COOPER/KRIPKE INVERSION)

Howard creates a working prototype of the Mars rover to deliver the first pitch at an Angels game. It goes impossibly slowly and he gets booed.

(THE FIRST PITCH INSUFFICIENCY)

Makes a Fitbit cheat machine.

(THE PERSPIRATION IMPLEMENTATION)

Howard thinks of an idea for using helium vortices in guidance systems.

(THE POSITIVE NEGATIVE REACTION)

Howard goes with Sheldon and Leonard to patent their infinite persistence gyroscope. When it turns out Howard can't be paid for his contribution to the invention because of a university policy, he forms a partnership with Sheldon and Leonard to split the proceeds.

(THE APPLICATION DETERIORATION)

Howard oversees the build and testing of a prototype of their infinite persistence gyroscope.

Zack, Penny's old boyfriend, points out that the military could have many uses for it.

(THE FERMENTATION BIFURCATION)

The military contacts Howard about the working proof of concept for the infinite persistence gyroscope.

(THE CONVERGENCE CONVERGENCE)

Howard, Sheldon, and Leonard agree to miniaturize the infinite persistence gyroscope for the military in two months.

(THE MILITARY MINIATURIZATION)

Howard unveils his remote-control miniature Stephen Hawking. It talks and its eyes light up in the dark.

(THE GEOLOGY ELEVATION)

Sheldon, Leonard, and Howard are ready to field test their quantum gyroscope, but the military takes it over.

(THE GYROSCOPIC COLLAPSE)

Howard collaborates with Amy to use phased arrays on her EEG cap to control robotic appendages with thoughts.

(THE COLLABORATION CONTAMINATION)

The Maternal Anti-Matter Equation

SUBJECT

Howard Wolowitz had a unique relationship with his mother, Debbie Melvina Wolowitz, from the time of his birth to the time of her death in February 2015. Most famous for her brisket, Debbie was a great cook for all of Howard's friends and was always there to help her son. She always knew exactly what to say. Or scream.

"[Howard's] not a man, he's a putz!"—Debbie Wolowitz

(THE DUMPLING PARADOX)

Debbie made chocolate milk and Eggos for Howard's breakfast well into his adulthood.

(THE PANCAKE BATTER ANOMALY)

Debbie was still making Howard's lunch in 2008. She wrote him notes to go with him that read, "I love you, bubbeleh!"

(THE JERUSALEM DUALITY)

On his birthday in 2008, Debbie made Howard French toast and gave him a crown to celebrate.

(THE PEANUT REACTION)

Debbie's supply of Valium comes in handy when Howard needs to give Sheldon a handful of it.

(THE BAD FISH PARADIGM)

When Howard was eleven, his mom gave him an Alf doll to help him sleep after his dad left.

(THE PRECIOUS FRAGMENTATION)

When asking Leonard about a kiss Penny unexpectedly gave him, Howard reveals a bit too much about his relationship with Debbie: "Is it that she was going for your cheek and you moved and she accidentally got lip? That happens with me and my mom all the time."

(THE BOYFRIEND COMPLEXITY)

Howard helps his mother with her morning routine: putting her wig on, drawing on her eyebrows, and more.

(THE COHABITATION FORMULATION)

Howard's mom takes him to the dentist. It's not weird, there are always lots of kids there with their moms. If he has no cavities, she takes him out for a treat.

(THE COHABITATION FORMULATION)

Mrs. Wolowitz: Who's there? Are you a sex criminal?
Howard: Sex criminals don't have a key, Ma!
Mrs. Wolowitz: Why were you so late?
Howard: I was out with Bernadette!
Mrs. Wolowitz: I know what that means, I watch *Dr. Phil.* I hope to God you used a condom.
Howard: I am not having this conversation with you, Ma.
Mrs. Wolowitz: God forbid you get one of them fancy sex diseases.
Howard: Nobody has a disease!
Mrs. Wolowitz: I hope not. I share a toilet with you. Is that what you want? To give your mother herpes?

(THE COHABITATION FORMULATION)

On the Sabbath, Howard and his mom had a habit of lighting the candles and watching *Wheel of Fortune.*

(THE ZARNECKI INCURSION)

When Howard finally tells his mother he's getting married to Bernadette, she collapses in the bathroom and has to be taken to the hospital. "Howard's mom had a heart attack because I have sex with him and she can't," says Bernadette, but it turns out it was just food poisoning.

(THE ENGAGEMENT REACTION)

Debbie only cuts Howard's meat for him when it's fatty.

(THE PULLED GROIN EXTRAPOLATION)

Thanks to his mom's parenting, Howard was in college before he learned one could use a thermometer orally.

(THE SEPARATION AGITATION)

When Howard and Bernadette do a magic show for a family member's birthday party, Howard's mom makes them purple sequined vests from fabric reclaimed from one of her old swimsuits. She has enough left over to make half a dozen napkins as well.

(THE SHINY TRINKET MANEUVER)

Howard finds his mother to be a pretty good shoulder to cry on, so long as you don't mind the scent of Bengay.

(THE SHINY TRINKET MANEUVER)

Howard and his mother have a double cemetery plot at Mount Sinai cemetery next to the guy who played Mr. Roper (Norman Fell) on *Three's Company*.

(THE VACATION SOLUTION)

Mrs. Wolowitz: It's this dress. When I put my front in, my back pops out. When I put my back in, my front pops out. It's like trying to keep two dogs in a bathtub.
Sheldon: What do you want me to do?
Mrs. Wolowitz: We're gonna have to work as a team. Get in here, grab a handful, and start stuffing.

(THE HAWKING EXCITATION)

Debbie accompanies Howard to astronaut training in Houston to take care of her little bubbeleh.

(THE WEREWOLF TRANSFORMATION)

After Howard goes on a two-day gaming binge, his mother arrives at Sheldon's house angry and ready to pick him up. She thought he was dead.

(THE WEEKEND VORTEX)

"Howard Joel Wolowitz, I've been worried sick for two days and I know you turned off your phone. You open this door right now because I've had it up to here! I have been to the morgue and the hospital, and I spent the last half hour walking up these fakakta stairs."

(THE WEEKEND VORTEX)

Had to convince his mother not to accompany him on his honeymoon with Bernadette.

(THE LAUNCH ACCELERATION)

Bernadette makes Howard talk to his mother about the fact that they aren't going to live with her while he's on the International Space Station. Debbie doesn't take it well and browbeats Howard into talking to Bernadette about staying.

(THE DATE NIGHT VARIABLE)

In 2012, Howard is still occasionally burped by his mother. Penny has even witnessed such.

(THE HABITATION CONFIGURATION)

Worried about his mother, Howard asks Raj to check in with her.

(THE SPOILER ALERT SEGMENTATION)

Howard installs a treadmill in his mother's house so she can get doctor-ordered exercise. He ends up dropping the box on her.

(THE GORILLA DISSOLUTION)

Howard is uncomfortable with his mother's burgeoning relationship with Stuart. Doubly so when he calls to confront his mother about it and hears Stuart on the outgoing voice mail message with his mom.

(THE LOCOMOTION INTERRUPTION)

Debbie puts up the money for Stuart to reopen his comic book store.

(THE HOOK-UP REVERBERATION)

Howard's mom is spotted at Benihana with Stuart, and Raj remarks that they have matching penguin pajamas, but Howard denies the fact that Stuart and his mom are likely dating.

(THE PROM EQUIVALENCY)

Stuart: What are you talking about? There's nothing weird going on between me and your mother.
Mrs. Wolowitz: Stewie, your bath is getting cold!

(THE PROM EQUIVALENCY)

Debbie Wolowitz passes away in Florida.

(THE COMIC BOOK STORE REGENERATION)

Howard's mom's ashes are lost on the flight back from Florida.

(THE INTIMACY ACCELERATION)

Howard takes all the food thawing in his mother's fridge and feeds all his friends with it as the last meal his mother ever made.

(THE LEFTOVER THERMALIZATION)

Howard's Familial Arboreal Chart

SUBJECT

Howard Wolowitz finds family important, but that's usually limited to his immediate family, what with his father's disappearance. That doesn't mean he didn't get close[1] with other members of his extended family.

AUNT GLADYS

Profession unknown

Debbie Wolowitz was visiting Gladys in Florida when she passed away.

(THE COMIC BOOK STORE REGENERATION)

AUNT IDA

Profession unknown

Howard's aunt Ida slipped in the tub and drowned.

(THE TABLE POLARIZATION)

UNCLE LOUIE

Profession unknown

Howard's uncle Louie had breasts. Howard had pictures.

(THE LUNAR EXCITATION)

HALLEY NEIL MICHAE

1. Very close ...

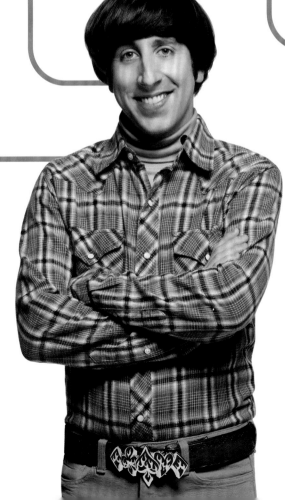

MOTHER

Deborah "Debbie" Melvina Wolowitz
Homemaker
Debbie Wolowitz cared for Howard until her passing, ensuring he never had to the cut the fat from his own meat and never wanted for brisket.

FATHER

Sam Wolowitz
Profession unknown
Sam Wolowitz left Debbie and Howard when Howard was just 11 years old. It devastated Howard forever and shaped him into the man he would become. Howard fantasized that after his dad left, he'd moved to the planet Melmac and Alf was going to bring him back to Howard.
(THE PRECIOUS FRAGMENTATION)

Howard's father sent him a letter on his 18th birthday. Howard burns the letter unread. Sheldon read it, though, and tells Penny, Amy, and Bernadette about its contents.
(THE CLOSET RECONFIGURATION)

AUNT BARBARA

Profession unknown
It was her house where Howard lost his virginity.

UNCLE MURRAY WOLOWITZ

Deceased
Murray's funeral opened up the possibility for Howard to lose his virginity.

COUSIN MARTY

Tax Lawyer
Howard's cousin Marty is a tax lawyer in Boca Raton who lasted two days on *Jeopardy!*.
(THE TABLE POLARIZATION)

HALF-BROTHER

Josh Wolowitz
Oceanography student
One day, there was a knock on Howard's door and on the other side was Josh Wolowitz, the half-brother Howard never knew he had. The kid is a spitting image of Howard and they share many interests. Though it's hard seeing that his father started another family after abandoning them stings, Howard is glad to connect with his half-brother.
(THE FORTIFICATION IMPLEMENTATION)

NAME: Dr. Rajesh Ramayan Koothrappali
BIRTHDAY: October 6, 1981
OCCUPATION: Astrophysicist

ASTROLOGICAL SIGN: Libra
DOG: Cinnamon
DOG'S BREED: Yorkshire
Terrier
DOG'S ASTROLOGICAL SIGN:
Libra

HEIGHT: 5'7"
WEIGHT: Ideal
ORIGINAL HOMETOWN: New
Delhi, India
CURRENT HOMETOWN:
Pasadena, California, USA

CLAIMS TO FAME: Discovered a trans-Neptunian planetoid,[1] once got handed the mic by the Spin Doctors at the Orange County Fair[2]

DEFINING QUIRKS: Suffered from selective mutism, rendering him unable to speak to women unless drunk. Claimed he would definitely murder a hobo if it got him laid.[3]

1. (The Griffin Equivalency) 2. (The Planetarium Collision) 3. (The Bozeman Reaction)

GREATEST FEARS: Nuclear war, accidentally being buried alive, any of those movies where you get that phone call that says you're going to die and then you do . . .[4] Also heights, spiders, and showing up to a costume party that turns out to be a regular party.[5]

FAVORITE MOVIE: *The Princess Bride*[6]

4. (The Alien Parasite Hypothesis) 5. (The Planetarium Collision) 6. (The Allowance Evaporation)

SEXUAL ORIENTATION: Metrosexual[7]

STANDARD PLANETARIUM QUOTE: "I'd like to thank you for joining me on this journey . . . through the stars. If you enjoyed this lecture, please come back Thursday for the exact same one."[8]

7. Raj defines this as liking women and their skincare products. (The Transporter Malfunction)
8. (The Planetarium Collision)

THE KOOTHRAPPALI EFFECT

Dr. Rajesh Ramayan Koothrappali

Known as "The Slumdog astrophysicist,"[1] Dr. Rajesh Koothrappali—known as Raj to his friends—is a soft, sensitive soul who loves gazing at the stars.

Though Raj claims to have been raised in abject poverty as a boy in New Delhi and moved to the United States yearning to find a better life, the reality is much different. His father is a wealthy gynecologist who drives a Bentley[2] and his mother has just as much money. His friends define the wealth of his family on the scale halfway between Bruce Wayne and Scrooge McDuck.[3] Like his best friend and hetero-life mate, Howard Wolowitz, Raj had a lonely childhood. Once, when he was six years old, he even tried starting a boy band called "Frankie Goes to Bollywood," but had no friends to join so his parents made the servants in their house play his backup dancers.[4]

English is his second language and he speaks with a noticable accent and struggles with American idioms, which factor into the jokes at his expense that he receives more often than he should. Despite being the constant butt of jokes in the United States, Raj still prefers it to his home country of India. Even though he has friends back in India,[5] he never wants to go back. Any time it's suggested that his friends go get Indian food, Raj's face recoils in disgust.

More than anything, Raj is a gentle man. He smells of lilac, wears women's deodorant to smell daisy fresh,[6] and is addicted to pedicures.[7] Despite being more in touch with this side of himself, Raj suffered from a social anxiety called selective mutism, which left him unable to speak to women without the aid of alcohol. He was only able to overcome his anxiety after many years of practice.

Raj studied astrophysics and got a job working at the California Institute of Technology. His visa to remain in the United States was dependent on him maintaining that job with the university, making him reluctant to do anything that would jeopardize his position.[8] However, he eventually he took a part-time job at the planetarium at Griffith Observatory, writing and hosting shows about the stars because he loved them so much.

More than any other member of his pack of friends, Raj suffered from loneliness the longest and still hasn't found that special someone. There's no telling if that's because of his own issues of compatibility or his "latent homosexual tendencies,"[9] but one thing is for certain: Raj is adorable, despite being consistently unlucky in love.

Regardless, Raj is constantly thankful to his friends for taking this journey in life with him . . . to the stars.

1. (The Psychic Vortex)
2. (The Griffin Equivalency)
3. (The Wiggly Finger Catalyst)
4. (The Pulled Groin Extrapolation)
5. He had friends specifically like Sheldon, Leonard, and Howard back in India. He dressed them all in leotards and goggles and they called themselves the New Delhi Power Rangers. (The Engagement Reaction)
6. (The Tam Turbulence)
7. (The Stag Convergence)
8. (The Pirate Solution)
9. According to Dr. Beverly Hofstadter, but what does she know? (The Maternal Capacitance)

Raj's Centerfold Situation

SUBJECT
The well-manicured Indian heartthrob and self-proclaimed "Slumdog astrophysicist," Raj is entirely resistible to the ladies. His wardrobe components include the special boxers his mother sent him to increase his sperm count[1] and his ever-present sweater vest.

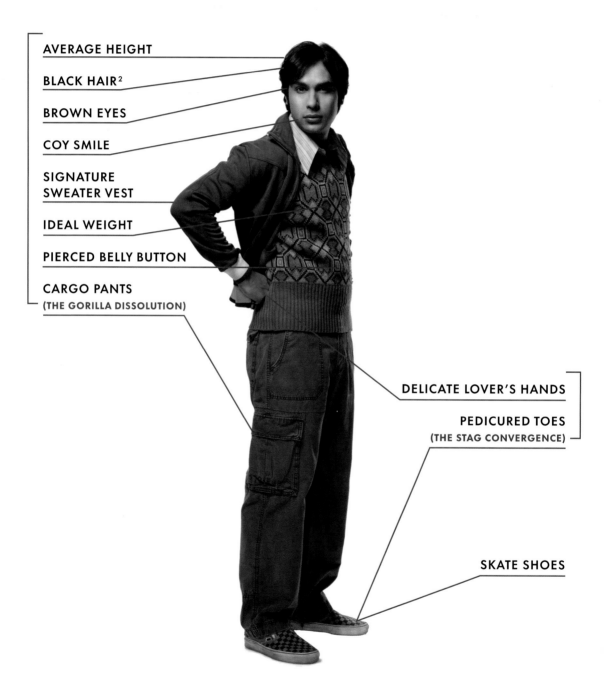

AVERAGE HEIGHT

BLACK HAIR[2]

BROWN EYES

COY SMILE

SIGNATURE
SWEATER VEST

IDEAL WEIGHT

PIERCED BELLY BUTTON

CARGO PANTS
(THE GORILLA DISSOLUTION)

DELICATE LOVER'S HANDS

PEDICURED TOES
(THE STAG CONVERGENCE)

SKATE SHOES

1. (The Grasshopper Experiment)
2. Raj kept it straightened until the final season.

Raj's Timeline

SUBJECT
For a complete timeline of Raj's romantic entanglements, see page 116.

S.01

THE GRASSHOPPER EXPERIMENT
"Where did my life go, Penny?"—Raj's first words spoken to a woman on the show.

S.02

THE GRIFFIN EQUIVALENCY
Named one of *People* magazine's "30 Under 30" after his discovery of a trans–Neptunian planetoid.

THE TERMINATOR DECOUPLING
Flirts with Summer Glau on the train to San Francisco.

THE HOFSTADTER ISOTOPE
Sleeps with a woman he picked up at the bar after Howard and Leonard strike out.

S.03

THE ELECTRIC CAN OPENER FLUCTUATION
While in the North Pole, slept naked with Howard, Sheldon, and Leonard when the heating breaks.

THE PIRATE SOLUTION
Raj is threatened with deportation.

THE PSYCHIC VORTEX
Raj dates a woman named Abby (Danica McKellar), but she wants to bring her friend on the second date. Sheldon wants no part of it, so Raj bribes him with his Hulk hands, signed by Stan Lee.

THE EXCELSIOR ACQUISITION
Stan Lee takes Raj and the fellas (minus Sheldon) out for gelato.

S.04

THE HOT TROLL DEVIATION
With his vast wealth and pettiness, Raj buys a giant desk to put in the office he shares with Sheldon merely to annoy him.

THE BOYFRIEND COMPLEXITY
Raj gets drunk while monitoring a telescope in Hawaii in pursuit of discovering a planet.

Howard and Raj kiss.

THE COHABITATION FORMULATION
Priya Koothrappali, Raj's sister, comes to visit from India and he forbids her from dating Leonard, to no avail.

THE WILDEBEEST IMPLEMENTATION
Tired of being alone, Raj takes experimental pills designed to combat his social awkwardness, then goes out to meet women while Sheldon observes. The drugs proceed to melt so many of his inhibitions, he strips naked in front of a woman in public.

THE ROOMMATE TRANSMOGRIFICATION

Raj "sleeps" with Penny.

THE TRANSPORTER MALFUNCTION

While calling his parents to ask them to finally set him up with a wife, Raj comes out to them as "metrosexual," which he defines as liking women *and* their skincare products.

THE BON VOYAGE REACTION

After getting dumped by Lucy, Raj finds he can talk to Penny, Bernadette, and Amy while sober.

THE SCAVENGER VORTEX

After everyone blows off Raj's murder mystery dinner party, he creates an elite scavenger hunt for the crew.

THE WORKPLACE PROXIMITY

Raj gets a couples massage with Howard.

THE LOCOMOTION INTERRUPTION

Raj gives Howard permission to sleep with his mother.

THE SEPTUM DEVIATION

For their 40th anniversary, Raj's parents split up, devastating him.

THE 2003 APPROXIMATION

Raj creates the band Footprints on the Moon with Howard.

THE BIRTHDAY SYNCHRONICITY

Raj is named godfather to Howard and Bernadette's daughter, Halley Wolowitz.

THE COMIC-CON CONUNDRUM

In an effort to earn enough money to pay for tickets to San Diego Comic-Con, Raj takes a second job at the comic book store.

Raj can no longer handle Howard's constant negativity, so he decides to take a break from him, and finds his self-confidence.

THE CONFIDENCE EROSION

Raj has an interview to be a consultant at the Griffith Observatory. He bombs it, but later goes back with newfound confidence and lands the job, playing host to programming at the planetarium.

Still fighting with Howard, Raj gives his extra ticket to see *Star Wars: Episode VIII—The Last Jedi* to Stuart.

THE CELEBRATION REVERBERATION

Thanks to Howard's laziness, Raj is forced to plan Halley's first birthday party singlehandedly. he and Howard have a shouting match in the bounce house and end up making up with each other.

THE COMET POLARIZATION

When Penny helps him discover a comet, Raj registers the discovery in his name only, causing friction with the group.

THE SIBLING REALIGNMENT

Raj gets pink eye a week before Amy and Sheldon's wedding.

THE DECISION REVERBERATION

After getting heckled at the planetarium, Raj gets accused of believing in aliens. Everyone at work makes fun of him.

THE MATERNAL CONCLUSION

Raj considers moving to London, but Howard stops him before he gets on the plane. They confess their love to each other.

THE STOCKHOLM SYNDROME

Raj goes to the Nobel Prize award ceremony to watch his friends receive their awards with Sarah Michelle Gellar on his arm. She insists it's not a date.

The Astronomic Gravity Theory

SUBJECT

As a doctor in the field of astrophysics, Raj has discovered many celestial objects and published even more papers. Though his sweet, sensitive outer layer portrays a touch of cluelessness, underneath it all is a brilliant scientist with an eye for the stars.

Discovered a trans-Neptunian planetoid, 2008-Nq Sub-17.

(THE GRIFFIN EQUIVALENCY)

When Raj's research on the predicted compositions of trans-Neptunian objects came to a dead end, his immigration statuswas jeopardized.

(THE PIRATE SOLUTION)

Raj wrote a paper on Kuiper Belt object size distribution.

(THE PIRATE SOLUTION)

Raj was part of a team that launched the New Horizons space probe to collect data about Pluto.

(THE SPACE PROBE DISINTEGRATION)

Raj worked on a project to communicate with alien life-forms and chose Leonard to be on his team. When they came up with nothing, they asked Sheldon and Howard to be part of the team as well.

(THE COMMUNICATION DETERIORATION)

Raj and Sheldon jointly discovered a medium-sized asteroid and named it Amy.

(THE SALES CALL SUBLIMATION)

Raj codiscovered a comet with Penny, though he tries to take all the credit for himself.

(THE COMET POLARIZATION)

Raj is asked to talk about the meteor shower on the local news, but ends up taking a few jabs at Neil deGrasse Tyson in the process.

(THE CONJUGAL CONFIGURATION)

Raj wrote a paper on specular reflections.

(THE DECISION REVERBERATION)

Emily or Cinnamon?

SUBJECT

In "The Anxiety Optimization," Howard invents a new game. He offers a quote and everyone else is supposed to guess whether Raj said it to his girl-friend, Emily, or his dog, Cinnamon.

1. "I want you to know that the bed seems so lonely without you in it."

2. "Check it out, I got us matching sweaters."

3. "You're so lucky. You have the shiniest hair."

4. "It's just so perfect that we're both Libras."

5. "How can such a little girl eat such a big steak?"

5. ???
4. Emily
3. Cinnamon
2. Cinnamon
1. Cinnamon

The Koothrappali Connection

SUBJECT

Raj has a large family in India—and that doesn't even count the army of servants they have—led by his loving, wealthy parents. His mother and father want him to get married, but to a nice Indian girl in a marriage that they've arranged. They find his dalliances with the locals distasteful and beneath him. Still, he loves them.

Raj's father wants Raj to be a gynecologist. "How can I be a gynecologist? I can barely look a woman in the eye." **—Raj**
(THE GRASSHOPPER EXPERIMENT)

Raj's parents get broadband and use their webcam to call Raj from India and let him know they've arranged a marriage between him and Lalita Gupta, a girl who used to beat him up in school.
(THE GRASSHOPPER EXPERIMENT)

Raj's parents disapprove of him dating Penny, disparaging his desire to "sample the local cuisine."
(THE GRIFFIN EQUIVALENCY)

Raj's parents disapprove of his going on Sheldon's arctic expedition.
(THE MONOPOLAR EXPEDITION)

Raj's cousin Venkatesh Koothrappali is also his attorney.
(THE PRECIOUS FRAGMENTATION)

Priya, Raj's lawyer sister, slept with Leonard, infuriating Raj to no end.
(THE IRISH PUB FORMATION)

It is a source of great pain to Raj's family that he has a Lieutenant Uhura uniform in his wardrobe.
(THE PRESTIDIGITATION APPROXIMATION)

Raj's parents disapprove of their daughter, Priya, dating Leonard. Raj also disapproves, but everyone takes him less seriously.
(THE HERB GARDEN GERMINATION)

When Priya gets Leonard on a video call, she can't stop him from starting a cybersex routine before he realizes her parents are in the room with her.
(THE INFESTATION HYPOTHESIS)

Raj's parents insist that if he dates an Indian girl, they'll buy him a Maserati.
(THE WIGGLY FINGER CATALYST)

Raj's parents, together for decades after their arranged marriage, get divorced.
(THE SEPTUM DEVIATION)

Raj's father comes to visit his son in the United States.
(THE CLEAN ROOM INFILTRATION)

Raj's dad is upset that his son bought a camera drone and cuts off his allowance. Raj pits his mother against his father in order to get his allowance doubled.
(THE GRADUATION TRANSMISSION)

Raj's father consoles Bernadette about her lack of enthusiasm for her baby.
(THE DEPENDENCE TRANSCENDENCE)

When Raj's baby brother would cry too much, the servants would just take him far away so the family couldn't hear it.
(THE HOLIDAY SUMMATION)

Raj's father calls him spoiled and says that's the reason no one likes him. Raj tells his dad he'll no longer take his money so he can't be accused of being spoiled. Raj goes on a quest to become self-sufficient.
(THE ALLOWANCE EVAPORATION)

Tired of being alone, Raj asks his father to arrange a marriage for him, setting the stage for the astrophysicist's courtship of Anu.
(THE WEDDING GIFT WORMHOLE)

Raj's dad tells him that his friends are the reason he can't get ahead in life.
(THE CONFIDENCE EROSION)

Raj's Murder Mystery Dinner Spectacular

In "The Mommy Observation," Raj takes the opportunity to stage a murder while Howard and Sheldon are out of town together.

In apartment 4A, the remaining group members wonder what they'll do that evening when Stuart walks in, says hello, and promptly chokes to death. Raj smiles. It's a Koothrappali Murder Mystery Dinner! Someone has murdered Stuart. But who?

AMY, BERNADETTE, PENNY, AND LEONARD are given envelopes with secret information about themselves as they work to uncover the murder.

BERNADETTE finds a receipt for coffee on Stuart, but the receipt is dated 20 years in the future.

LEONARD discovers the time machine the killer used to go back in time to kill Stuart, and the entire group of would-be sleuths hurtle 20 years into the future. Raj hands out more envelopes to tell everyone what their lives are like in the future, offering more clues as to the motive for Stuart's murder.

AMY wins the Nobel Prize in Physiology and uses the money to buy Stuart's comic book store and close it down so Sheldon will pay more attention to her.

PENNY is a famous actress living in London and Leonard is a professor at Stanford. As Leonard's and Penny's careers take off, they drift apart. When they argue about drifting apart, Raj revises their backstories to put them together as lovebirds in New York, where they both work and have three beautiful kids.

RAJ drifts from the group when he becomes a boy toy for Madonna.

PENNY was the murderer and reveals it before it was necessary.

THEY ALL promise to meet in front of the building twenty years hence to have dinner as friends like they always do. They all put it in their calendars and Stuart writes it on his hand.

TWENTY YEARS LATER, Stuart is the only one who shows up.

Raj's Scavenger Vortex

SUBJECT

Raj has a definite interest in games, as evidenced every time he breaks out a tabletop game with the guys. But he also loves the intense nerdery required to compete in scavenger hunts and murder mysteries. As an event-planning enthusiast, Raj loves to combine those things and create experiences for his friends.

In "The Scavenger Vortex," Raj puts on an elaborate scavenger hunt for his friends, full of clues so esoteric that no one but his friends would be able to decipher them. Which is why when everyone splits off into pairs, no one wants Penny on their team.

TEAMS

Sheldon and Penny

Howard and Amy

Leonard and Bernadette

1 The first puzzle is a jigsaw puzzle that leads them to the comic book store.

2 The second puzzle is a riddle, officiated by a cardboard cutout of the Riddler. "Riddle me this: Arrah, arrah, and gather round, the work of this hero is legion-bound. He multiplies N by the number of He, and in this room the thing you'll see." The clue leads to the geology lab at the university.

"'Arrah, arrah' in the riddle meant Jan Arrah, a member of the Legion of Super-Heroes known as Element Lad. Then the word 'He' wasn't the masculine pronoun, but rather H-E, the abbreviation for helium. Element Lad's ability is the power to transmute chemical elements. Helium has an atomic number of 2. If you multiply that by the atomic number of N—nitrogen—you get 14, which is the atomic number of silicon, which is the most common element in the Earth's surface, which narrowed it down to the chemical lab or the geology lab. Finally, the line, 'In this room the thing you'll see,' was an obvious reference to Fantastic Four member The Thing, who's made entirely of rock."

3 Third puzzle is another Riddler envelope in the lab. "To continue on your journey, leave no stone unturned." In the geology lab, behind a Rolling Stones poster, are map coordinates:

34.1516
–118.0767

Which lead to a bowling alley.

4 The fourth puzzle leads to the elevator shaft at the apartment.

5 The fifth puzzle calls for Leonard to descend the elevator shaft and offers a clue that leads to the planetarium.

6 The sixth puzzle is at the planetarium.

7 The seventh leads to the La BreaTar Pits.

8 The eighth leads to the laundry room at the apartment building, where there are three laundry bags. In the bags are dirty laundry. Lots of pants and one of Sheldon's shirts. On Sheldon's shirts are spots.

The clue leads them to Sheldon's spot on the couch, but there is no coin there. Raj has slipped coins into *everyone's* pockets as a metaphor for the idea that they all win when they're all having fun. The contestants don't take that well.

PRIZE

A gold coin

WINNERS

Everyone

The Amy Farrah Fowler Stratagem

Amy Farrah Fowler
The Nobel Prize in Physics, 2019

Born: December 17, 1979, Glendale, California[1]

Affiliation at the time of the award: The California Institute of Technology

Prize motivation: "for the discovery of super-asymmetry as a provable model for quantum string theory."

Prize share: 1/2, alongside Dr. Sheldon Cooper

Work:

Where supersymmetry is a proposed type of space-time symmetry, super-asymmetry as developed by Drs. Cooper and Fowler posits that the world is asymmetrical and full of symmetry, clearly dependent on observer position. They rebuilt string theory, taking super-asymmetry into account from the beginning of their equations.

Biography:

Born to an overbearing mother and an overly quiet father, Dr. Amy Farrah Fowler became fascinated by the inner workings of the brain, motivating her to study neurobiology at Harvard University.

Her upbringing was lonely due to her high intelligence and low acumen in the arena of social skills. Amy preferred to spend her hours obsessing over *Little House on the Prairie* rather than socializing with other kids. To that end, she didn't have friends in school, which created frequent awkward situations. She didn't have a date to prom and was relentlessly bullied in school.[2] She went on a trip to Norway for schooling there and found very much the same treatment at the hands of the foreign students.[3]

1. (The Opening Night Excitation)
2. In 9th grade, the girls at school put Rogaine in Amy's hand lotion, leading to unfortunate nicknames like "Gorilla Fingers Fowler." (The Speckerman Recurrence)
3. Her "friends" in Norway once trapped her in a sauna with a horny otter. (The Isolation Permutation)

She found her love for biology at a young age due to her domineering mother. Instead of enrolling her in the Girl Scouts, Amy's mother enrolled her in the Girl Sprouts. She claimed that she didn't want Amy selling cookies on some street corner. So, Amy went right to the library to find out what her mother was talking about, which led her to a lifelong obsession with the biological sciences.[4]

Eventually, she would become one of the premiere neurobiologists working on research at the California Institute of Technology, keeping her close to her parents and tied to important work that fascinated her. Much of her earliest work involved capuchin monkeys and their various behaviors and addictions.[5] It's rare for a woman to win a Nobel Prize in Physics—only four had done it in the past—but she's an even rarer case because she's not a physicist at all. Her ability to think about physics from a neurobiological standpoint aided in her husband Dr. Sheldon Cooper's understanding of string theory, changing how he viewed everything.[6] This outside-the-box thinking led the two of them to work feverishly on writing a bulletproof paper that would change the face of physics forever. The pair of them came together to publish a paper on super-asymmetry and earn top honors from the Nobel prize committee in 2019. They traveled to Sweden with their closest friends in order to attend the award ceremony.

They received the award, the greatest achievement of their lives, to thunderous applause under the gaze of the first, most important group of friends she ever had.[7]

4. (The Proton Transmogrification)
5. For an experiment, Amy once taught a capuchin monkey named Ricky how to smoke cigarettes. The biggest thing she learned was that he looked much cooler than the nonsmoking monkeys, who just sat around masturbating. (The Herb Garden Germination and The Agreement Dissection)
6. (The Bow-Tie Asymmetry)
7. (The Stockholm Syndrome)

SUBJECT
Amy's style is nothing if not unique, a blend of LITTLE HOUSE ON THE PRAIRIE nostalgia and "grandmother chic."

DANDRUFF
(THE LAUNCH ACCELERATION)

ADORABLE, SMUSHY FACE
(THE WEEKEND VORTEX)

PALE, HUNCHED SHOULDERS
(THE LAUNCH ACCELERATION)

HIPS THAT CAN'T OPEN WIDER THAN 22 DEGREES
(THE SPACE PROBE DISINTEGRATION)

HAIR THE COLOR OF MUD
(THE COOPER EXTRACTION)

FASHION SENSE TO MATCH SHELDON'S MEEMAW
(THE 2003 APPROXIMATION)

EXTREMELY BRITTLE ANKLES
(THE SPACE PROBE DISINTEGRATION)

FEET LIKE RICHARD FEYNMAN'S HANDS
(THE PROPAGATION PROPOSITION)

TOES WITH SELF-SEVERED WEBBING[1]
(THE FLAMING SPITTOON ACQUISITION)

"This entire ensemble once belonged to my dead grandmother. Everything except bra and panties. And they're a leopard-spotted secret I share with Victoria."
(The Infestation Hypothesis)

1. Amy severed the webbing herself, using nothing but nitrous oxide from cans of whipped cream as anesthesia. (The Flaming Spittoon Acquisition)

Amy's Timeline

SUBJECT
For a complete timeline of Amy's relationship with Dr. Sheldon Cooper, see page 100.

S.03

THE LUNAR EXCITATION
Amy goes on a date with Sheldon at a coffee shop which was arranged by Howard and Raj via a dating website.

S.04

THE DESPERATION EMANATION
Amy introduces Sheldon to her mother as a ruse to get her mother off her back about dating.

THE 21-SECOND EXCITATION
Amy gets her first "girl's night" ever with Penny and Bernadette.

THE LOVE CAR DISPLACEMENT
Amy invites Penny, her new best friend, to be her plus-one at the Institute of Interdisciplinary Studies' symposium on the impact of current scientific research on societal interactions.

THE ZARNECKI INCURSION
Amy takes her first drink of alcohol.

S.05

THE SHINY TRINKET MANEUVER
Amy's paper on how a cooperative long-term potentiation can map memory sequences in dendritic branches makes the cover of *Neuron*.

THE ROTHMAN DISINTEGRATION
Amy gives Penny a massive painting of the two of them.

S.04

THE HIGGS BOSON OBSERVATION
When Sheldon gets an attractive new assistant, a jealous Amy drops by his office to mark her scent on his belongings. She confesses that she did the same thing to Penny's apartment.

THE PARKING SPOT ESCALATION
Amy gets her first bikini wax. The beauticians have to take a break to get more wax.

THE CONTRACTUAL OBLIGATION IMPLEMENTATION
Bernadette and Penny bring Amy to Disneyland, where they all get princess makeovers.

Amy discovers she's on a no-fly list, forcing the girls to cancel a trip they had planned to Las Vegas.

THE LOVE SPELL POTENTIAL
After her Las Vegas trip is canceled, Amy plays *Dungeons & Dragons* for the first time.

THE WORKPLACE PROXIMITY
Amy is invited to work on a research experiment at Caltech to see if deficiency of the monoamine oxidase enzyme leads to paralyzing fear in monkeys. Sheldon has the same reaction to the images in the study as the capuchin monkeys do.

S.07

THE MISINTERPRETATION AGITATION
Studying one-celled organisms to try to find the chemicals that lead to the feeling of shame, Amy loves her job.

THE COMIC BOOK STORE REGENERATION
Amy leaves little puzzles for Penny in order to test her intelligence against that of chimps in a lab.

S.08

THE BACHELOR PARTY CORROSION
Penny pierces Amy's ears.

THE COLLABORATION FLUCTUATION
Amy works on an experiment to prove that the signal to move a muscle occurs before you decided to move it.

S.09

THE GYROSCOPIC CHALLENGE
Amy is offered a spot to be a visiting researcher at Princeton.

S.10

THE SOLO OSCILLATION
The *New England Journal of Medicine* has a blurb about Amy and Sheldon's project.

THE NOVELIZATION CORRELATION
Wil Wheaton's reboot of *Professor Proton* has Amy appear as a guest.

S.11

THE SIBLING REALIGNMENT
Amy gets pink eye a week before her wedding.

THE LAUREATE ACCUMULATION
At a reception for Nobel laureates to campaign for her own Nobel Prize, Amy melts down and screams at Drs. Pemberton and Campbell, the scientists who proved Amy and Sheldon's theory of super-asymmetry.

S.12

THE INSPIRATION DEPRIVATION
After her public meltdown, Amy gets called into HR. She continues breaking down, worried she's letting down girls and women everywhere.

THE CHANGE CONSTANT
Amy gets a makeover from Raj.

THE STOCKHOLM SYNDROME
With her friends watching and Dr. Sheldon Cooper at her side, Amy receives the Nobel Prize in Physics.

The Harp Harmony Hypothesis

SUBJECT

Amy loves playing her harp in her apartment. It's a source of entertainment and meditation, helping to ground and relax her. Unfortunately, the sound of Amy's harp triggers a trauma response in Sheldon, transporting him back to his childhood, but she still loves playing it.[1] Though she cuts back on playing it in deference to Sheldon, she keeps it in her apartment, ready at a moment's notice.

AMY'S GREATEST HITS

"The Girl from Ipanema" (Stan Getz)
(THE INFESTATION HYPOTHESIS)

Bossa nova standards
(THE INFESTATION HYPOTHESIS)

The theme song to *Diff'rent Strokes*
(THE INFESTATION HYPOTHESIS)

"Everybody Hurts" (R.E.M.)
(THE ISOLATION PERMUTATION)

"Wanted Dead or Alive" (Bon Jovi)
(THE WEREWOLF TRANSFORMATION")

"If I Didn't Have You" (Howard Wolowitz)
(THE ROMANCE RESONANCE)

"Anything" (Neil Diamond)
(THE SCAVENGER VORTEX)

Wagner's Bridal Chorus from *Lohengrin*
(THE CONJUGAL CONJECTURE)

1. (The Infestation Hypothesis)

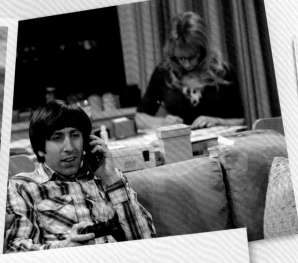

NAME: Bernadette Maryann Rostenkowski-Wolowitz

BIRTHDAY: 1984

HOMETOWN: Yorba Linda, California[1]

RELIGIOUS AFFILIATION: Catholic[2]

HEIGHT: 4'10" (Too short to play TWISTER. Or ride roller coasters. Or sit with her feet touching the floor.[3])

- -

1. (The Griffin Equivalency) 2. (The Planetarium Collision) 3. (The Bozeman Reaction)

EDUCATION: PhD in Microbiology from the University of California

CURRENT OCCUPATION: Pharmaceutical Research Scientist at ZanGen Pharmaceuticals

FORMER OCCUPATIONS: Waitress at the Cheesecake Factory, Beauty Pageant Contestant[4]

HUSBAND: Howard Wolowitz

- -

4. (The Troll Manifestation)

THE BERNADETTE BIOGAPHY

Bernadette Maryann Rostenkowski-Wolowitz

Bernadette is tight-lipped about her past and family life. Her father was a police officer and her family was always worried whether or not he was going to come home safe one night to the next.[1] His professional life had a profound impact on his daughter, and how could it not, with her first nursery being his office, peppered with bloody homicide photos?[2] These early influences are what set the stage for Bernadette's cutting sense of humor. Bernadette's maternal influence was overbearing, much like her future mother-in-law, Debbie Wolowitz. "She wouldn't let me ride a bicycle," Bernadette once confessed, "because she was afraid I might hit a bump and lose my virginity."[3]

Her early life was full of study and beauty; Bernadette was a regular contestant in beauty pageants, most notably the Miss California Quiznos 1999 pageant,[4] of which video footage still exists.

Bernadette worked hard to put herself through school, paying her tuition by working at the Cheesecake Factory. This is where she

would meet the then-future astronaut, Howard Wolowitz. The pair of them fell in love. Eventually, they would be married in a simple ceremony officiated by their friends on the eve of Howard's ascent into space, where he would spend time on the International Space Station. Together, they would have two children in rapid succession, Halley (named for Halley's Comet) and Michael.[5]

While being a devoted mother, Bernadette works hard to maintain her professional life as a medical researcher for the company ZanGen Pharmaceuticals. There, she researches drugs for the benefit of all humanity.[6] In this quest to benefit humanity, she also has the knack for finding uncommon side-effect for drugs and marketing in that direction for the benefit of her company. For instance, ZanGen once developed a drug for dandruff with the side-effect of horrible anal leakage. Bernadette had the idea to repackage the dandruff medication as a cure for constipation.[7]

1. (The Russian Rocket Reaction)
2. (The Dependence Transcendence)
3. (The Creepy Candy Coating Corollary)
4. (The Troll Manifestation)
5. Though his first name is technically Neil, Bernadette does not recognize that moniker for her son (The Neonatal Nomenclature)
6. Mainly her own pocketbook, though.
7. (The Spoiler Alert Segmentation)

Bernadette's Pictorial Pageant

SUBJECT
Bernadette is a former beauty pageant queen, and anyone who looked at her would agree.

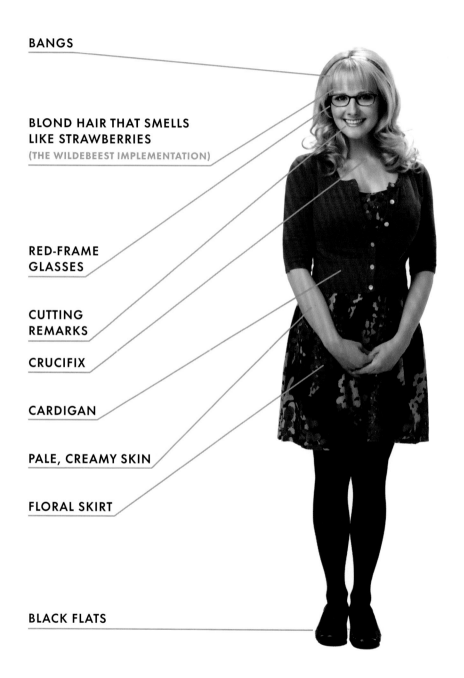

BANGS

**BLOND HAIR THAT SMELLS
LIKE STRAWBERRIES**
(THE WILDEBEEST IMPLEMENTATION)

**RED-FRAME
GLASSES**

**CUTTING
REMARKS**

CRUCIFIX

CARDIGAN

PALE, CREAMY SKIN

FLORAL SKIRT

BLACK FLATS

SUBJECT

For a complete timeline of Bernadette's relationship with Howard Wolowitz, see page 113.

S.03

THE CREEPY CANDY
COATING COROLLARY

Bernadette goes on a blind date with Howard.

S.04

THE 21-SECOND EXCITATION

At a slumber party with Penny and Amy, Bernadette bonds with her friends.

THE JUSTICE LEAGUE
RECOMBINATION

Bernadette is forced to quarantine because her research team had a party where they did Jell-O shots out of petri dishes that used to contain yellow fever.

THE COHABITATION
FORMULATION

When Bernadette suggests that Howard move in with her, it causes a fight between him and his mother. Howard reluctantly agrees, though.

THE HERB GARDEN
GERMINATION

According to the latest gossip, Bernadette considers breaking up with Howard. Howard proposes to her and she says yes.

THE ENGAGEMENT REACTION

After a "getting to know you" lunch with Bernadette, Howard's mother is admitted into the hospital.

THE SKANK REFLEX ANALYSIS

When it's revealed to Howard that Raj has a huge crush on Bernadette, Bernadette freaks out at the shy astrophysicist.

S.05

THE PULLED GROIN
EXTRAPOLATION

Bernadette gets upset when Howard suggests they'll move into his house after the wedding, but agrees to a trial weekend to see what it would be like. It does not go well.

THE WEREWOLF
TRANSFORMATION

Bernadette goes to astronaut training to help Howard make it throug, but finds that his mother is already there to do the same thing.

THE COUNTDOWN REFLECTION

When Howard's rocket launch is moved up, he and Bernadette have a quick wedding before he leaves. Raj, Leonard, Penny, Sheldon, and Amy all quickly get ordained to marry them on the rooftop of the apartment building. Sheldon does his portion partially in Klingon.

THE SPOILER ALERT
SEGMENTATION

Bernadette gets a bonus trip to Las Vegas from work because she has the idea of rebranding a dandruff medication with the side effect of anal leakage as a cure for constipation. She brings Howard along.

Bernadette gets upset that Penny is there for Halley's first words instead of her.

THE PROTON REGENERATION

Bernadette wants to name their son, Michael, after her father, but Howard doesn't want to. They end up naming him Neil Michael. Neil for Armstrong, Gaiman, and Diamond. Michael because Bernadette had to get six stitches.

THE GATES EXCITATION

Amy tells Bernadette that new mothers are cognitively primed to take in new information, and Bernadette feels like she's been wasting it making up songs about her babies' toes.

THE SIBLING REALIGNMENT

Bernadette gets pink eye a week before Amy and Sheldon's wedding.

THE CITATION NEGATION

Bernadette employs Denise as a coach in playing *Fortnite* to show up Howard.

THE CONFIRMATION POLARIZATION

Bernadette's anti-inflammatory drug is approved by the FDA after 5 years of research. She wants Penny to be the head of her sales team.

THE CONFERENCE VALUATION

Bernadette and Penny go to a work conference to debut Bernadette's new drug.

THE LAUREATE ACCUMULATION

Bernadette writes a children's book about Howard called *The Frightened Little Astronaut* and has Stuart illustrate it.

THE STOCKHOLM SYNDROME

Bernadette leaves her children at home to accompany her friends to Sweden in order to watch Sheldon and Amy receive the Nobel Prize.

The Bernadette Burn Situation

SUBJECT
Though Bernadette is accomplished at getting anything she wants through manipulation and back-room diplomacy, she's also quick with a cutting remark or threat.

"You better find my husband's mother, 'cause one way or another we're walking out of this airport with a dead woman."

(THE INTIMACY ACCELERATION)

"Gosh, Amy. I'm sensing a little hostility. Is it maybe because like Sheldon's work, your sex life is also theoretical?"

(THE PARKING SPOT ESCALATION)

To Howard: "I told you, you shouldn't have espresso after dinner. I know the little cups make you feel big, but it's not worth it."

(THE CLOSET RECONFIGURATION)

"It's simple. This was my idea. I'm driving. I'm Cinderella. You bitches got a problem with that, we could stop the car right now."

(THE CONTRACTUAL OBLIGATION IMPLEMENTATION)

"I'm a vengeful person with access to weapon-ized smallpox."

(THE RECOMBINATION HYPOTHESIS)

"Sorry I'm late. The leaf blower broke so I had to hand-dry my mother-in-law."

(THE STATUS QUO COMBUSTION)

"Your kid might be a honor student but you're a moron!"

(THE SCAVENGER VORTEX)

"At the office, I have two assistants! I don't even know their names. I just call them Thing 1 and Thing 2."

(THE RETRACTION REACTION)

"Oh, I understand. You wanna do something you're already good at? I know, why don't I get you a job at the 'sitting around all day wearing yoga pants' factory?'"

(THE LOCOMOTION INTERRUPTION)

"One of the great things about being pregnant is drinking cranberry juice out of a wineglass and watching people freak out."

(THE RELAXATION INTEGRATION)

"Let's just say the next time you move a dozen vials of raccoon virus to the fridge, make two trips."

(THE ROMANCE RESONANCE)

"Sheldon doesn't know when he's being mean because the part of his brain that should know is getting a wedgie from the rest of his brain."

(THE HAWKING EXCITATION)

To Howard: "If you like pushing buttons so much, try pushing them on the washing machine."

(THE TANGIBLE AFFECTION PROOF)

"My boss said he hadn't decided yet, so I gently reminded him that he's an old rich white guy, and I'm a sweet little pregnant lady who's not afraid to cry in front of a jury."

(THE MILITARY MINIATURIZATION)

"I've got a sexy new tube top that says 'come hither' and a bottle of pepper spray that says 'close enough, Jack!'"

(THE LOVE SPELL POTENTIAL)

"Look at Howard. He was a disaster when I met him. Now he's a foxy astronaut with a hot wife."

(THE CONFIRMATION POLARIZATION)

The Bernadette Grab Bag

SUBJECT

Some of the most interesting tidbits, facts, and laughs about Bernadette.

If she hadn't gone into microbiology, she would have gone into physics. Or ice dancing. One or the other.

(THE GORILLA EXPERIMENT)

Does a pitch-perfect impression of Howard's mother.

(THE BOYFRIEND COMPLEXITY)

Is much smarter than Howard, but pretends that he's smarter.

(THE ALIEN PARASITE HYPOTHESIS)

Bernadette took Howard to the beach once, and according to her, he almost burst into flames like a vampire.

(THE ZARNECKI INCURSION)

Bernadette wants to take Sheldon dancing because she assumes he'd look like a spider on a hot plate doing it.

(THE AGREEMENT DISSECTION)

Official member of Sheldon Cooper's Council of Ladies.

(THE EGG SALAD EQUIVALENCY)

Bernadette has a saying in the pharmaceutical industry: "Mo' infections, mo' money."

(THE ROMANCE RESONANCE)

Bernadette competed in the Miss California Quiznos 1999 pageant.

(THE TROLL MANIFESTATION)

She owns a parabolic microphone for eavesdropping.

(THE MYSTERY DATE OBSERVATION)

Bernadette practiced ventriloquism as a child for her talent in beauty pageants. Her ventriloquist dummy was named Tammy Jo St. Cloud.

(THE COGNITION REGENERATION)

Bernadette got sick in line for the Mad Tea Party ride at Disneyland.

(THE DONATION OSCILLATION)

Playing games with Bernadette, according to her husband, is akin to entering a steel cage with a wolverine.

(THE SCAVENGER VORTEX)

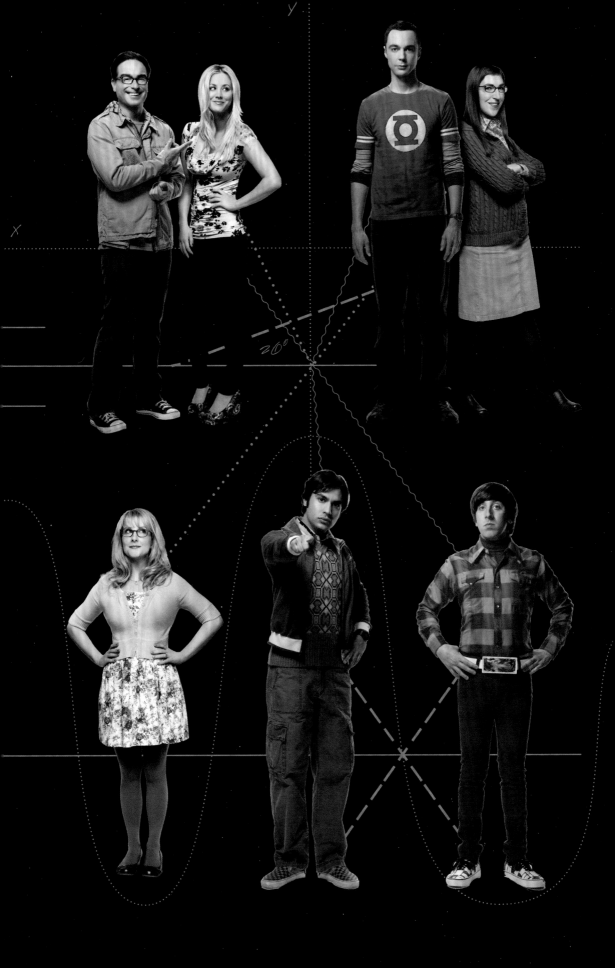

THE RELATION- SHIP INTERCON- NECTIVITY THEOREM

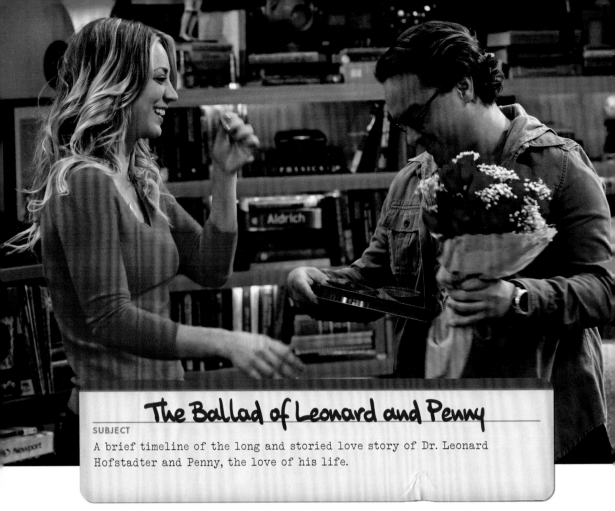

The Ballad of Leonard and Penny

SUBJECT

A brief timeline of the long and storied love story of Dr. Leonard Hofstadter and Penny, the love of his life.

Leonard and Penny meet for the first time.
(PILOT)

Leonard and Penny's first kiss. He's dressed as Bilbo Baggins, she's dressed as a sexy cat.
(THE MIDDLE EARTH PARADIGM)

Leonard and Penny's first official date.
(THE TANGERINE FACTOR)

Penny brushes Leonard off, worried she's not smart enough for him.
(THE BAD FISH PARADIGM)

Leonard has an intervention with Penny for her *Age of Conan* MMORPG addiction.
(THE BARBARIAN SUBLIMATION)

Sheldon asks Penny not to appear as a sexual rival to Dr. Stephanie Barnett so Leonard can continue dating her.
(THE WHITE ASPARAGUS TRIANGULATION)

Leonard helps Penny go through her finances after she borrows money from Sheldon and her power is cut off.
(THE FINANCIAL PERMEABILITY)

Penny and Leonard get drunk escaping Leonard's mother. He licks salt from her neck and eats a lime from her mouth, leading them to make out.
(THE MATERNAL CAPACITANCE)

Penny goes on a date with Stuart, but says Leonard's name while she makes out with the comic book store owner.
(THE CLASSIFIED MATERIALS TURBULENCE)

Penny gives Leonard a snuggy to take on the North Pole expedition, causing Leonard to not want to go.
(THE MONOPOLAR EXPEDITION)

Leonard and Penny make out feverishly when Leonard returns from the North Pole.
(THE ELECTRIC CAN OPENER FLUCTUATION)

Leonard gives Penny a preserved snowflake from the North Pole.
(THE ELECTRIC CAN OPENER FLUCTUATION)

Leonard and Penny sleep together for the first time. The sex is "fine."
(THE ELECTRIC CAN OPENER FLUCTUATION & THE JIMINY CONJECTURE)

In an effort to improve the sex, Leonard and Penny get so drunk they puke.
(THE JIMINY CONJECTURE)

Leonard and Penny decide to be just friends and promptly sleep together again.
(THE JIMINY CONJECTURE)

Leonard and Penny break Penny's bed.
(THE GOTHOWITZ DEVIATION)

Penny sleeps over in apartment 4A with Leonard, then makes French toast for the boys.
(THE GOTHOWITZ DEVIATION)

Penny refers to Leonard as "honey," to differentiate him from those she calls "sweetie" in an attempt to soften thinly veiled insults.
(THE PIRATE SOLUTION)

Leonard feels that Penny doesn't introduce him to her friends because he's a "tiny little man who flies kites."
(THE CORNHUSKER VORTEX)

Leonard learns the rules of American football in order to impress Penny.
(THE CORNHUSKER VORTEX)

Leonard and Penny have a fight when Justin, an ex-boyfriend and musician from Nebraska, comes to say with her for a few weeks.
(THE GUITARIST AMPLIFICATION)

Penny tries learning physics from Sheldon so she can better talk to Leonard.
(THE GORILLA EXPERIMENT)

Penny finally meets Dr. Beverly Hofstadter, Leonard's mom, as Leonard's girlfriend. Penny promptly gets Beverly drunk and embarrasses Leonard.
(THE MATERNAL CONGRUENCE)

Penny and Leonard go on a double date with Howard and Bernadette.
(THE PSYCHIC VORTEX)

Leonard invites Penny to accompany him to Switzerland for Valentine's Day to see the CERN supercollider, but she gets too sick to go. Leonard takes Raj instead.
(THE LARGE HADRON COLLISION)

Penny makes Leonard watch five seasons of *Sex and the City*.
(THE PRECIOUS FRAGMENTATION)

Leonard tells Penny that he loves her after she quotes Yoda from *The Empire Strikes Back*. Instead of responding with "I love you, too" or "I know," she responds with an awkward "Thank you."
(THE WHEATON RECURRENCE)

Penny breaks up with Leonard at the bowling alley, thanks to goading from Wil Wheaton.
The Wheaton Recurrence

Penny and Leonard are broken up but work out custody issues with Sheldon and agree to be friends again.
(THE SPAGHETTI CATALYST)

Leonard invites Penny to come to their lunar ranging experiment but finds that she's on a date with Zack Johnson, the guy whose family designs the menus at the Cheesecake Factory.
(THE LUNAR EXCITATION)

Amy and Bernadette ask Penny in a game of Truth or Dare to explain why she's no longer dating Leonard, but she can't come up with a reason and quits playing, retreating to her room.
(THE 21-SECOND EXCITATION)

Penny pretends she and Leonard got back together so as not to disappoint her visiting father, Wyatt.
(THE BOYFRIEND COMPLEXITY)

Penny resumes dating Zack, only because she's afraid to be alone on New Year's Eve. Leonard doesn't like that but is okay using Zack to be their Superman for a costume contest.
(THE JUSTICE LEAGUE RECOMBINATION)

Amy comes to comfort Penny when Penny discovers that Leonard and Priya are dating.
(THE COHABITATION FORMULATION)

Penny reveals to Amy and Bernadette that for the first couple of months of their relationship, whenever she took off her shirt, Leonard would giggle and say, "Oh, boy, my breast friends!"
(THE ZARNECKI INCURSION)

Leonard worries about Penny and Priya talking to each other in fear that Penny might tell Priya about the body-glitter-covered striptease he did for her, as well as other secrets.
(THE ENGAGEMENT REACTION)

Penny confesses to Raj that Leonard is a great guy and she should never have broken up with him.
(THE ROOMMATE TRANSMOGRIFICATION)

On a "not-date" to the movies, Leonard and Penny fight through the night, not ready to admit they aren't over each other.
(THE ORNITHOPHOBIA DIFFUSION)

Leonard asks Penny out on a proper date. In his overanalyzed fantasy, they pretend it's their first, trying to get to know each other all over again. It goes south, but Penny shows up on his doorstep in the middle of the night to sleep with him. They agree to build "Leonard and Penny 2.0" as a relationship and not tell anyone about it until they see if it can work out. In Penny's fantasy, they end up in a shotgun wedding.
(THE RECOMBINATION HYPOTHESIS)

Leonard and Penny go on their first date and it goes well.
(THE BETA TEST INITIATION)

They decide to give each other reports on what bugs them for "Leonard and Penny 2.0" but they each get offended by the other's pet peeves.
(THE BETA TEST INITIATION)

Leonard accidentally gets shot in the pinkie toe when he takes Penny on a date to the shooting range.
(THE BETA TEST INITIATION)

In an effort to be more adventurous and spontaneous, Leonard shows up in the laundry room and propositions Penny. She turns him down and makes him help fold laundry.
(THE STAG CONVERGENCE)

Penny asks Leonard if they can change the speed of their relationship from "taking it slow" to something faster. She means sex, but during sex, Leonard blurts out, "Will you marry me?"
(THE LAUNCH ACCELERATION)

Leonard arranges a date for Penny that features all her favorite things. Chief among them is a sports game. Leonard even paints "Go Sports" on his stomach. Raj crashes the date and tries to goad Penny into telling Leonard she loves him, but she gives him the boot instead.
(THE DATE NIGHT VARIABLE)

Penny admits to Amy and Bernadette that she loves Leonard, but can't tell him because he'll take it the wrong way. She confesses to considering breaking up with him. Sheldon demands that Penny reconsider and works to manage the situation.
(THE DECOUPLING FLUCTUATION)

Penny tries breaking up with Leonard, but has sex with him instead.
(THE DECOUPLING FLUCTUATION)

In an effort to take an interest in Leonard's work, Penny visits him at the lab. He shows her the project he's working on and it takes her breath away, reminding her just how smart he really is. She then demands sex. Immediately. Right there in the lab.
(THE HOLOGRAPHIC EXCITATION)

Penny goes back to school, taking a single history class. Leonard reads her paper and sees that it's terrible. He rewrites it for her, infuriating her because she wants to get by under her own steam.
(THE EXTRACT OBLITERATION)

Penny has to do an oral project with a guy at school, which makes Leonard extremely uncomfortable. When he tells the guy that Penny's boyfriend is scary and part of a gang, Penny isn't happy about it.
(THE 43 PECULIARITY)

Penny tells Leonard that she loves him for the first time. Saying it was clearly an accident.
(THE 43 PECULIARITY)

"Oh, poor you, is having a real-life girlfriend who has sex with you getting in the way of your board games?"—**Penny**

(THE SANTA SIMULATION)

When Sheldon's assistant, Alex, hits on Leonard, Leonard likes it, making Penny jealous. To make up for it, he plays Penny a song on a cello to the tune of "Mary Had a Little Lamb:" "I'm sorry Alex hit on me, hit on me, hit on me, Sorry Alex hit on me, I'd no idea I'm cute."

(THE EGG SALAD EQUIVALENCY)

In an effort to keep Leonard interested, Penny buys a pair of glasses to look more like a scientist. It works, turning him on immediately.

(THE EGG SALAD EQUIVALENCY)

Leonard can't take Sheldon's antics anymore and threatens to move out. He wants to move into Penny's apartment, but she isn't so hot on the idea. She has to break it to him that him moving in is happening a little too fast.

(THE SPOILER ALERT SEGMENTATION)

Leonard and Penny go on a double date with a fighting Howard and Bernadette for Valentine's Day. Penny has a meltdown and ruins the date because things have been going so well between them. As a Valentine's Day gift, Leonard offers to never ask to marry her again, but tells her if she wants to get married, she has to ask him.

(THE TANGIBLE AFFECTION PROOF)

Leonard watches *Buffy the Vampire Slayer* with Penny. She doesn't get it.

(THE CLOSURE ALTERNATIVE)

When Leonard has the opportunity of a lifetime to spend four months on a boat for a scientific mission organized by Stephen Hawking, he and Penny deal with their relationship. She sends him away at the airport, saying, "I love you."

(THE BON VOYAGE REACTION)

Penny gets upset when Leonard is having a good time in the North Sea on his scientific expedition. Sheldon helps her remember why she loves him and why he cares.

(THE HOFSTADTER INSUFFICIENCY)

Leonard gets home a few days early from his science experiment to surprise Penny. They keep it a secret from Sheldon, who assumes that Penny is cheating on Leonard.

(THE DECEPTION VERIFICATION)

Penny employs Raj to help her plan a romantic evening for Leonard. They have a candlelit evening and she gives him a first edition of *Hitchhiker's Guide to the Galaxy.* He already had a copy, though.

(THE ROMANCE RESONANCE)

Penny reveals that when she was dating Zack Johnson, they went to one of those cheesy wedding chapels and got married on Thanksgiving. She had no idea those weddings were real.

(THE THANKSGIVING DECOUPLING)

Leonard gets Penny an audition for the new *Star Wars* movie. She gets down on one knee and proposes to Leonard, but he's unsure.

(THE HESITATION RAMIFICATION)

Leonard and Penny stay home for Valentine's Day and babysit Cinnamon for Raj. Leonard gets Penny tickets to a Lakers game and offers to let her take whoever she wants. When Cinnamon eats Valentine's Day chocolates, Leonard and Penny have to get her to the emergency vet.

(THE LOCOMOTIVE MANIPULATION)

When Penny's car breaks down, she's afraid she's going to have to go back to waitressing and give up her dream of being an actress. Leonard buys her a replacement car so she can continue living her dream.

(THE FRIENDSHIP TURBULENCE)

At the funeral of Professor Proton, Penny asks Leonard to marry her, to tie up their 2-1 proposal/refusal score. Leonard refuses to answer quickly, but eventually declines.

(THE PROTON TRANSMOGRIFICATION)

Penny seriously considers marrying Leonard because she needs to make good decisions with her life. She realizes the only thing she needs to be happy is Leonard. He agrees to get married, pulls a ring from his wallet to give to Penny, and gets down on one knee. He's carried this ring for a couple of years.

(THE GORILLA DISSOLUTION)

Leonard and Penny reveal their engagement to the gang. Leonard also calls his mom to let her know.

(THE STATUS QUO COMBUSTION)

Leonard gives Penny his high school briefcase to use for her new job.

(THE HOOK-UP REVERBERATION)

When Penny gets use of the company car for work, she sells the car Leonard bought her and gives him the cash back. Leonard doesn't want to take the cash. They decide to open their first joint bank account with it. Then they go to Howard and Bernadette to ask about how they deal with money.

(THE EXPEDITION APPROXIMATION)

Leonard doesn't like the fact that Penny doesn't wear her engagement ring on sales calls.

(THE MISINTERPRETATION AGITATION)

Leonard and Penny dance at the fake prom the girls put together to bring the guys to. The pair of them share a romantic moment.

(THE PROM EQUIVALENCY)

Sheldon finally agrees to let Leonard move in with Penny, but asks him to do it gradually. Leonard starts with one day a week.

(THE SPACE PROBE DISINTEGRATION)

As a present, Leonard buys Penny body paint and a canvas for them to make love on from the "dirty store."

(THE COLONIZATION APPLICATION)

When Leonard's flight is canceled and he can't make the commencement speech he was invited to give at his old high school, Penny offers to let him give it to her. "I could pretend I'm a high school cheerleader who can't control herself around esteemed alumni . . ." She organizes for Leonard to give his speech via Skype.

(THE GRADUATION TRANSMISSION)

Leonard and Penny get drawn into an argument about when their wedding date will be and decide to head to Las Vegas and do it right then. On the way, Leonard confesses to having a makeout session with another woman during his North Sea expedition, souring the mood.

(THE COMMITMENT DETERMINATION)

Leonard and Penny get married. On their honeymoon, Penny's jealousy over Leonard's makeout session with Mandy Chao ruins the honeymoon.

(THE MATRIMONIAL MOMENTUM)

Leonard dreams of a scenario where, in order to get over her jealousy of Mandy Chao, Penny kisses Sheldon in front of him.

(THE SEPARATION OSCILLATION)

Sheldon gets Penny and Leonard a trip to San Francisco as a wedding present. With him in tow.

(THE SEPARATION OSCILLATION)

Howard, Raj, and Sheldon take Leonard to Mexico for his post-marriage bachelor party in Richard Feynman's van, which they accidentally set on fire. Amy bakes suggestive cookies for Penny to celebrate.

(THE BACHELOR PARTY CORROSION)

Leonard moves into Penny's apartment, though they split their time between both apartments.

(THE 2003 APPROXIMATION)

Leonard and Penny head out on a date to the movies early to spy on Amy's date, Dave.

(THE MYSTERY DATE OBSERVATION)

Penny and Leonard celebrate their first Thanksgiving as husband and wife. Leonard shows off his Mr. Spock oven mitts as they cook. Penny forgets Leonard's birthday when trying to log into his iPad, causing friction between them.

(THE PLATONIC PERMUTATION)

When Leonard mentions that Penny hates the lingerie he got her for Valentine's Day because it makes her look like a "slutty carrot," she realizes he's read her journal.

(THE PLATONIC PERMUTATION)

Penny convinces Leonard to see a psychiatrist in order to help her drug sales.

(THE SALES CALL SUBLIMATION)

Penny reminds Leonard not to make her mad on Valentine's Day.

(THE VALENTINO SUBMERGENCE)

Penny and Bernadette show up to the lab to help out Leonard and Howard. When they have

to run out for solder, they get dragged into an advance screening of *Suicide Squad*, then lie about getting a flat tire.

(THE SOLDER EXCURSION DIVERSION)

Penny and Leonard decide to go to a cabin in the woods. Amy wants to go as well, and manipulates Sheldon into going along, too. They get into an argument when it's revealed that Leonard has a secret bank account to keep Penny from squandering money.

(THE BIG BEAR PRECIPITATION)

Penny picks up Leonard's mom from the airport in an effort to get to know her better. She finds Beverly Hofstadter was insulted and hurt that she wasn't invited to the wedding.

(THE LINE SUBSTITUTION SOLUTION)

Penny and Leonard stage a wedding ceremony so Leonard's mom can be there. Things get hairy when Sheldon invites his mother and Leonard invites his father.

(THE CONVERGENCE CONVERGENCE)

Leonard and Penny try to keep their arguing families calm enough to enjoy their second wedding for their benefit. Bernadette officiates the wedding. Sheldon arrives just before they kiss to say a few words, and Bernadette pronounces Sheldon the "weird other husband who came with the apartment."

(THE CONJUGAL CONJECTURE)

With Leonard and Sheldon working late nights on their project for the Air Force, Penny and Amy make them breakfast because they miss them.

(THE DEPENDENCE TRANSCENDENCE)

Penny has slowly been removing Leonard's collectibles one at a time from his room one at a time and putting them in storage, hoping he wouldn't notice.

(THE VERACITY ELASTICITY)

Penny has had enough with Leonard, who seems to take her for granted and doesn't even try anymore. She decides to take Amy to the spa day she'd invited Leonard to instead.

(THE ROMANCE RECALIBRATION)

In an effort to help their relationship, Leonard and Penny ask Sheldon to make a Relationship

Agreement for them. Samples:

ARTICLE 8, SUBSECTION B, Leonard will restrict video gaming in underpants to hours Penny is not home. This includes boxers, briefs, thongs, G strings, or anything else that calls attention to his pasty little thighs.
ARTICLE 10, SUBSECTION C, If questioned, Penny may not say that everything is fine if it isn't. Other unacceptable responses include: "It's nothing," "Don't worry about it," and "I said it's nothing, don't worry about it."

(THE ROMANCE RECALIBRATION)

In order to do more things that make Leonard happy, Penny agrees to go to Comic-Con. Eventually, the entire group decides not to go at all.

(THE COMIC-CON CONUNDRUM)

Penny starts hanging out with Raj more, making Leonard jealous and sad.

(THE COLLABORATION FLUCTUATION)

Penny considers taking a job with her ex-boyfriend Zack, but this triggers all of Leonard's

jealousy. When Zack's fiancée finds out he offered Penny the job, he's forced to retract it.

(THE COGNITION REGENERATION)

Leonard has an exorbitant dry-cleaning bill for his Starfleet uniform from all the green paint he has Penny wear for his Orion alien girl fantasies.

(THE EXPLOSION IMPLOSION)

While trying to find a stash of bitcoin, Leonard discovers a video Penny filmed while drunk the first time they broke up. She confessed her love to him and told him that she knew she'd marry him, but just wasn't ready for marriage. Sheldon's elaborate scheme to get revenge for the bitcoin led to it getting deleted by Stuart.

(THE BITCOIN ENTANGLEMENT)

Penny gets upset when she becomes the villain in Leonard's murder mystery novel series starring Logan Dean, a 5'8" stand-in for the much shorter Leonard.

(THE NOVELIZATION CORRELATION)

When Leonard says that he and Penny are a little like Amy's parents, Penny gets offended.

(THE CONJUGAL CONFIGURATION)

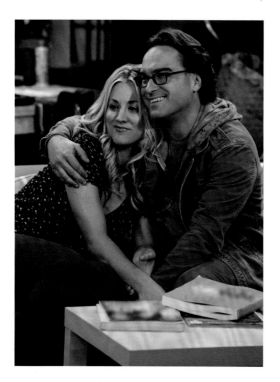

Leonard and Penny befuddle Amy and Sheldon by getting them a gift for their wedding that they'll never figure out. It's a crystal chakra wand they got from Howard and Bernadette, who got it from Raj for their wedding. Sheldon and Amy assume it's a clue to a scavenger hunt.

(THE WEDDING GIFT WORMHOLE)

Howard and Bernadette suggest Leonard and Penny buy the house next to theirs. They don't even think about it.

(THE PROCREATION CALCULATION)

Leonard and Penny fill out a questionnaire Raj gave them to see how well they know each other. Penny struggles with the idea that she doesn't want kids. To make it up to Leonard, who really wants kids, she rents him the 1966 Batmobile for a day.

(THE PROCREATION CALCULATION)

At the Halloween party, Penny and Leonard argue about when their first kiss was, but Penny pretends to forget about their actual first kiss because it wasn't romantic, the way she wants to remember a meaningful first kiss.

(THE IMITATION PERTURBATION)

Leonard gets put in charge of allocating extra grant money at the university. His decisive attitude is a huge turn-on for Penny.

(THE GRANT ALLOCATION DERIVATION)

When Penny runs into her ex-boyfriend Zack at a bar, he tells her he's fabulously rich and retired, and bought a boat. When Zack invites Penny and Leonard to dine with him and his wife on said boat, Leonard gets awkward when they ask him to donate sperm so they can have a baby.

(THE PROPAGATION PROPOSITION)

Leonard decides not to donate his sperm to Zack Johnson.

(THE DONATION OSCILLATION)

Penny is pregnant. She and Leonard try to keep it a secret from everyone until after the ceremony, but are forced to tell Sheldon on the plane to Sweden.

(THE STOCKHOLM SYNDROME)

The Love Memento Maturation

SUBJECT

Like nerds, lovers also like to keep mementos of their favorite things, collectibles of the heart. Though Penny doesn't claim to be a geek, she does keep a box filled with a collection of romantic gestures Leonard has made to her over the years. Penny and Leonard go through its contents in "The Romance Resonance."

1. The plane tickets he bought her to go home for the holidays when she was too poor to do so

2. The rose Leonard left in her windshield just because

3. The 11–page "Thank You" letter he wrote after the first time they had sex

4. Their first pregnancy test

The Boyfriend Observation

SUBJECT

Penny has a storied dating history, coupling with lunks, hunks, and Leonard. Even though she would eventually settle down with Leonard, Penny had many different dates over the years.

As Penny moves into apartment 4B she sends Leonard and Sheldon to fetch her TV from Kurt, her ex-boyfriend. Kurt relieves them of their pants.

(PILOT)

Doug is seen dropping Penny off at her apartment and making out with her. As they make out, Leonard tries handing Penny her mail, to which Doug's only reply is "What's up, bro?"

(THE FUZZY BOOTS COROLLARY)

Penny broke up with Mike after he blogged about their dates and sexual adventures.

(THE NERDVANA ANNIHILATION)

Penny has her first date with Leonard.

(THE TANGERINE FACTOR)

Eric is a hunk Penny dates and ends up in an awkward kiss-length contest against Leonard and Leslie Winkle.

(THE CODPIECE TOPOLOGY)

Penny goes on a date with Raj, accompanying him to the party to celebrate his appearance in *People* magazine's "30 Under 30."

(THE GRIFFIN EQUIVALENCY)

Penny dates Dr. David Underhill, but while posing nude for him, she discovers that he's married after finding nude pictures of his current wife.

(THE BATH ITEM GIFT HYPOTHESIS)

Penny goes on a date with Stuart from the comic book store to his art gallery showing.

(THE HOFSTADTER ISOTOPE)

Penny goes roller skating and disco dancing with Leonard, on a double date with Howard and Bernadette.

(THE EINSTEIN APPROXIMATION)

Penny dates Zack, the guy who designs the menus at the Cheesecake Factory, and brings him to the lunar ranging Leonard invited her to. He's probably the nicest guy she'll ever meet.

(THE LUNAR EXCITATION)

Penny has to chaperone Amy and Sheldon on their first date and ends up having dinner with them, which is sort of a date.

(THE ROBOTIC MANIPULATION)

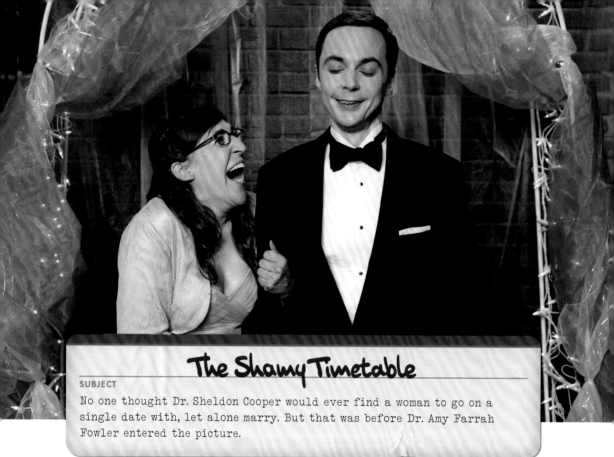

The Shamy Timetable

SUBJECT

No one thought Dr. Sheldon Cooper would ever find a woman to go on a single date with, let alone marry. But that was before Dr. Amy Farrah Fowler entered the picture.

On their first "date" Sheldon is blackmailed into going on a blind date with Amy. Amy goes because her agreement with her mother requires her to go on at least one date per year. Amy tells Sheldon that all physical contact is off the table, to which Sheldon replies by offering to buy her a drink.

(THE LUNAR EXCITATION)

Howard dubs the pairing of Sheldon and Amy "Shamy."

(THE ROBOTIC MANIPULATION)

Penny drives Sheldon to his first actual date with Amy.

(THE ROBOTIC MANIPULATION)

Amy and Sheldon break up after they have a disagreement about which field is superior, neurobiology or theoretical physics. Mary Cooper uses reverse psychology to get them back together.

(THE ZAZZY SUBSTITUTION)

Amy expresses a desire for Sheldon to meet her mother, sending Sheldon into a panic. When she explains that it's a ruse because the concept of love is absurd, Sheldon agrees.

(THE DESPERATION EMANATION)

While eating lunch over a brain dissection, Amy promises Sheldon that if he dies and donates his body to science, she'll cut his brain like Canadian bacon.

(THE ALIEN PARASITE HYPOTHESIS)

When Amy is attracted to Penny's ex-boyfriend Zack, Sheldon tries arranging for the two of them to have sex, so he no longer has to hear about her desires. Instead of acting on it, Amy takes up the Vulcan practice of Kolinahr.

(THE ALIEN PARASITE HYPOTHESIS)

Amy declines to stay in a hotel room with Sheldon for fear they may get to know each other too well and jeopardize their friendship.

(THE LOVE CAR DISPLACEMENT)

Amy claims to have engaged in intimate relations with Sheldon as an experiment to analyze meme theory among social groups and engage Sheldon in the social sciences.

(THE HERB GARDEN GERMINATION)

Amy offers herself for Sheldon's experimentation with kissing, but he refuses.

(THE AGREEMENT DISSECTION)

Amy and Sheldon dance a cha-cha and retire to Amy's apartment for a Yoo-hoo. There, she kisses him. Sheldon's response? "Fascinating." Amy proceeds to vomit. The next morning, they agree to restart their relationship from the last point it worked.

(THE AGREEMENT DISSECTION)

Amy is devastated when Penny and Bernadette go shopping for bridesmaids' dresses without her. Craving intimacy and physical contact, she asks Sheldon for a wild night of torrid lovemaking that soothes her soul and inflames her loins. Sheldon counter-proposes gently stroking her head while repeating "Aw, who's a good Amy?" Amy counter-proposes 7 minutes of French kissing, culminating in second base. Sheldon counters with neck massage, then she gets him that beverage. Amy's final offer is that they cuddle. Sheldon agrees.

(THE ISOLATION PERMUTATION)

When Stuart asks Amy out, Sheldon gets inexplicably jealous. He then interrupts their movie date to tell her his feelings. He asks to alter the paradigm of their relationship. With no change in their physical intimacy whatsoever, he would like to be her boyfriend.

(THE FLAMING SPITTOON ACQUISITION)

Sheldon and Amy go to the zoo all the time and Amy recognizes Sheldon's delighted "koala face."

(THE SHINY TRINKET MANEUVER)

When the rest of the guys invite Sheldon to a weekend binge of *Star Wars*, Sheldon wants to go, but Amy has obligated him to come to her aunt's 93rd birthday party. He works feverishly to get out of it, even going so far as to try bribing Amy with "Cooper Coupons." It doesn't work, but Amy lets him stay anyway, despite how much it hurts.

(THE WEEKEND VORTEX)

Sheldon reports that he and Amy once spent 6½ hours in a room together in silence. He found it to be a "magical evening."

(THE WEEKEND VORTEX)

In order to get Sheldon to advance their relationship, Amy tries to make him happy. She organizes to make him a junior conductor on Amtrak. This is usually a position reserved for children, but she talked them into making an exception.

(THE LAUNCH ACCELERATION)

Despite prohibitions in the relationship agreement, Sheldon holds Amy's hand while Howard blasts up into space. "Boldly go, Howard," he says while Amy looks on, touched.

(THE COUNTDOWN REFLECTION)

Amy and Sheldon go on their second anniversary date. After Amy gets rid of Raj (who was invited to the date by Sheldon), she tells Sheldon he looks like a sexy praying mantis. When the date goes further south, Amy gives Sheldon an ultimatum: "You say something nice and from the heart, or you and I are done." He quotes the first *Spider-Man* movie.

(THE DATE NIGHT VARIABLE)

At the movies, Sheldon and Amy hold hands.

(THE DECOUPLING FLUCTUATION)

Amy and Sheldon try to agree on a couples costume, but can't. Sheldon offers to give up, but Amy refuses. "There are certain things that say to the world 'I have a boyfriend and he's not made up.' Matching costumes, hickeys, and sex tapes."

(THE HOLOGRAPHIC EXCITATION)

After Wil Wheaton is rude to Amy and Sheldon sides with Wil, Amy gets understandably upset. At first Sheldon is oblivious, but once he realizes she's mad, he works to make it up to her.

(THE HABITATION CONFIGURATION)

Amy gets sick and, thanks to the relationship agreement, Sheldon is forced to take care of her. She loses her mind when he vigorously applies Vicks VapoRub to her chest. She recovers but pretends to be sick for two more days because of all the attention. When Sheldon discovers the ruse, he asks to enact some sort of consequence. A spanking is suggested as punishment, and Amy *readily* agrees.

(THE FISH GUTS DISPLACEMENT)

Amy offers Sheldon a much-needed hug after he discovers Kripke's research is superior to his. In order to cover for his inferior research, he pretends to have been distracted by a sexual relationship with Amy. When Penny calls him on it, he admits that having a physical relationship with Amy in the future is actually a possibility.

(THE COOPER/KRIPKE INVERSION)

Amy suggests moving in with Sheldon after Leonard threatens to move out, but Sheldon isn't so hot on the idea. Sheldon and Penny work to make sure the roommate arrangements stay as they are.

(THE SPOILER ALERT SEGMENTATION)

Sheldon hands his assistant, Dr. Alex Jensen, about $2,000 and asks her to find a Valentine's Day gift for Amy. "She likes monkeys and the color gray." She comes back with a signed drawing from Santiago Ramón y Cajal, the father of neuroscience, but Sheldon keeps it for himself. In a romantic gesture, Amy cancels all of their Valentine's day plans and offers to order pizza and watch a "Star War Trek thing" with Sheldon. Sheldon makes her his emergency contact with the university, which makes her cry.

(THE TANGIBLE AFFECTION PROOF)

Amy works with Sheldon to address his compulsive need for closure.

(THE CLOSURE ALTERNATIVE)

While playing D&D, Howard and Bernadette cast a love spell on Amy and Sheldon's characters, trying to get them to talk about sex with each other. Amy flees, thinking they're making fun of her. Sheldon confesses that he has not ruled out a physical relationship. They role-play a romantic encounter.

(THE LOVE SPELL POTENTIAL)

After Amy "ruins" *Raiders of the Lost Ark* for Sheldon, Sheldon reads *Pride and Prejudice* in hopes of ruining it for her. When that doesn't work, he moves on to *Little House on the Prairie*.

(THE RAIDERS MINIMIZATION)

Amy hopes to put Sheldon's love of repetition to good use one day.

(THE WORKPLACE PROXIMITY)

Amy measures the diameter of a suspicious mole on Sheldon.

(THE ROMANCE RESONANCE)

Sheldon blames Amy for distracting him and forcing him to make a mistake on his breakthrough find of a new element. He confesses that it's because he keeps thinking about wanting to kiss her. Not just on the cheek, but on the mouth. Like mommies and daddies do. But it was all just a fantasy in Amy's head.

(THE ROMANCE RESONANCE)

After she witnesses a tender moment between Howard and Raj, Amy is convinced that they will have sex before she and Sheldon do.

(THE PROTON DISPLACEMENT)

Sheldon ignores Amy for a week when he gets a Roomba. She kicks it when he's not looking.

(THE THANKSGIVING DECOUPLING)

Amy reveals that she has a 50-pound bag of rice in her apartment wearing a Sheldon shirt. She's upset that a mouse lives inside it.

(THE COOPER EXTRACTION)

Leonard tells Amy that she's Sheldon's screensaver on his computer, proving how much he cares about her.

(THE COOPER EXTRACTION)

Amy proposes that she and Sheldon go to a bed-and-breakfast in Napa Valley for a Valentine's Day trip. She lures him with dinner on a vintage Pullman train car. A train enthusiast at a neighboring table draws all of Sheldon's attention. Amy and Sheldon get angry and *really* kiss for the first time.

(THE LOCOMOTIVE MANIPULATION)

When Sheldon realizes that Amy has made an impact on his personality, he goes to break up with her. "Amy has made me a more affectionate, open-minded person. And that stops now." In order to stay with Sheldon, she tricks him into thinking that Leonard has manipulated him into sowing discord in their relationship in order to take the focus off the new dining table Leonard bought for apartment 4A.

(THE TABLE POLARIZATION)

Amy lies to Sheldon about being sick in order to have a night off from his complaining about what he'll do post–string theory. Sheldon goes out with Penny, and Amy confesses to Leonard that she's jealous of Penny's close relationship with Sheldon.

(THE ANYTHING CAN HAPPEN RECURRENCE)

Amy suggests that she move in with Sheldon as Leonard plans to move out. When Sheldon decides to ride the rails like a hobo, Amy blames Leonard and beats him with a pillow.

(THE STATUS QUO COMBUSTION)

Amy accompanies Leonard to retrieve Sheldon from the police station in Kingman, Arizona. When Amy arrives, Sheldon asks her, "Why did *you* come?"

(THE LOCOMOTION INTERRUPTION)

At the fake prom the girls throw, Sheldon has a panic attack because he feels pressured into the possibility of being intimate with Amy. As they discuss it, they confess their love for each other.

(THE PROM EQUIVALENCY)

Amy kisses Sheldon under the mistletoe at a Christmas tree lot, much to Sheldon's dismay. He decides to get back at her for making him miserable by buying her a present. He gets a picture of himself on Santa's lap for her. She surprises him with a box full of cookies.

(THE CLEAN ROOM INFILTRATION)

With Leonard and Penny in tow, Amy takes Sheldon to a basket weaving night.

(THE SPACE PROBE DISINTEGRATION)

Amy helps Barry Kripke with a string theory issue as it relates to neuroscience, drawing Sheldon's jealousy.

(THE COMIC BOOK STORE REGENERATION)

Sheldon and Amy decide to take their relationship to the next level by getting a joint pet turtle. When the turtle bites Sheldon, they don't keep it.

(THE COLONIZATION APPLICATION)

Amy is upset when Sheldon reveals he applied to be a colonist on Mars. They argue, but in a tender moment he asks her to apply to go with him.

(THE COLONIZATION APPLICATION)

Sheldon and Amy build a blanket fort together. This leads to their first sleepover. Amy reveals that she smuggled in a sleepover kit with a toothbrush and pajamas over two years ago. Sheldon admires her preparedness.

(THE FORTIFICATION IMPLEMENTATION)

Amy stops speaking to Sheldon after he stops kissing her on their fifth anniversary date to ask if he should watch *The Flash* television show.

(THE COMMITMENT DETERMINATION)

Amy takes a step back from the relationship just as Sheldon is about to propose.

(THE COMMITMENT DETERMINATION)

Despite their being broken up, Sheldon tries to convince Amy to move in with him.

(THE 2003 APPROXIMATION)

With Sheldon and Amy broken up, Barry Kripke asks Amy out. He promptly sends her naked photos of himself.

(THE PERSPIRATION IMPLEMENTATION)

Sheldon goes to propose to Amy again, but catches her kissing a new guy named Dave who is obsessed with Sheldon.

(THE SPOCK RESONANCE)

After no one will go with him to the Thanksgiving lunch at the aquarium, Sheldon offers Amy the tickets so they don't go to waste. They decide to go together. They have such a nice time that Amy asks Sheldon to be her boyfriend again, but he refuses.

(THE PLATONIC PERMUTATION)

Amy calls Dave, the man she's been dating, to go out on another date, while Sheldon realizes he still loves Amy. He crashes the date to tell her, and they kiss, with Dave encouraging them.

(THE EARWORM REVERBATION)

"She's like the dryer sheets of my heart."
—**Sheldon,** about Amy

(THE EARWORM REVERBATION)

Amy tries to teach Sheldon empathy so he'll apologize to his friends for being mean to them when they took care of him while he was sick.

(THE EMPATHY OPTIMIZATION)

Sheldon's Meemaw comes to visit in order to size Amy up, ensuring she's good enough for Sheldon. They clash.

(THE MEEMAW MATERIALIZATION)

Sheldon reveals to Amy his "Fortress of Shame," where he keeps everything he's ever owned, including a ziplock bag filled with all his old ziplock bags. It's a secret storage unit.

(THE SOLDER EXCURSION DIVERSION)

Since Sheldon would rather wait in line for a special screening of *The Avengers*, he hires Stuart to go shopping with Amy on his behalf.

(THE LINE SUBSTITUTION SOLUTION)

Amy calls Sheldon "babe" once and he asks her to get a drug test.

(THE LINE SUBSTITUTION SOLUTION)

When Leonard and Sheldon are working late nights on their project for the Air Force, Penny and Amy make them breakfast because they miss them.

(THE DEPENDENCE TRANSCENDENCE)

Dr. Bert Kibbler reveals that Amy is popular at the university and the only reason Sheldon is popular is because he's dating Amy.

(THE DEPENDENCE TRANSCENDENCE)

A pipe bursts in Amy's apartment and she's forced to stay in apartment 4A for as many as six weeks.

(THE COHABITATION EXPERIMENTATION)

Amy and Sheldon take their relationship to the next level by sharing a toothbrush holder.

(THE HOT TUB CONTAMINATION)

Amy's apartment has been done for weeks, but she keeps telling Sheldon it's delayed so they can continue living together. Sheldon admits he's open to the possibility of them moving in together.

(THE VERACITY ELASTICITY)

After Amy runs an experiment that combines her neurons with Sheldon's, Sheldon becomes obsessed with making a baby with her, thinking their child would be genetically superior. He tries to seduce her, dressed like, as Amy describes, the "Rat Pack Pee-Wee Herman."

(THE BRAIN BOWL INCUBATION)

Sheldon gives Amy a framed MRI of his brain for her birthday. The orbital frontal cortex is lit up because he was thinking of her.

(THE PROPERTY DIVISION COLLISION)

When Sheldon and Amy move into Penny's old apartment in a more permanent way, Sheldon gets unnerved by Raj moving into his old room. Dr. Beverly Hofstadter explains that it's because Raj taking the room represents the loss of Sheldon's escape hatch, in case he wants to escape from his relationship with Amy.

(THE ESCAPE HATCH IDENTIFICATION)

Amy and Sheldon collaborate on a scientific theory and struggle to agree on ground rules for the partnership, until Amy suggests regular treats. Sheldon says, "Biology and physics, coming together…it's like the peanut butter cup of the mind. Oooh! I know what I want my treat to be!"

(THE COLLABORATION FLUCTUATION)

Sheldon tells the group that he was attracted to Amy's body from the start, but Amy clarifies: it's because they have the same blood type and he might need to harvest an organ.

(THE SEPARATION AGITATION)

While off researching at Princeton, Amy gets extremely jealous of the time Sheldon spends with Dr. Nowitzki, an attractive, blond colleague. It's a shock to everyone when Dr. Nowitzki kisses Sheldon at work. He then flies directly to Princeton, where he proposes to Amy.

(THE LONG DISTANCE DISSONANCE)

Amy says yes to Sheldon after hearing his impassioned explanation. And the fact that he got Stephen Hawking's blessing.

(THE PROPOSAL PROPOSAL)

Amy and Sheldon continue to bicker about the details of the wedding.

(THE BITCOIN ENTANGLEMENT)

Amy and Sheldon decide to employ a mathematical approach called decision theory to plan their wedding. It goes poorly and they decide to get married at city hall. While there, they decide they want to have a real wedding and leave.

(THE CONFIDENCE EROSION)

Sheldon works to provide an authentic *Little House on the Prairie* dinner for Amy for her birthday. Afterward, they end up with food poisoning.

(THE CELEBRATION REVERBERATION)

While trying to decide which of their friends will be in the wedding, Amy and Sheldon put them through a series of inconsequential tests. The tests offer other results, but ultimately, they choose Leonard and Penny for best man and maid of honor.

(THE MATRIMONIAL METRIC)

The *New England Journal of Medicine* has a blurb about Amy and Sheldon's joint project.

(THE SOLO OSCILLATION)

With nothing of interest to pursue professionally, Sheldon kicks Amy out of the apartment so he can have some alone time to think.

(THE SOLO OSCILLATION)

In trying to help find names for Howard and Bernadette's son, Sheldon and Amy reveal how many kids they want: Amy, 2; Sheldon, 15. Amy's appalled until Sheldon reveals that he's sure they could find a suitable uterus to rent to bear many of them. All eyes turn to Penny.

(THE NEONATAL NOMENCLATURE)

They give out invitations for their wedding, with shots of their MRI scans photoshopped to look like they're kissing. The date is May 12. Sheldon is happy for the math behind it. The month squared equals the square of the sum of the members of the set of prime factors of the day.

(THE ATHENAEUM ALLOCATION)

Amy's bachelorette party is a quilting bee. She's not thrilled, so Penny and Bernadette take her out drinking. Amy passes out after a few shots and Penny and Bernadette tell her it was even more wild than she could have imagined.

(THE RECLUSIVE POTENTIAL)

When Sheldon takes a liking to Denise, the assistant manager at the comic book store, Amy confronts her, then asks for training in liking comic books.

(THE COMET POLARIZATION)

Amy tries on wedding dresses and finds one she loves, but Penny and Bernadette don't.

(THE MONETARY INSUFFICIENCY)

Amy and Sheldon get married, with Mark Hamill officiating. As they leave, Barry Kripke sings them off.

(THE BOW TIE ASYMMETRY)

Amy and Sheldon head to New York on their honeymoon.

(THE CONJUGAL CONFIGURATION)

Amy and Sheldon return from their honeymoon and give everyone "I ♥ New York" merchandise they don't want. Then the pair work on thank-you notes for the wedding gifts.

(THE WEDDING GIFT WORMHOLE)

Sheldon digitally places people who couldn't be in the wedding into the photos.

(THE TAM TURBULENCE)

Amy is furious when Sheldon gets her removed from her research to work on their joint research on super-asymmetry.

(THE PLANETARIUM COLLISION)

In an effort to be a better husband, Sheldon wants to bond with Amy's parents. This causes a crisis for Amy, who has been blaming Sheldon for the fact that she never spends time with her mom. He gives them vegetable-based nicknames: Turnip and Old Lad Green Beans.

(THE CONSUMMATION DEVIATION)

Nearing the end of work on their paper, Amy and Sheldon ask Leonard and Raj to research the citations in the paper because they don't trust a grad student. Leonard finds a paper that seems to disprove Amy and Sheldon's theory of super-asymmetry. This devastates Amy and Sheldon and they spend days in bed, depressed.

(THE CITATION NEGATION)

A pair of scientists, Drs. Campbell and Pemberton, prove Amy and Sheldon's paper on super-asymmetry.

(THE CONFIRMATION POLARIZATION)

Sheldon offers to give up his chance to win a Nobel Prize in order to make sure Amy gets the credit she deserves on their paper.

(THE CONFIRMATION POLARIZATION)

The university hosts a reception of Nobel laureates for Amy and Sheldon to campaign for their Nobel Prize for super-asymmetry. Amy has a meltdown and screams at Drs. Campbell and Pemberton that they're frauds.

(THE LAUREATE ACCUMULATION)

Amy and Sheldon go to a sensory deprivation tank in order to get their minds off the Nobel Prize.

(THE INSPIRATION DEVIATION)

Amy's makeover pushes Sheldon over the edge because everything is changing after they win the Nobel P rize.

(THE CHANGE CONSTANT)

Amy and Sheldon accept their Nobel Prize in Physics.

(THE STOCKHOLM SYNDROME)

THE RELATIONSHIP AGREEMENT

Notorious for his love of contracts, Sheldon insists that if he and Amy are to date, they must sign a relationship agreement. Several clauses are revealed on the show.

Sheldon breaks into Amy's apartment and presents her with a "relationship agreement."

SECTION 5: Hand-holding—Hand-holding is only allowed under the following circumstances: A: Either party is in danger of falling off of a cliff, precipice, or ledge. B: Either party is deserving of a hearty handshake after winning a Nobel Prize. C: Moral support during flu shots. (**THE FLAMING SPITTOON ACQUISITION**)

SECTION 4: Boo-boos and ouchies—Amy must help Sheldon when he has a small injury. He employs this section when he gets a splinter. (**THE FLAMING SPITTOON ACQUISITION**)

According to the relationship agreement, Sheldon and Amy's Date Night is every second Thursday of the month and, in the case of there being five Thursdays in a month, Date Night will be on the third Thursday instead.

The minutes of the previous date must be read and agreed to with a motion on each subsequent date.

Amy must provide written notice 72 hours in advance of any trip or travel. She must also check the tire pressure and call the Centers for Disease Control to ask which vaccines or shots they recommend for the trip. (**THE SHINY TRINKET MANEUVER**)

On the anniversary of their first date, Sheldon must take Amy to a nice dinner, ask about her day, and engage in physical contact that a disinterested onlooker might mistake for intimacy. There is no clause that prevents Sheldon from outsourcing any of these things to Raj. (**THE DATE NIGHT VARIABLE**)

The relationship agreement clearly states that when one of them is sick, the other must take care of them. (**THE FISH GUTS DISPLACEMENT**)

During their annual "state of the relationship" summit, Amy is displeased with Sheldon's proposed pet names for her. Sheldon submitted a notarized list to her, but she found Gollum, Flakey, Princess Corncob, Fester, and the others unacceptable. (**THE LOCOMOTION MANIPULATION**)

The agreement covers a wide array of scenarios including career changes, financial instability, intelligent dog uprising, and more. (**THE MOMMY OBSERVATION**)

The agreement precludes Amy from physical contact with anyone other than Sheldon. (**THE GORILLA DISSOLUTION**)

If Sheldon misses dates, he's contractually obligated to make them up. "It's better than hot," Amy says. "It's binding." (**THE FIRST PITCH INSUFFICIENCY**)

Pouting or being moody is disallowed on date night. (**THE FORTIFICATION IMPLEMENTATION**)

Cosmetic surgery is forbidden unless it's to look like a Klingon. (**THE BACHELOR PARTY CORROSION**)

There is a "no nostalgia" clause. (**THE ROMANCE RECALIBRATION**)

The relationship agreement turns into "the marriage contract." Section 3, article 5 is a "none of your beeswax" clause. (**THE TAM TURBULENCE**)

Sheldon's Feline Formula

SUBJECT

No relationship is smooth sailing all the way. Amy and Sheldon's is no exception. To cope with breakups like Amy and Sheldon's, lovers do all kinds of bizarre things to fill the void. For Sheldon, breaking up with Amy in "The Zazzy Substitution" cracked him. The only way he could cope was by adopting 25 cats, and naming almost all of them after scientists. When Sheldon and Amy get back together, they ended up paying a line of children $20 each to take them away.

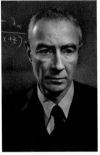

Robert Oppenheimer 1904–1967
THEORETICAL PHYSICIST

Oppenheimer led Los Alamos Laboratory during World War II and is widely credited as being the father of the atomic bomb. For his part in creating the bomb, he spent the rest of his life lobbying to prevent nuclear weapons from proliferating.

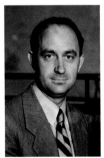

Enrico Fermi 1901–1954
THEORETICAL AND EXPERIMENTAL PHYSICIST
Nobel Prize in Physics, 1938

Known as the creator of the world's first nuclear reactor and the "architect of the nuclear age." Like Sheldon, he worked on many patents that were taken over by the US government.

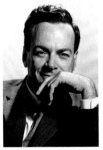

Richard Feynman 1918–1988
THEORETICAL PHYSICIST
Nobel Prize in Physics, 1965

A personal hero of Sheldon Cooper's, Richard Feynman was one of the best-known scientists in the world during his lifetime. He assisted in the creation of the atomic bomb, was a professor of theoretical physics at the California Institute of Technology, and, in the 1980s, was a member of the panel that investigated the Space Shuttle *Challenger* disaster.

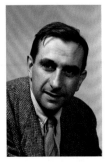

Edward Teller 1908–2003
THEORETICAL PHYSICIST

Known as the father of the hydrogen bomb, Edward Teller was an early member of the Manhattan Project. Teller was one of the first scientists to raise the specter of climate change in his address to the American Chemical Society in 1957.

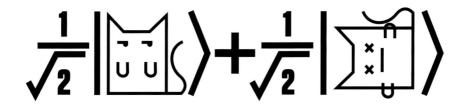

$$\frac{1}{\sqrt{2}} \left| \begin{array}{c} \end{array} \right\rangle + \frac{1}{\sqrt{2}} \left| \begin{array}{c} \end{array} \right\rangle$$

Otto Frisch 1904–1979
NUCLEAR PHYSICIST

Frisch advanced the first theoretic explanations of nuclear fission and even coined that term. Naturally, he was leader of the Manhattan Project's Critical Assemblies Group, tasked with accurately determining exactly how much enriched uranium would be required to create critical mass.

Pief Panofsky 1919–2007
PHYSICIST

The German American physicist Wolfgang Kurt Hermann "Pief" Panofsky was born in Berlin, Germany, to a family of art historians. He took the turn into physics when his family moved him to the United States at the age of 15, when he entered Princeton. He received his PhD in physics from the California Institute of Technology in 1942 and served as a consultant on the Manhattan Project.

Viktor Weisskopf 1908–2002
THEORETICAL PHYSICIST

Viktor Frederick "Viki" Weisskopf served as the group leader for the Theoretical Division of the Manhattan Project. He made significant contributions to the development of quantum theory and quantum electrodynamics, but was insecure about his mathematical abilities. This might have cost him a Nobel Prize, when he didn't publish the results that accurately predicted what is now known as the Lamb shift.

Zazzles
CAT

Zazzles was originally going to be named after the physicist and physician Dr. Hermann von Helmholtz (1821–1894), best known for his theories on the conservation of energy as well as his work in electrical dynamics, in chemical thermodynamics, and on the mechanical foundations of thermodynamics. Sheldon found Zazzles to be far too zazzy to be Dr. Hermann von Helmholtz, though.

BEST FORT EVER !

FORT KNOX vs.

FORT WAYNE

FORT KNOX vs.

FORT IRWIN vs.

FORT TICONDEROGA

FORT TICONDEROGA

FORT SUMTER vs.

FORT BENNING

FORT SUMTER vs.

FORT BRAGG vs.

FORT COZY McBLANKET

FORT COZY McBLANKET

VITAL INFORMATION ABOUT EACH CONTESTANT

Fort Knox—This military base in the heart of Kentucky guards the United States Bullion Depository, which is used to store much of the gold reserves of the United States. It was featured heavily in the James Bond adventure *Goldfinger* (1964).

Fort Wayne—Was a trio of military log stockades that served as a military outpost from 1794-1819 for the Northwest Indian War and, eventually, the War of 1812. It is the namesake of the city of Fort Wayne, Indiana.

Fort Irwin—Located deep in the Mojave Desert, it's a major training facility for the United States

military. It is a massive military base with a population of almost 10,000 and boasts a solar farm representing the largest renewable energy project in the history of the Department of Defense.

Fort Ticonderoga—Formerly known as Fort Carillon, Fort Ticonderoga was built by the French in the mid-1700s near the south end of Lake Champlain in New York. It served an important part of the American Revolution, but was abandoned in 1781 for having no military value. It fell into disrepair and became a tourist attraction from 1820 onward.

Fort Sumter—Fort Sumter is a sea fort built atop

One important part of being in a relationship is recognizing when your partner needs help or encouragement. In "The Fortification Implementation," Amy sees just such an opportunity when Sheldon is feeling down for not scoring an invite to symposium held at the house of Richard Feynman. Together, they build a blanket fort to decide which is actually the best fort ever.

FORT KNOX vs.

FORT COZY McBLANKET

FORT COZY McBLANKET

an artificial island off the coast of Charleston, South Carolina. It was built in 1814 after the British sacked Washington, DC in the War of 1812. Plagued by problems, it was never quite completed, but that didn't stop it from being an important Civil War battle site. Now it stands as a national park in Charleston Harbor.

Fort Benning—Named for Confederate general and American traitor Henry L. Benning, Fort Benning is a United States Army post on the border between Alabama and Georgia. Since 1909, it's served as the home of the army infantry. It began its life as Camp Benning in 1918 as a place to train American troops to send to World War I, and became a permanent base in 1920 by an act of Congress.

Fort Bragg—One of the largest military installations in the world, Fort Bragg resides in North Carolina, home to the Airborne and Special Operations Forces for the US military. Originally Camp Bragg when it was established in 1918, Fort Bragg was named for US Army artillery commander Braxton Bragg, who eventually betrayed his country, fighting against it in the Civil War.

Fort Cozy McBlanket—This blanket fort (circa 2015) has a physics book lending library, strings of Christmas lights, and a load-bearing Batman blanket. It also boasts walls made of an original 1978 *Star Wars* sheet and a C-3PO blanket.

Sheldon's Relationship Ranking

SUBJECT

In "The First Pitch Insufficiency," Sheldon lets Leonard know that his relationship is superior to Leonard and Amy's. He then goes on to rank all of the relationships in the group by quality as follows:

1. **Sheldon and Amy**

2. **Howard and Bernadette**

3. **Raj and his girlfriend**

4. **Penny and chardonnay**

5. **Penny and Leonard — they fight all the time.**

Sheldon's Enemies List

SUBJECT

Sheldon Cooper has an enemies list. This list has been kept on a $5\frac{1}{4}$" floppy disk since he started it at the age of 9[1]. Each documents a sort of relationship that Sheldon has with people who he perceives have wronged him. Some of these people actually have wronged him, others include Jim Henson. There are at least 62 people on the list including:

Wil Wheaton—Though he's since fallen off the list after making amends with Sheldon, actor and gamer Wil Wheaton rated #6 for ditching a convention appearance. Wheaton had been Sheldon's idol for his portrayal of Wesley Crusher, but his absence at the '95 Dixie Trek Convention was enough to land him on Sheldon's list.

Billy Sparks—Billy Sparks, one of Sheldon's childhood bullies, shoved a Mexican peso so far up Sheldon's nose that Sheldon still has problems getting through security at the airport.[2]

Tam Nguyen—Sheldon's childhood best friend, Tam Nguyen, found himself on Sheldon's enemies list after Sheldon moved to California and Tam didn't follow.[3]

Jim Henson—The father of the Muppets and *Sesame Street* found himself on Sheldon's list for putting a terrifying giant yellow bird on television and in Sheldon's nightmares.[4]

The person in charge of quality control at the Verbatim Corporation in 1989—In "The Russian Rocket Reaction," Sheldon tries to boot up the floppy disk he's kept his enemies list on for the past 22 years, but it fails to load. That's why the person in charge of quality control at the Verbatim Corporation in 1989 makes it to #62 on Sheldon's enemies list.

1. (The Russian Rocket Reaction)
2. (The Shiny Trinket Maneuver)
3. (The Tam Turbulence)
4. Ibid.

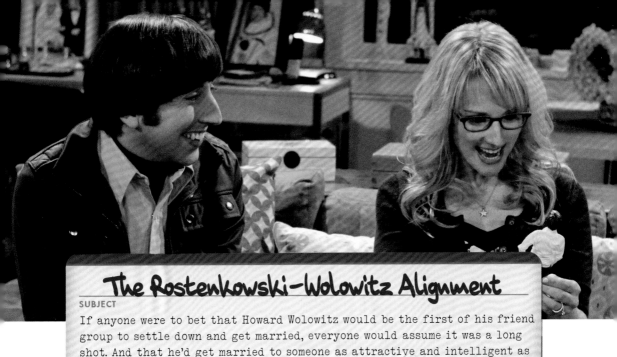

The Rostenkowski-Wolowitz Alignment

SUBJECT

If anyone were to bet that Howard Wolowitz would be the first of his friend group to settle down and get married, everyone would assume it was a long shot. And that he'd get married to someone as attractive and intelligent as Bernadette Rostenkowski? Unthinkable. But it happened.

Howard invokes a pact he made with Leonard in order to force his girlfriend to set Howard up with one of her friends. This brings Howard and Bernadette on their first date.

(THE CREEPY CANDY COATING COROLLARY)

Bernadette is introduced to the folks in apartment 4A as Howard's girlfriend.

(THE GORILLA EXPERIMENT)

Howard goes on a double date with Bernadette alongside Penny and Leonard. They go to the skating rink for disco night.

(THE EINSTEIN APPROXIMATION)

Howard's big plan for Bernadette's Valentine's Day is to take her to the PF Chang's "$39.95 Lover's Special."

(THE LARGE HADRON COLLISION)

The pair suffer their first break up because Bernadette catches Howard having sex in *World of Warcraft* with a character named Glissinda the Troll under the Bridge of Souls.

(THE HOT TROLL DEVIATION)

Bernadette agrees to a coffee date with Howard and they decide to resume seeing each other, starting with a mini-golf date.

(THE HOT TROLL DEVIATION)

After a fight with his mother, Howard moves in with Bernadette. After he treats her like his mother and expects her to do all the things his mother did for him, he moves back home.

(THE COHABITATION FORMULATION)

According to the latest gossip, Bernadette considers breaking up with Howard. Instead, Howard proposes to her and she says yes.

(THE HERB GARDEN GERMINATION)

When Howard finally tells his mother he's getting married to Bernadette, she collapses in the bathroom and has to be taken to the hospital.

(THE ENGAGEMENT REACTION)

With her new degree and job, Bernadette buys Howard a Rolex, making him feel inadequate about his own career.

(THE ROOMMATE TRANSMOGRIFICATION)

According to Howard, Bernadette doesn't care where he "gets his motor running" as long as he "parks in the right garage."

(THE WIGGLY FINGER CATALYST)

Howard is chosen to be a payload specialist on a mission to the International Space Station to help install a telescope his team designed. The idea of Howard going into space freaks

Bernadette out and she tries to prevent him from going.

(THE RUSSIAN ROCKET REACTION)

Sometimes, Bernadette and Howard pretend his arrhythmia is acting up and she's his cardiologist. The naughty part is that she's not in his HMO network.

(THE RECOMBINATION HYPOTHESIS)

Bernadette wants Howard to sign a prenuptial agreement, testing their relationship.

(THE VACATION SOLUTION)

As the fellas try to plan Howard's bachelor party, he reveals that he promised Bernadette no strippers. Wil Wheaton shows up and films the whole thing, including Raj revealing all of Howard's secrets. Wheaton uploads it, Bernadette sees it, and it infuriates her. She almost calls off the wedding, but Howard assures her that the man she's disgusted by is dead and he's been made a better man by her.

(THE STAG CONVERGENCE)

The timeline for Howard's space trip is accelerated, forcing him to miss his originally planned wedding date with Bernadette.

(THE LAUNCH ACCELERATION)

Howard has to convince his mother not to accompany him on his honeymoon.

(THE LAUNCH ACCELERATION)

When Howard's rocket launch is moved up, he and Bernadette have a quick wedding before he leaves. Raj, Leonard, Penny, Sheldon, and Amy all quickly get ordained to marry them on the rooftop of the apartment building. Sheldon does his portion partially in Klingon.

(THE COUNTDOWN REFLECTION)

Bernadette makes Howard talk to his mother about the fact that they aren't going to live with her while he's on the International Space Station. His mother doesn't take it well and browbeats Howard into talking to Bernadette about staying.

(THE DATE NIGHT VARIABLE)

Bernadette refers to Howard as her little "Astro-naughty Hottie."

(THE HIGGS BOSON OBSERVATION)

Bernadette is not above mashing up Benadryl into Howard's ice cream to get Howard to fall asleep.

(THE PARKING SPOT ESCALATION)

Howard is forced to go fishing with Bernadette's father in an effort to get to know him better. Penny has to train him to fish. When they both decide the trip isn't for them, Bernadette's father suggests they go to a casino and learn craps instead.

(THE FISH GUTS DISPLACEMENT)

Howard is taken off his joint bank account with Bernadette until he can learn the value of money. He goes hungry at lunch because he blew all his money on *Pokémon* cards.

(THE COOPER/KRIPKE INVERSION)

Raj asks Howard and Bernadette to dogsit Cinnamon, his Yorkshire terrier. They take her to the park and promptly lose her.

(THE PROTON RESURGENCE)

On Valentine's Day, Howard finds a drowning rabbit in the hot tub. He and Bernadette rescue it and name it Valentino. It promptly bites Howard and distracts Bernadette from her moment to tell him she's pregnant.

(THE VALENTINO SUBMERGENCE)

Bernadette tells Howard that she's pregnant. Then she tells Penny and Amy that they conceived on Sheldon's bed.

(THE POSITIVE NEGATIVE REACTION)

Their daughter, Halley Wolowitz.

(THE BIRTHDAY SYNCHRONICITY)

Bernadette finds out she's pregnant again.

(THE PROPOSAL PROPOSAL)

Howard wants to stay home full time with the kids. But so does Bernadette, or at least she wants the option.

(THE GEOLOGY METHODOLOGY)

Howard and Bernadette leave the kids behind at home to accompany their friends to, where they're thanked by Sheldon for their part in his Nobel Prize win.

(THE STOCKHOLM SYNDROME)

SUBJECT

Howard wants the group to play a song he wrote for Bernadette for the anniversary of their first date in "The Romance Resonance." Penny plays tambourine, Leonard plays cello, Raj plays ukulele, Sheldon plays recorder, Amy is on harp, and Howard is on the keyboard. But the song doesn't happen as planned because there was an accident at Bernadette's lab and she's in quarantine, so they take the song to her in the lab.

IF I DIDN'T HAVE YOU

HOWARD

If I didn't have you, life would be blue,
I'd be Doctor Who without the Tardis,
I'd be a candle without a wick,
A Watson without a Crick,
I'd be one of my outfits without Dick-ie
I'd be cheese without the mac,
Jobs without the Wozniak.
I'd be solving exponential equations
That use bases not found on your calculator,
Making it much harder to crack.
I'd be an atom without a bomb,
A dot without the com,
And I'd probably still live with my mom.

FRIENDS

And he'd probably still live with his mom.

HOWARD

Ever since I met you,
You turned my world around.
You supported all my dreams and all my hopes.
You're like Uranium 235 and I'm Uranium 238,
Almost inseparable isotopes.
I couldn't have imagined
How good my life would get,
From the moment that I met you, Bernadette.
If I didn't have you, life would be dreary.
I'd be string theory without any string.
I'd be binary code without a one,
Cathode ray tube without an electron gun.
I'd be *Firefly*, *Buffy*, and *Avengers* without Joss Whedon.
I'd speak a lot more Klingon:
qalopmeH QaQ jajvam[1]

FRIENDS

And he'd definitely still live with his mom.

HOWARD

Ever since I met you,
You turned my world around.
You're my best friend and my lover.
We're like changing electric and magnetic fields:
You can't have one without the other.
I couldn't have imagined
How good my life would get,
From the moment that I met you, Bernadette.

HOWARD AND FRIENDS

Oh, we couldn't have imagined
How good our lives would get,
From the moment that we met you, Bernadette.

1. Klingon for "Today is good for me to celebrate you."

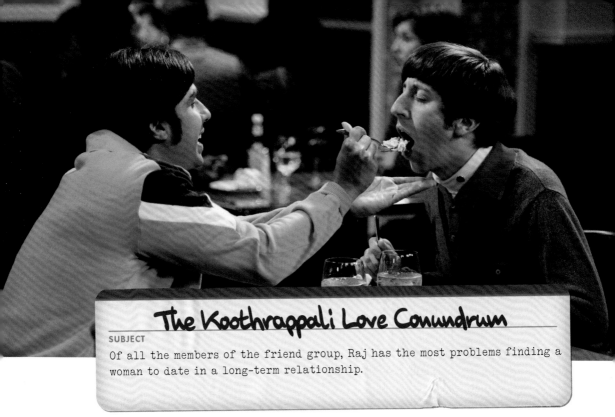

The Koothrappali Love Conundrum

SUBJECT

Of all the members of the friend group, Raj has the most problems finding a woman to date in a long-term relationship.

Raj, dressed as the Norse god Thor, sleeps with a drunk partygoer at Penny's Halloween party.
(THE MIDDLE EARTH PARADIGM)

When he's honored by *People* magazine on their "30 Under 30" list, Raj goes on a date with Penny to the celebration.
(THE GRIFFIN EQUIVALENCY)

Raj sleeps with a woman he picks up at the bar.
(THE HOFSTADTER ISOTOPE)

Raj strikes out with the goth chicks he and Howard picked up at the nightclub after Howard refuses to get a tattoo.
(THE GOTHOWITZ DEVIATION)

Dr. Elizabeth Plimpton seduces Raj after trying to convince Raj, Howard, and Leonard to have a foursome with her.
(THE PLIMPTON STIMULATION)

Raj kisses Howard.
(THE BOYFRIEND COMPLEXITY)

Raj fantasizes about Bernadette. When she calls him on it, he finds himself in a Bollywood dance number with her.
(THE THESPIAN CATALYST)

Raj "sleeps" with Penny.
(THE ROOMMATE TRANSMOGRIFICATION)

Turns out, Raj didn't sleep with Penny.
(THE SKANK REFLEX ANALYSIS)

Raj kisses Howard again, this time through Howard's long-distance kissing machine.
(THE INFESTATION HYPOTHESIS)

Thinking it might be easier for Raj to talk to a woman without hearing, Penny sets Raj up with Emily, a deaf woman. She's only interested in Raj's wealth.
(THE WIGGLY FINGER CATALYST)

Raj tries dating Siri on his new iPhone. He programs her to call him "Sexy."
(THE BETA TEST INITIATION)

Raj laments that even if he gets a girlfriend, he will always be the guy who got a girlfriend *after* Sheldon Cooper.
(THE WEEKEND VORTEX)

Sick of being single, Raj asks his parents to play matchmaker and set him up with a bride. He brings Howard and Bernadette on his first date with Lakshmi. Everything is going well until

Lakshmi reveals that she's gay. As a consolation, Howard and Bernadette get him a Yorkshire terrier that he names Cinnamon.

(THE TRANSPORTER MALFUNCTION)

When Penny, Bernadette, and Amy take Raj along on girls' night, they work to set him up.

(THE SANTA SIMULATION)

"I make it a rule to only fall for one of my friends' girlfriends at a time. I'm old-fashioned that way."—**Raj**

(THE SANTA SIMULATION)

At a singles Valentine's Day party at the comic book store, Raj meets Lucy. He asks her on a coffee date, during which she promptly ditches him.

(THE TANGIBLE AFFECTION PROOF)

Raj dedicates himself as a monk, eschewing all worldly pleasures. Until Lucy's number falls back in his lap.

(THE TANGIBLE AFFECTION PROOF)

Raj and Lucy go out. He takes her to a library where they can communicate via text instead of awkwardly talking to each other. It goes well and Lucy asks for a goodbye kiss. Unfortunately, she has a panic attack and bails.

(THE CONTRACTUAL OBLIGATION IMPLEMENTATION)

Raj finds Lucy's blog about her dating life. He tries to be more "manly" on his next date with her. She sees through the ruse and they have a nice date.

(THE CLOSURE ALTERNATIVE)

Raj kills himself in Dungeons & Dragons in order to go on a last-minute date with Lucy, who was so nervous about the date, she spread roll-on deodorant all over her body. After a tense moment, she attempts to escape out the bathroom window but gets trapped and has to call Raj for help. He confesses his feelings for her and they kiss.

(THE LOVE SPELL POTENTIAL)

Raj asks Lucy to hang out with his friends. He chooses just one to start with and picks Amy. It doesn't go well and Lucy bails. Then she breaks up with him.

(THE BON VOYAGE REACTION)

In an effort to get Raj back in the game after Lucy, Howard takes him to a mixer at the university. He connects with Mrs. Davis from human resources, but it leads nowhere.

(THE HOFSTADTER INSUFFICIENCY)

Raj and Stuart make online dating profiles. No one bites.

(THE RAIDERS MINIMIZATION)

After Lucy is dressed down by Penny at the Cheesecake Factory, she asks Raj to meet her for coffee.

(THE ITCHY BRAIN SIMULATION)

Almost meets someone but blows it. "I was walking Cinnamon and this girl introduced herself, but she was so cute I panicked and said, 'Wouldn't it be easier if instead of talking we could just sniff each other's butts?'"—**Raj**

(THE HESITATION RAMIFICATION)

When Cinnamon is poisoned with chocolate, Raj gets the number of Yvette, the vet who takes care of her.

(THE LOCOMOTIVE MANIPULATION)

Raj goes back to online dating and finds Emily Sweeney, a woman he wants to go to coffee with. He asks Amy to be his wingmate to help get the girl, but Amy ends up hanging out with her instead.

(THE FRIENDSHIP TURBULENCE)

Raj runs into Emily again and apologizes to her, and they have coffee together. Things go well and they set up weekend plans. At the same time, Lucy, Raj's ex-girlfriend, emails him and wants to get back together. He plans to say yes to both of them.

(THE INDECISION AMALGAMATION)

Howard and Bernadette accompany Raj and Emily on a double date.

(THE RELATIONSHIP DIREMPTION)

Raj watches *House of 1000 Corpses* with Howard in order to prepare to watch it with Emily, a huge horror film nerd.

(THE ANYTHING CAN HAPPEN RECURRENCE)

Raj goes with Sheldon to see a movie, where they run into Emily. She's with another date.

She apologizes.

(THE GORILLA DISSOLUTION)

Raj, fully dating Emily, brings her to meet the crew.
(THE HOOK-UP REVERBERATION)

Raj sleeps over at Emily's house.
(THE COLONIZATION OPTIMIZATION)

As part of an agreement between Raj and Emily, she can only joke about murdering someone if she adds "just kidding" to the end of that statement.
(THE COLONIZATION OPTIMIZATION)

Raj admits that he was once going to get circumcised to date Rachel Bernstein.
(THE 2003 APPROXIMATION)

Raj meets Claire, a young bartender/screenwriter, at the comic book shop and they hit it off. He helps her with her screenplay and fantasizes about marrying her and having children.
(THE MEEMAW MATERIALIZATION)

Raj is so obsessed with Claire, he breaks up with Emily right before Valentine's Day, but Claire got a boyfriend already, leaving him alone.
(THE VALENTINO SUBMERGENCE)

Emily misses Raj and gives him an antique sextant to get back together with him. On his way to see her, he gets a call from Claire and doesn't know who he should go see. Claire tells him that Emily is playing him, but it doesn't matter, he still sleeps with Emily.
(THE APPLICATION DETERIORATION)

Raj dates both Claire and Emily.
(THE VIEWING PARTY COMBUSTION)

Raj decides he wants to take Claire on a wine-tasting trip with Leonard, Penny, and Howard. He accidentally reveals to Claire that he's dating other women.
(THE FERMENTATION BIFURCATION)

Dumped by both Emily and Claire, Raj is once again single.
(THE HOT TUB CONTAMINATION)

Raj dates Isabella, the janitor at the astronomy lab. Everyone assumes she's a fellow astronomer

and he's a bit ashamed of her job as a janitor, but goes out of his way to get a date with her.
(THE BRAIN BOWL INCUBATION)

Isabella breaks up with Raj with no reason given.
(THE EMOTION DETECTION AUTOMATION)

Raj puts together a focus group of ex-girlfriends to see what's wrong with him and why he's a bad boyfriend.
(THE EMOTION DETECTION AUTOMATION)

Raj and Stuart both crash a work get-together of Bernadette's to meet her new coworker, Ruchi. They argue about who will get the chance to date her.

(THE RELAXATION INTEGRATION)

Raj runs into Ruchi at a bar watching cricket. They hit it off and he sleeps over at her house.
(THE GEOLOGY METHODOLOGY)

After sleeping with Ruchi in their casual relationship, Raj learns that she is trying to steal Bernadette's projects at work. When Raj tells Bernadette he's in a relationship with Ruchi after sticking up for her, Ruchi dumps Raj.
(THE TESLA RECOIL)

Raj sleeps with Nell, a woman he met at the planetarium. She's "technically" married and has only been separated for two weeks. Raj is freaked out when her husband shows up at the planetarium to confront him.
(THE SEPARATION TRIANGULATION)

After finding a downed drone, Raj and Howard repair it and try to return it to its owner. They track it to a cute customer of the comic book store named Cynthia. Raj gets her number.
It goes nowhere after Cynthia discovers footage on the drone of Raj being creepy.
(THE TENANT DISASSOCIATION)

Raj asks a woman with pink eye in line at the pharmacy to go to Amy and Sheldon's wedding with him.

(THE SIBLING REALIGNMENT)

Tired of being alone, Raj calls his father and asks him to arrange a marriage for him. He agrees to help as long as Raj stops Instagramming photos of himself and Cinnamon in matching

sweaters. He sets Raj up with a woman named Anu. Raj announces to the group that he's getting married.

(THE WEDDING GIFT WORMHOLE)

Raj and Anu go on their first date. She's aggressively demanding. On their second date, she proposes to him and he says yes, moments after telling her he's a romantic and can't do it.

(THE PROCREATION CALCULATION)

Raj brings Anu to the apartment. They're planning a wedding in India. Then she suggests they have to have sex before deciding to get married.

(THE CONSUMMATION DEVIATION)

Raj and Anu have a spat when he helps her install her doorbell camera and he sees her ex-boyfriend drop by.

(THE PAINTBALL SCATTERING)

Raj and Anu decide to restart their relationship at the beginning, with a date.

(THE PROPAGATION PROPOSITION)

Anu is offered a job in London. Raj considers moving away from his friends and his job to go with her to London.

(THE PLAGIARISM SCHISM)

Howard buys a $1,300 plane ticket to get into the airport and convince Raj not to move to London. The two men profess their undying love for each other.

(THE MATERNAL CONCLUSION)

Sarah Michelle Gellar insists that her date to the Nobel Prize award ceremony with Raj is not actually a date. She is still married to Freddie Prinze Jr., but Raj brings her anyway, remaining truly single for the foreseeable future.

(THE STOCKHOLM SYNDROME)

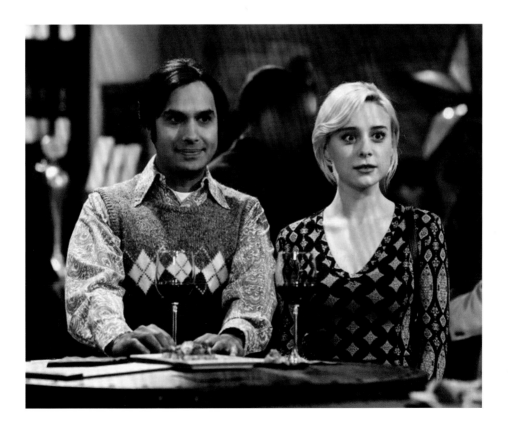

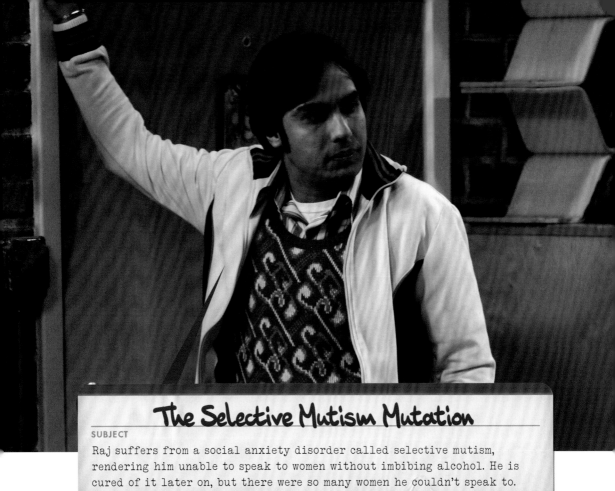

The Selective Mutism Mutation

SUBJECT

Raj suffers from a social anxiety disorder called selective mutism, rendering him unable to speak to women without imbibing alcohol. He is cured of it later on, but there were so many women he couldn't speak to.

"I wish I had [Howard's] confidence. I have such difficulty speaking to women. Or around women. Or, at times, even effeminate men."

(The Middle Earth Paradigm)

Penny
(PILOT)

Lalita Gupta
(THE GRASSHOPPER EXPERIMENT)

Missy Cooper
(THE PORK CHOP INDETERMINANCY)

Summer Glau
(THE TERMINATOR DECOUPLING)

Dr. Milstone from MIT
(THE PIRATE SOLUTION)

Hypothetically, himself if he had woman parts
(THE CRUCIFEROUS VEGETABLE AMPLIFICATION)

Dr. Amy Farrah Fowler
(THE ZAZZY SUBSTITUTION)

Special Agent Page, FBI
(THE APOLOGY INSUFFICIENCY)

The nurse at Caltech
(THE HIGGS BOSON OBSERVATION)

Dr. Alex Jensen, Sheldon's assistant
(THE EGG SALAD EQUIVALENCY)

Mrs. Davis from Human Resources
(THE EGG SALAD EQUIVALENCY)

Anu
(THE CONSUMMATION DEVIATION)

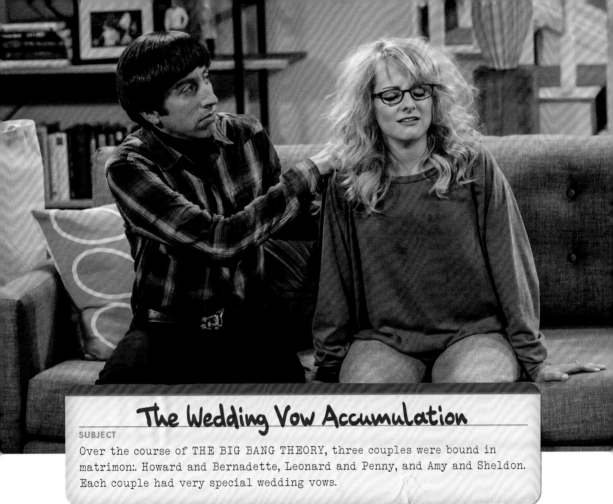

The Wedding Vow Accumulation

SUBJECT

Over the course of THE BIG BANG THEORY, three couples were bound in matrimony: Howard and Bernadette, Leonard and Penny, and Amy and Sheldon. Each couple had very special wedding vows.

HOWARD AND BERNADETTE

Howard and Bernadette got married in a hurried ceremony in "The Countdown Reflection." Their friends officiated the wedding quickly so Howard could make it to the International Space Station for his NASA mission.

BERNADETTE'S WEDDING VOWS

Howard Joel Wolowitz, like you, this is going to be short and sweet. I love you with all my heart and soul and promise to be with you forever.

HOWARD'S WEDDING VOWS

Bernadette Maryann Rostenkowski, until I met you I couldn't imagine spending my life with just one person. And now I can't imagine spending one day of it without you.

LEONARD AND PENNY

When Leonard and Penny first got married in Las Vegas in "The Matrimonial Momentum," they didn't get a chance to have their friends or family there. They also didn't have a chance to do anything traditional as far as wedding vows or pomp. When Leonard's mother expresses genuine disappointment at not being able to attend their wedding, they hold a second ceremony. In "The Conjugal Conjecture," they get married in a ceremony officiated by Bernadette that all can attend. Penny's vows are actually just a *Toy Story* reference.

LEONARD'S WEDDING VOWS

Penny, we are made of particles that have existed since the universe began. I like to think those atoms have traveled 14 billion years through time and space to create us so that we could be together and make each other whole.

PENNY'S WEDDING VOWS

Leonard, I mean, you're not only the love of my life. I mean, you're my best friend. You've got a friend in me. You got troubles. I got them, too. There isn't anything I wouldn't do for you. We stick together, and we can see it though . . . cause you got a friend in me.

SHELDON AND AMY

When Sheldon and Amy finally get married in "The Bow Tie Asymmetry," it's in a large ceremony at the Athenaeum Club overseen by their friends and family. Wil Wheaton is originally scheduled to officiate, but Howard manages to get Mark Hamill to do the honors instead. When they give their vows, it puts the Luke Skywalker actor in tears.

AMY'S WEDDING VOWS

Sheldon, when I was a little girl, I used to dream about my wedding. But eventually I stopped, because I thought that day would never come. And then I met you. From the first moment in that coffee shop, I knew there was something special between us, even though I did work on a study that disproved love at first sight. Clearly it was wrong. Because I felt something that day, and those feelings have only gotten stronger with time. I can't imagine loving you more than I do right now. But I felt that way yesterday and the day before yesterday and the day before that.

Sheldon, I don't know what the future holds, but I know I've never been happier than I am now in this moment, marrying you.

SHELDON'S WEDDING VOWS

Amy, I usually know exactly what to say. But at this moment I have no words. I guess I'm overwhelmed by you. In a good way. Not like, elevator-in-the-Haunted-Mansion way. Even if I can't tell you now how I feel, I will spend the rest of my life showing you how much I love you.

(4.)

THE SUPPORTING PLAYER SYMPOSIUM

Crisis with Infinite Stuarts

NAME: STUART DAVID BLOOM

BORN: MAY 7, 1974

SEX: OCCASIONALLY

EDUCATION: RHODE ISLAND SCHOOL OF DESIGN

Stuart David Bloom is the owner of the Comic Center of Pasadena, the comic book shop frequented by Sheldon Cooper, Leonard Hofstadter, and all their friends. His job yields him a 45 percent discount on comics,[1] but he makes far less than minimum wage. He does it for the love of comics and the art. He works a 70-hour work week and averages $1.65 an hour, which comes out to about $6,000 a year.[2] He briefly dated Penny, but when she blurted Leonard's name during a makeout session, it really destroyed the magic. He's a nervous fellow and finds friends wherever he can.

Eventually, he makes money working for Howard and Bernadette, caring for Howard's mother, Debbie, in the final years of her life. She even gives him the money to reopen the comic book store after a disastrous fire destroyed the interior.[3] With nowhere else to go, he moves into the Wolowitz home and even stays long after Debbie's death, much to the consternation of Howard and Bernadette.

A lovable weirdo, he hangs out with the crew, but no one seems to feel intensely enough about him one way or the other to make him stop hanging out with them or bring him fully into the group.

Perhaps his superpower is his ability to make everyone ambivalent about his presence.

"Not clinically depressed at all."
(The Holographic Excitation)

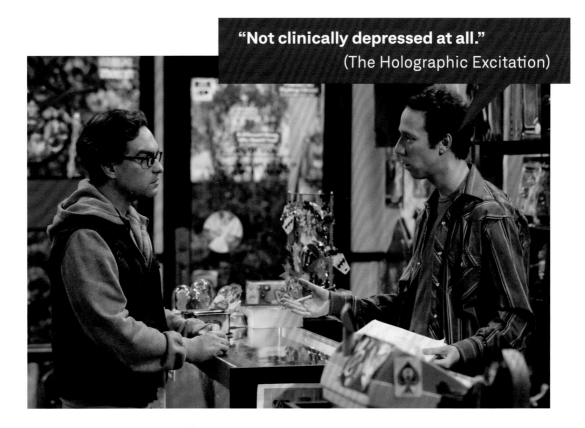

1. (The Hofstadter Isotope)
2. (The Justice League Recombination)
3. (The Hook-Up Reverberation)

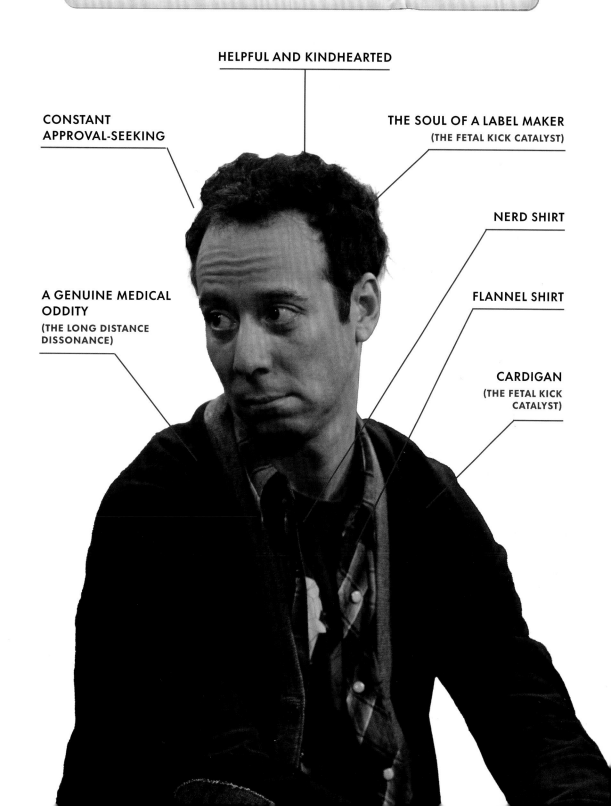

Stuart's Pictorial Record

SUBJECT

Stuart is the owner of the Comic Center of Pasadena and a friend to the group. Consistently down on his luck, Stuart tries to find friends wherever they'll have him.

HELPFUL AND KINDHEARTED

CONSTANT APPROVAL-SEEKING

THE SOUL OF A LABEL MAKER
(THE FETAL KICK CATALYST)

NERD SHIRT

A GENUINE MEDICAL ODDITY
(THE LONG DISTANCE DISSONANCE)

FLANNEL SHIRT

CARDIGAN
(THE FETAL KICK CATALYST)

Stuart's Timeline

THE HOFSTADTER ISOTOPE — Stuart's first appearance.

THE CLASSIFIED MATERIALS TURBULENCE — Penny goes on a date with Stuart, but says Leonard's name while she makes out with him, ruining the magic.

THE CREEPY CANDY COATING COROLLARY — Stuart wins the *Mystic Warlords of Ka'a* tournament with his buddy Wil Wheaton.

Stan Lee signs comics at his store and afterward takes Stuart, Leonard, Howard, and Raj out for gelato.

THE EXCELSIOR ACQUISITION — Stuart gives Penny Stan Lee's address in exchange for her acquiescence in accompanying him to a wedding.

THE WHEATON RECURRENCE — Alongside Wil Wheaton, Stuart bowls against Sheldon and the gang.

THE DESPERATION EMANATION — Stuart claims to have a girlfriend he met at Comic-Con, the one place where, he says, "I own a comic book store" is an actual pickup line.

THE TOAST DERIVATION — Due to financial reasons, Stuart moves into the comic book store.

THE FLAMING SPITTOON ACQUISITION — Stuart asks Amy out via text message. They go for coffee. He has a pumpkin latte. Then they go on a movie date, which Sheldon interrupts.

THE FRIENDSHIP CONTRACTION — Stuart moves up one slot to become Sheldon's 9th favorite person when Sheldon's pen pal in Somalia is kidnapped by pirates.

THE DECOUPLING FLUCTUATION — Stuart goes to the movies with the crew as a replacement for Howard while he's in space.

THE RE-ENTRY MINIMIZATION — Raj has Stuart move in with him until the comic book store owner gets back on his feet.

THE DECEPTION VERIFICATION — Stuart cons Sheldon into paying $1,200 for an Aquaman statue and $200 for a worthless Batman squirt gun.

THE RAIDERS MINIMIZATION — With Raj's help, Stuart starts an online dating profile.

THE HESITATION RAMIFICATION — Raj doesn't have a date, so he brings Stuart to watch Penny's episode of *NCIS*. Then he and Raj go to the mall and practice talking to people so they can meet girls.

THE STATUS QUO COMBUSTION — Stuart accidentally burns down the comic book store with a hot plate. When he needs a place to stay, Howard hires him to take care of his mom, Debbie.

THE LOCOMOTION INTERRUPTION

Howard freaks out when he discovers that Stuart has moved into his childhood home with Debbie Wolowitz.

THE HOOK-UP REVERBERATION

Howard's mom gets cable for Stuart and gets him seven HBOs.

THE PROM EQUIVALENCY

Stuart goes to the prom the girls throw and brings Jeanie, Howard's second cousin.

THE COMIC BOOK STORE REGENERATION

With money Debbie Wolowitz gives him, Stuart reopens the comic book store.

THE PERSPIRATION IMPLEMENTATION

In an effort to attract a larger female clientele, Stuart brings Amy, Penny, and Bernadette to the store to consult with him.

THE SALES CALL SUBLIMATION

Stuart moves out of Howard and Bernadette's house.

THE HOT TUB CONTAMINATION

When Stuart thinks Howard and Bernadette are going out of town, he breaks into their house to skinny-dip in the hot tub. He gets scared when Raj shows up for the same reason.

THE PROPERTY DIVISION COLLISION

Stuart gets evicted from his apartment and asks to move back in with Howard and Bernadette as a trial run. He goes out of his way to be overly helpful in order to continue mooching off them.

Stuart's shop gets a terrific review from Neil Gaiman on Twitter: "The next time you're in Pasadena, check out The Comic Center. Great vibe, old school. The owner really knows his stuff."

THE COMET POLARIZATION

Sheldon is infuriated by the fame Gaiman's tweet brings the comic book store, as it changes the character of the place.

The store gets so busy, Stuart has to hire an assistant manager named Denise.

Neil Gaiman hangs around recommending his own comics, but no one seems to recognize him.

THE BOW TIE ASYMMETRY

Stuart and Denise go to Sheldon and Amy's wedding together and she finds him very attractive based on his intimate knowledge of *Star Wars* lore.

THE WEDDING GIFT WORMHOLE

It turns out that Stuart and Denise made out at Amy and Sheldon's wedding and he's not sure where their relationship is going. He asks her out and she says yes.

THE PROCREATION CALCULATION

Stuart brings Denise home . . . to the Wolowitz house.

THE LAUREATE ACCUMULATION

Bernadette writes a children's book about Howard called *The Frightened Little Astronaut* and has Stuart illustrate it.

THE MATERNAL CONCLUSION

Stuart agrees to move in with Denise, bringing him his "happily ever after."

Emily Sweeney, Demon Dermatologist

NAME: EMILY SWEENEY

OCCUPATION: DERMATOLOGIST AT HUNTINGTON HOSPITAL[1]

HOBBIES: MURDER . . . ?

INTERESTS: ALSO MURDER AND CUTTING PEOPLE WITH KNIVES[2]

TURN-ONS: SEX IN GRAVEYARDS,[3] SCARY MOVIES, AND, ONCE AGAIN, MURDER

Emily Sweeney finds Raj on a dating site and the two of them embark on what would become Raj's longest relationship to date. That wasn't her first exposure to the group, though. At one point, she was set up on a blind date with Howard. Howard clogged her toilet and snuck out the window. Her friends still refer to him as "Clogzilla."[4] Her work as a dermatologist at Huntington Hospital doesn't quite jive with the murderous, horror-obsessed persona of her personal life.

Emily's Pictorial Record

INNOCENT BUT MURDEROUS LOOK

RED HAIR
(THE FRIENDSHIP TURBULENCE)

SLY SMILE

**THREE TATTOOS: ONE ON
HER SHOULDER, ONE NOT
ON HER SHOULDER,
AND ONE REALLY NOT
ON HER SHOULDER**
(THE GORILLA DISSOLUTION)

**SALLY FROM THE *NIGHTMARE
BEFORE CHRISTMAS* (1993) IS
HER SHOULDER TATTOO**
(THE PROM EQUIVALENCY)

CONCEALED KNIFE[5]

SCARY, BUT CUTE SCARY
(THE RELATIONSHIP DIREMPTION)

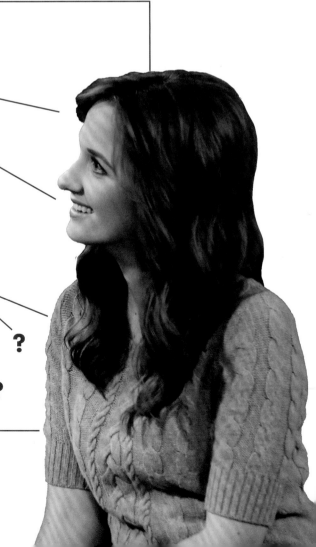

1. (The Relationship Diremption)
2. Ibid.
3. (The Commitment Determination)
4. (The Relationship Diremption)
5. Probably . . .

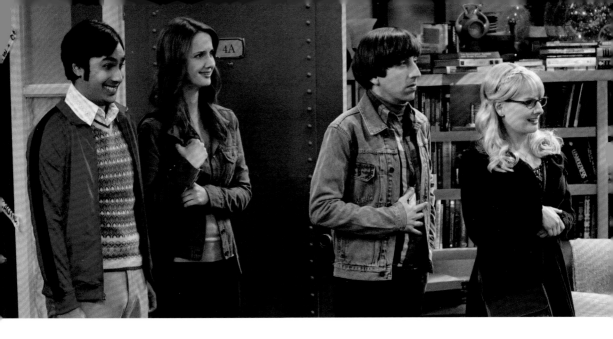

Emily's Landmark Episodes

Emily meets Raj on an online dating site and goes to meet him.

(THE FRIENDSHIP TURBULENCE)

Raj runs into Emily again and apologizes to her for how their first meeting went. They get coffee together. They hit it off and set up another date.

(THE INDECISION AMALGAMATION)

Emily accompanies Raj on a double date with Howard and Bernadette. Howard is terrified because she recognizes him as "Clogzilla."

(THE RELATIONSHIP DIREMPTION)

Emily confesses to Raj that horror movies turn her on.

(THE ANYTHING CAN HAPPEN RECURRENCE)

Raj catches Emily at the movies with another guy. She comes over to Raj's house to explain herself. They make out.

(THE GORILLA DISSOLUTION)

Emily meets Penny and Leonard for the first time. Emily treats Penny coldly because she's jealous of the time Penny and Raj "slept together."

(THE HOOK-UP REVERBERATION)

Raj takes Emily to the prom his friends organized.

(THE PROM EQUIVALENCY)

Emily convinces Raj, Leonard, and Amy to go to an escape room, but the puzzles aren't difficult for the group and they escape in minutes.

(THE INTIMACY ACCELERATION)

Emily intimates to Raj that she may well be hiding a body in the closet.

(THE COLONIZATION APPLICATION)

Raj and Emily have a picnic in a graveyard.

(THE COMMITMENT DETERMINATION)

Sheldon clashes with Emily and he later makes a heartfelt apology to her.

(THE EMPATHY OPTIMIZATION)

Raj breaks up with Emily.

(THE VALENTINO SUBMERGENCE)

Emily sends Raj a belated Valentine's Day gift in hopes of resuming their relationship.

(THE APPLICATION DETERIORATION)

When Raj calls upon his ex-girlfriends to offer counsel about why he's so solidly single, Emily shows up.

(THE EMOTION DETECTION AUTOMATION)

The Winkle Effect

NAME: LESLIE WINKLE

OCCUPATION: EXPERIMENTAL PHYSICIST AT THE CALIFORNIA INSTITUTE OF TECHNOLOGY

BORN: 1977[1]

> Penny: **"Oh! A girl scientist"**
> Leslie: **"Yep. Come for the breasts, stay for the brains."**
>
> **(THE HAMBURGER POSTULATE)**

Leslie Winkle is every bit a counterpart to Leonard Hofstadter, and it's no wonder they dated, however briefly. They worked together at Caltech, though their work didn't often intersect. She was more interested in sex and using her equipment inappropriately.[2] Her focus was on high-energy physics and the search for supersymmetry.

Leslie's Pictorial Record

> **"The Doctor Doom to my Mister Fantastic. The Dr. Octopus to my Spider-Man. The Doctor Sivana to my Captain Marvel."**
> —Sheldon Cooper on Leslie Winkle, in "The Codpiece Topology"

DARK GLASSES

CURLY HAIR

SARDONIC SMILE

COY GLINT IN HER EYE

1. The same year as *Star Wars: Episode IV—A New Hope.*
2. Leslie once used liquid nitrogen to flash-freeze a banana, then smashed it up and placed the chips on her cereal. (The Hamburger Postulate)

Leslie's Timeline

THE FUZZY BOOTS COROLLARY — Leslie Winkle's first appearance, and her first date with Leonard.

THE HAMBURGER POSTULATE — Playing the violin, Leslie Winkle propositions a cello-playing Leonard. They engage in coitus.

THE BAT JAR CONJECTURE — Much to Sheldon's dismay, Leslie helps Leonard win the Physics Bowl.

THE BAD FISH PARADIGM — Leslie reignites her relationship with Leonard after he gets brushed off by Penny.

THE CODPIECE TOPOLOGY — Leslie dates Leonard, but annoys Sheldon.

THE CUSHION SATURATION — Leslie enters a "friends with benefits" relationship with Howard Wolowitz.

THE HOFSTADTER ISOTOPE — Leslie dumps Howard.

THE LUNAR EXCITATION — Leonard comes crawling back to Leslie, but she slams the door in his face.

THE CELEBRATION EXPERIMENTATION — Leslie shows up for Sheldon's birthday party to call him a dumbass one last time.

The Kripke Crypto Key

NAME: BARRY KRIPKE

BORN: MAY 12

OCCUPATION: PLASMA PHYSICIST AND STRING THEORIST AT THE
CALIFORNIA INSTITUTE OF TECHNOLOGY

HOBBIES: POLO, WATER POLO, ROCK CLIMBING, ANTAGONISM[1]
DISLIKES: SHELDON COOPER

INTERESTING FACT: ONCE POSTED HIGH-RESOLUTION PICTURES
OF HIS JUNK ON CRAIGSLIST[2]

Barry Kripke is the chief antagonist of anyone doing any work at Caltech. He's a geek like the rest of them, but somehow twice the misanthrope. Sheldon Cooper was dismayed to admit that Kripke was an excellent scientist whose work in some cases even exceeded his own.[3] Kripke's superior work is the only logical explanation for his continued employment, especially after playing pranks on coworkers[4] and having HR complaints filed against him.[5]

Barry's Pictorial Record

SMUG, ANTAGONIZING LOOK

HUNCHED SHOULDERS

GRAYING HAIR

1. (The Friendship Algorithm)
2. (The Beta Test Initiation)
3. (The Cooper/Kripke Inversion)
4. While Sheldon was doing an interview on NPR's *Science Friday* with Ira Flatow, Barry piped helium into Sheldon's office to make his voice pitch higher. (The Vengeance Formulation)
5. Barry was once told by HR, in writing, that he could not have his grad students do all his dirty jobs for him. (The Athenaeum Allocation)

The Kripke Rivalry Rundown

Barry Kripke's antagonism is legendary. He can have a rivalry with anyone (though mainly with Sheldon). Kripke's robot, the Krippler, fights MONTE, the robot designed by Howard, tearing it to shreds.

(THE KILLER ROBOT INSTABILITY)

When Sheldon needs access to the open science grid computer that Kripke controls, he tries to befriend Barry, with disastrous results.

(THE SHELDON ALGORITHM)

Kripke mocks Sheldon for having to retract the results of his North Pole experiment.

(THE ELECTRIC CAN OPENER FLUCTUATION)

When Sheldon is interviewed by Ira Flatow on NPR's *Science Friday*, Kripke pumps helium into the room to disrupt it.

(THE VENGEANCE FORMULATION)

Kripke and Sheldon fight over which of them gets Dr. Rothman's office after Rothman retires. They even go to President Siebert to mediate.

After Kripke refuses a match of Rock-Paper-Scissors-Lizard-Spock over the office, Sheldon challenges him to a duel. In an effort to find a level playing field for the two of them, they play a game of one-on-one basketball. When neither can score a basket, they decide on a free-throw contest instead. When that doesn't work, they end up seeing who can bounce the basketball highest. Sheldon wins.

(THE ROTHMAN DISINTEGRATION)

Kripke and Sheldon must work together on a grant proposal for a fusion reactor.

(THE COOPER/KRIPKE INVERSION)

When Professor Tupperman dies, a slot for tenure opens up. Kripke does battle with Sheldon, Leonard, and Raj for the slot.

(THE TENURE TURBULENCE)

Kripke shows up to taunt Sheldon, calling him his favorite superhero, "The Retractor." after Sheldon had to retract his paper on the discovery of a new super-heavy element.

(THE DISCOVERY DISSIPATION)

Kripke starts a fencing club that Leonard, Sheldon, Howard, and Raj join to get fit. Sheldon challenges Kripke to a duel after Kripke expresses interest in asking Amy out.

(THE PERSPIRATION IMPLEMENTATION)

When Leonard and Sheldon need helium to conduct an experiment, they ask Kripke for some since there's a shortage. Naturally, he says no.

(THE HELIUM INSUFFICENCY)

When Sheldon goes to work on a top-secret project without Howard and Leonard, the pair enlist Kripke to one-up Sheldon.

(THE TESLA RECOIL)

Sheldon and Amy pick the perfect venue for their wedding, but it's already been booked on their date by Kripke for his birthday party.

(THE ATHENAEUM ALLOCATION)

Kripke doesn't want to see Sheldon win a Nobel Prize, but he wants to see that fraud Dr. Pemberton win one even less.

(THE PLAGIARISM SCHISM)

Kripke prank calls Amy and Sheldon to tell them they've won the Nobel Prize ... in being suckers.

(THE CHANGE CONSTANT)

Get to Know Barry

He fights using robots because, in his own words, he's creepy, pathetic, and can't get girls.

(THE KILLER ROBOT INSTABILITY)

He's a "ginormous knob," according to Raj.

(THE FRIENDSHIP ALGORITHM)

Kripke doesn't think Penny is a very hot name, so decides to call her Roxanne.

(THE FRIENDSHIP ALGORITHM)

Told there will be a raffle, Kripke hangs out with Sheldon in apartment 4A.

(THE TOAST DERIVATION)

Kripke has no luck with Siri's voice-recognition functions.

(THE BETA TEST INITIATION)

Kripke hasn't watched *Star Trek* since discovering the strip club near his apartment has a free buffet.

(THE ROTHMAN DISINTEGRATION)

For reasons no one is quite sure of, Kripke is overly interested in Sheldon and Amy's sex life.

(THE COOPER/KRIPKE INVERSION)

After getting obsessed with a stripper, Kripke buys her a Prius.

(THE VALENTINO SUBMERGENCE)

Kripke thinks he's got a shot with Leonard's mother.

(THE CELEBRATION EXPERIMENTATION)

HR told Kripke, in writing, that he can't have his grad students do every dirty job for him.

(THE ATHENAEUM ALLOCATION)

Mary Cooper's God Particle

NAME: MARY COOPER

BORN: JANUARY 13, 1950

HOMETOWN: GALVESTON, TEXAS

OCCUPATION: CHURCH WORKER

CHILDREN: GEORGE, SHELDON, MISSY

Despite her extraordinary kindness and religious nature, Mary Cooper is, according to her son Sheldon, a "demented sex pervert."[1] Her conservative politics and anti-science religious beliefs were not impediments to raising a brilliant scientist like Sheldon, and she sacrificed everything she could to ensure he had the education a mind like his deserved.

Mary Cooper isn't above playing mother to all of Sheldon's friends and, in Leonard's case, is a better mother to him than his own. She loves unconditionally and can be vicious if necessary to protect those she loves.

Mary Cooper's Defining Characteristics

SUBJECT

Mary Cooper is a devout Born-Again Christian and mother. For all of her faults, she did the best she could raising a kid like Sheldon.

- **Brown hair**

- **Blue eyes**

- **Love for Jesus**

- **Floral print dress**

- **Mild Dr Pepper addiction**
 (THE PRECIOUS FRAGMENTATION)

1. (The Mommy Observation)

The Quotable Mary Cooper

Mary Cooper has a way with words and offers wisdom and wit in equal measure. Here's a look at Mary at her most quotable.

"It's a good thing you two decided to end the relationship so I didn't have to end it for you. You go to your room."—Mary Cooper, using reverse psychology on her son to bring him and Amy back together in "The Zazzy Substitution"

"It's okay to be smarter than everybody, but you can't go around pointing it out! Don't you remember the ass-kickings you got from the neighbor kids?"

(THE LUMINOUS FISH EFFECT)

"I remember one summer when [Sheldon] was thirteen, he built a small nuclear reactor in the shed and told everyone he was going to provide free electricity for the whole town. The only problem was he had no, no what-cha call 'em, fissionable materials. Anyway, he went on the internets to get some and a man from the government came by and sat him down real gentle and told him it's against the law to have yellow cake uranium in a shed."

(THE LUMINOUS FISH EFFECT)

"When we deceive for personal gain, we make Jesus cry."

(THE CLASSIFIED MATERIALS TURBULENCE)

"Well, you can't force things. You need to figure out if you're in a relationship or if you're just calling it one. It's like they said, 'A cat can have kittens in the oven, but that don't make 'em biscuits.'"

(THE RHINITIS REVELATION)

"Sheldon, you pester me one more time about chicken, I will put you over my knee right here in this restaurant."

(THE RHINITIS REVELATION)

"You take notes, darlin'. The real way to get a man is through melted cheese and cream of mushroom soup. He'll die at 50, but his love will be true."

(THE RHINITIS REVELATION)

When Amy, Penny, and Bernadette arrive in the laundry room and tell Sheldon they need something from him, he assumes it's sex, and says his mother used to say that's what happens to pretty boys in the big city.

(THE CLOSET RECONFIGURATION)

"When I was pregnant with Shelly, I was driving to church, and I was praying to the Lord to give me a son smarter than his dumb-ass daddy. And I looked over and I saw a Jesus bobblehead in the Subaru next to me nodding yes."

(THE MATERNAL COMBUSTION)

"Shelly, how do I put this? By your third birthday, you had memorized over a thousand different kinds of trains, and I never imagined a woman getting aboard any of them."

(THE RHINITIS REVELATION)

"Hon, you think maybe the reason you're havin' trouble findin' a guy to settle down with is because you're lettin' 'em ride the roller coaster without buyin' a ticket?"—Mary Cooper to Penny, in "The Rhinitis Revelation"

The Mary Cooper Trivialities

Gave birth to Sheldon in a Kmart.

(THE LUMINOUS FISH EFFECT)

Instead of the titanium centrifuge for separating radioactive isotopes that he'd requested, Mary Cooper gave Sheldon a motorized dirt bike for his twelfth birthday.

(THE PEANUT REACTION)

Smokes in the car, which Jesus is okay with.

(THE BAD FISH PARADIGM)

Hit Sheldon with a Bible when he didn't eat his Brussel sprouts.

(THE MATERNAL CAPACITANCE)

Believes in creationism.

(THE ELECTRIC CAN OPENER FLUCTUATION)

Believes Jesus would have forgiven her if she had put ground glass in her husband's meatloaf.

(THE GUITARIST AMPLIFICATION)

Likes cooking Italian food because, according to her, that's what the Romans made Jesus eat.

(THE SPAGHETTI CATALYST)

Taught Sheldon to recite the following while urinating: "Pee for Houston, pee for Austin, pee for the state my heart got lost in. And shake twice for Texas."

(THE PLIMPTON STIMULATION)

Requires Sheldon to go to church at least once a year.

(THE LUNAR EXCITATION)

Believes the Earth is only 6,000 years old.

(THE RHINITIS REVELATION)

Mary Cooper still sends Sheldon to his room.

(THE MOMMY OBSERVATION)

Has been there for every award Sheldon has won since he beat out his twin sister, Missy, for the "I did it on the potty" trophy.

(THE MATERNAL COMBUSTION)

She gets sweet on Leonard's dad, Alfred. They leave the pre-wedding dinner early to have a nightcap alone together. Everyone assumes they slept together, but they didn't.

(THE CONVERGENCE CONVERGENCE & THE CONJUGAL CONJECTURE)

The Anti-Maternal Hofstadter Particle

NAME: DR. BEVERLY HOFSTADTER

BORN: CIRCA 1956

HOME STATE: NEW JERSEY

OCCUPATION: PSYCHIATRIST, NEUROSCIENTIST, AUTHOR

CHILDREN: 3

MARITAL STATUS: DIVORCED

Dr. Beverly Hofstadter looks at the entire world as a potential science experiment. That didn't stop at motherhood, either. Each of her children, especially Leonard, was an experiment for her research. Leonard's childhood turned into a published tome called *The Disappointing Child*.

Beverly is much more at home speaking with Leonard's best friend Sheldon than she is with her own son. She even befriended Leonard's wife before giving him the approval he sought so much. Her unusual parenting philosophies wedged a barrier between her and her son and may well have contributed to his social awkwardness.

Dr. Beverly Hofstadter's Pictorial Record

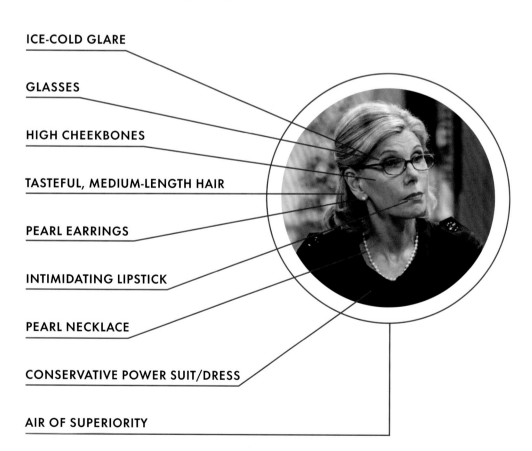

ICE-COLD GLARE

GLASSES

HIGH CHEEKBONES

TASTEFUL, MEDIUM-LENGTH HAIR

PEARL EARRINGS

INTIMIDATING LIPSTICK

PEARL NECKLACE

CONSERVATIVE POWER SUIT/DRESS

AIR OF SUPERIORITY

The Parenting Philosophy Phylum

Dr. Beverly Hofstadter is an unusual parent, approaching everything with an eye toward social science and psychology. This was the worst for Leonard.

Beverly didn't celebrate her children's birthdays. She only celebrated achievements, and passing through her birth canal was not considered an achievement. She published a paper on it.

(THE PEANUT REACTION)

While Leonard was potty-training, Beverly attached electrodes to his head.

(THE MATERNAL CAPACITANCE)

Holidays were not celebrated in the Hofstadter household, but instead studied for their anthropological and psychological implications for human society.

(THE MATERNAL CONGRUENCE)

For Christmas, the Hofstadter presented papers instead of presents, then broke off into focus groups for critique.

(THE MATERNAL CONGRUENCE)

Instead of leaving Santa milk and cookies, the kids in the Hofstadter house had to leave research papers. Santa would grade the papers. Leonard got a C– four years in a row.

(THE SANTA SIMULATION)

"It's a parent's job to make sure a child's self–esteem is not dependent on a parent's approval."

(THE MATERNAL COMBUSTION)

Beverly begrudgingly admits there's more than one way to raise a child.

(THE MATERNAL COMBUSTION)

According to Beverly, Leonard's childhood wasn't one big social experiment. It was an opportunity for thousands of small experiments.

(THE CONFERENCE VALUATION)

The Disappointing Child

SUBJECT

Dr. Beverly Hofstadter won awards for her book, THE DISAPPOINTING CHILD, written about her son, Leonard.

> **"Not that book . . . it's got, like, every horrible story from my childhood in it."**
> —Leonard, in "The Raiders Minimization"

> **"Even if you have kids, there's no guarantee you're going to like them. It's right off the dust jacket of my mom's last book."**—Leonard, in "The Shiny Trinket Maneuver"

The Disappointing Child by Beverly Hofstadter is on the recommended reading list for Penny's psychology class.

(THE RAIDERS MINIMIZATION)

The book contains chapters on potty training and bed-wetting. "Basically, if something came out of me, she wrote about it," says Leonard. There was a chapter on "The Breast Feeding Crisis."

> **Leonard:** "It was not a crisis. Apparently, I favored the left one, she got a little lopsided."
> **Penny:** "Oh my God! You still go left!"

(THE RAIDERS MINIMIZATION)

The book documents the time Leonard put on his mom's makeup and wore balloon boobies.

> **Leonard:** "They weren't boobies, they were muscles. And the makeup was green. I was pretending to be the Hulk."
> **Penny:** "You were wearing her bra."
> **Leonard:** "That was to keep my muscles from sagging, can we please stop talking about this?"

(THE RAIDERS MINIMIZATION)

Beverly Hofstadter documented a time when she staged an Easter Egg hunt with no eggs to see how long Leonard would keep looking for them.

(THE RAIDERS MINIMIZATION)

When Leonard was six years old, he walked in on his parents naked and saw his mother swatting his father's bottom with Leonard's Ping-Pong paddle. Beverly wrote about it in her book.

(THE RAIDERS MINIMIZATION)

Beverly Hofstadter Stats

Beverly suggests to Leonard that if he wants to sleep with Penny, he needs to find out what cologne her father wore.

(THE MATERNAL CAPACITANCE)

Beverly only had sex with Leonard's father for the purpose of reproduction. Both of Leonard's parents published papers on it.

(THE MATERNAL CAPACITANCE)

Beverly suggests that Howard's and Raj's fear of women is what caused the creation of their "ersatz homosexual marriage" to satisfy their need for intimacy.

(THE MATERNAL CAPACITANCE)

Beverly just likes scanning brains.

(THE MATERNAL CAPACITANCE)

After writing a paper disproving quantum brain dynamic theory, Beverly gets notes on it from Sheldon.

(THE MATERNAL CONGRUENCE)

In order to better understand her son, Beverly learned the verbal and facial tics Leonard displayed when lying from when he first started pleasuring himself.

(THE MATERNAL CONGRUENCE)

After discovering that her husband, Alfred, Leonard's father, was cheating on her with a waitress from the university cafeteria, Beverly Hofstadter gets divorced.

(THE MATERNAL CONGRUENCE)

Kissed Sheldon Cooper.

(THE MATERNAL CONGRUENCE)

Beverly appears via webcam to talk Leonard through the heartbreak he experiences after catching Penny with Raj. The most she can tell him is to "Buck up, sissy pants."

(THE SKANK REFLEX ANALYSIS)

Beverly has misgivings about Penny, but since Sheldon speaks fondly of her, that's good enough for Beverly.

(THE STATUS QUO COMBUSTION)

Beverly assures everyone that she would murder her son if Leonard let anything happen to Sheldon.

(THE MATERNAL CONGRUENCE)

She invites Sheldon to her 60th birthday party, but not Leonard.

(THE CELEBRATION EXPERIMENTATION)

At one point, Beverly takes up polyamory.

(THE PLAGIARISM SCHISM)

The Sibling Rivalry Relationship

NAME: PRIYA KOOTRAPPALI

OCCUPATION: CORPORATE LAWYER

HOMETOWN: NEW DELHI, INDIA

> **"That bitch is crafty."**—Amy on Priya, in "The Wildebeest Implementation"

It was a cool April day in 2005 when Priya Koothrappali first met her brother's friends, Sheldon, Howard, and Leonard at a Bob's Big Boy in Toluca Lake, California. That's when Howard and Leonard pinkie swore that neither would try to sleep with Raj's sister.[1] Leonard broke the pinkie swear and Priya found Leonard to be an available, if not ideal, sexual partner.

As a corporate lawyer with licenses to practice law in three countries, she travels around the world. When that brings her back into the orbit of her brother and his friends, she finds herself drawn to Leonard once more. Sexually.

She spends quite some time living in California, but her job eventually takes her back to India. She maintains a long-distance relationship with Leonard for a time, but then they break up.

As a child, she shared a room with Raj,[2] and some of Raj's more unusual eccentricities caused her and her family great shame.[3]

Priya's Defining Characteristics

SUBJECT

Priya Koothrappali is a beautiful, intelligent woman, and it's a wonder she ever saw anything in Leonard. As Raj's more successful sister, it's shocking she never helped her brother find a girlfriend.

> **"Smart, beautiful woman with the smoldering sexuality of a crouched Bengal tiger."**—Amy, in "The Cohabitation Formulation"

- **Too much makeup**[4]

- **Cunning smile**

- **Power suit**

- **Expensive watch**

- **Raven black hair**

- **Brown eyes**

FUN FACT:

Priya once dressed up as Lieutenant Uhura for Leonard.
In Raj's bedroom.
In her older brother's Uhura costume.
(THE ROOMMATE TRANSMOGRIFICATION)

1. (The Irish Pub Formation)
2. This is why she's intimately familiar with his masturbatory habits. (The Wildebeest Implementation)
3. Ibid.
4. According to Penny. (The Wildebeest Implementation)

President Siebert

NAME: DR. SIEBERT

OCCUPATION: PRESIDENT OF THE CALIFORNIA INSTITUTE OF TECHNOLOGY

EDUCATION: PHYSICIST WITH A DOCTORATE FROM INDIANA UNIVERSITY[5]

PETS: SEVERAL DOGS

WIFE: DEFINITELY

CHILDREN: A DAUGHTER

Dr. Siebert is an ambitious man, eager to keep money flowing into the coffers of the university. To that end, he'll do just about anything to promote, protect, or defend any scientist bringing good attention to the school.

If there's one thing he's annoyed by, it's Sheldon Cooper, but when Sheldon is up for a Nobel Prize, Siebert moves heaven and earth to make sure he gets whatever he needs. His hard work pays off, both for Caltech and for Amy and Sheldon.

Dr. Siebert's Defining Characteristics

SUBJECT

Dr. Siebert is the president of the California Institute of Technology. Don't let all of his blustering political maneuvering distract from the fact that he has a doctorate in physics, too.

- **Tailored suit**
- **Cheesy grin**
- **Glad-handing hands**

FUN FACTS:

President Siebert once sent Sheldon to the North Pole.

(THE MONOPOLAR EXPEDITION)

Siebert's wife sicced their dogs on Sheldon after he arrived to question her husband in the middle of the night.

(THE MONOPOLAR EXPEDITION)

He once forced the guys to fund-raise at a fancy party with donors. It went well until one of the donors insisted on trying to sleep with Leonard.

(THE BENEFACTOR FACTOR)

Siebert really doesn't like all the suggestion boxes Sheldon keeps installing in his office.

(THE VACATION SOLUTION)

Doesn't wash his hands in the bathroom.

(THE ROTHMAN DISINTEGRATION)

Tells Sheldon not to call him at home.

(THE PARKING SPOT ESCALATION)

Informs Sheldon that he has to remain in string theory, as that's why the university hired him.

(THE STATUS QUO COMBUSTION)

Has a private dining room for the VIPs of the university.

(THE PAINTBALL SCATTERING)

5. (The Planetarium Collision)

The Gentle Giant Formation

NAME: DR. BERTRAM "BERT" KIBBLER

FIELD OF STUDY: GEOLOGY

OCCUPATION: ON THE FACULTY OF THE CALIFORNIA INSTITUTE OF TECHNOLOGY

Dr. Bert Kibbler is a geologist at Caltech and might be the tallest and most gentle geologist on staff. His measured, lovable demeanor is something that everyone around him seems to enjoy, though Sheldon is put off by the fact that Bert is a geologist (even though Sheldon finds his work inspired).[1] He's always ready for a rock pun and will never take them for granite.

He won the MacArthur Fellowship Grant[2] which also annoys Sheldon[3] but not as much as the fact that Bert considers nominating Howard for the award as well.

Bert's Defining Characteristics

SUBJECT

Dr. Bert Kibbler is the tallest person on campus and can barely fit through doorways. Here's a look at his other unique attributes.

- **Bald head**
- **Untamed beard**
- **Untamed loneliness**
- **Thick glasses**
- **Gentle smile**
- **Khakis**
- **Rock puns at the ready**

1. (The Geology Methodology)
2. (The Geology Elevation)
3. Really, what makes a geologist worthy of a genius grant?

Bert's Timeline

THE CONTRACTUAL OBLIGATION IMPLEMENTATION

In Dr. Bert Kibbler's first appearance, he tells Raj's date, Lucy, that she can do better.

THE OCCUPATION RECALIBRATION

Bert hits on Amy regularly, bringing her shiny rocks every day.

THE DEPENDENCE TRANSCENDENCE

After hosting a party that only Amy and Penny attend, Bert sends them both away after they make a geology pun because he's in love with both of them.

THE GEOLOGY ELEVATION

Bert is awarded a MacArthur "genius grant" for his work in geology. Sheldon's not the happiest about it. Sheldon hurts himself trying to deal with his rage, even hurting his hand trying to Captain Kirk —chop Bert in the back.

Ellen DeGeneres tapes an episode of her show, while Sheldon and Dr. Bert Kibbler watch from the audience.

THE ALLOWANCE EVAPORATION

Sheldon and Amy meet Bert at a Mexican restaurant while they're on a date. He gets stood up, so Sheldon invites him to join them.

THE RECOLLECTION DISSIPATION

Bert calls in to the live *Fun with Flags* retrospective to let everyone know he has a girlfriend named Rebecca.

THE GEOLOGY METHODOLOGY

Bert asks Sheldon if he'll collaborate on a research project combining physics and geology. Sheldon, embarrassed about the geology aspect, agrees to help him, though he tries to keep it a secret. Sheldon insults him so much, Bert asks Leonard to help him instead.

THE SOLO OSCILLATION

Bert replaces Howard in the filk band, Footprints on the Moon. Howard eventually rejoins the band and the newly formed trio perform at a bar mitzvah, singing a song Bert wrote about the boulder that chases Indiana Jones.

THE WEDDING GIFT WORMHOLE

Bert helps Amy and Sheldon identify the substance Leonard and Penny's wedding gift is made of, since they think it's part of a scavenger hunt.

THE IMITATION PERTURBATION

Bert comes to Leonard's Halloween party dressed as a "famous" geologist.

THE METEORITE MANIFESTATION

Bert returns, asking Raj for help with a meteorite he found. It looks like there's an organic signature inside.

THE STOCKHOLM SYNDROME

Bert dog-sits Cinnamon while Raj goes to the Nobel Prize awards ceremony. Raj convinces him that Cinnamon will help him meet chicks.

THE
CELEBRITY
SITUATIONS

NAME: WIL WHEATON

BORN: JULY 29, 1972

HOBBIES: TABLETOP GAMES, *DUNGEONS & DRAGONS*, TORMENTING SHELDON COOPER[1]

BEST KNOWN FOR: PLAYING WESLEY CRUSHER ON *STAR TREK: THE NEXT GENERATION*, TAKING OVER THE ROLE OF PROFESSOR PROTON, HIS PIVOTAL PART IN *SERIAL APE-IST 2: MONKEY SEE, MONKEY KILL*

Wil Wheaton was Sheldon Cooper's idol until the 1995 Dixie Trek Convention. When the young *Star Trek* star was a no-show after Sheldon had waited in line for so long, he quickly found a spot on Sheldon's enemies list. The two of them didn't encounter each other again until a *Mystic Warlords of Ka'a* tournament at the Comic Center of Pasadena.[2] There, Wil Wheaton spun a fanciful (and false!) tale to Sheldon about having to skip the convention due to the unexpected death of his beloved Meemaw. All this was to lull Sheldon into throwing the final game of the tournament, resulting in Wheaton's win. This only serves to heighten Sheldon's rivalry with the *Star Trek* alum.

Feeling bad about their rivalry, Wil Wheaton eventually invited Sheldon to a party at his house and offered him a signed toy to make up for the wrongs he'd done him. At that point, the pair become friends and Wheaton enters the orbit of the friend group.

He's honored to be asked to officiate Sheldon's wedding to Amy, but is replaced at the last minute by *Star Wars* legend Mark Hamill.[3]

The Wheaton Pictorial Record

SUBJECT
Wil Wheaton is the most famous of the friends that spend time with Sheldon and the group.

SCRUFFY BEARD

SKEPTICAL LOOK

BIKINI **?**

GORILLA HANDS

RED FUR **?**

1. At least until they buried the hatchet. (The Russian Rocket Reaction)
2. (Creepy Candy Coated Corollary)
3. (The Bow Tie Asymmetry)

Wil Wheaton's Timeline

THE CREEPY CANDY COATED COROLLARY

Wil Wheaton's first appearance. He's signed up to play in a *Mystic Warlords of Ka'a* tournament alongside Stuart.

THE WHEATON RECURRENCE

Stuart brings Wil along as a substitute on his bowling team.

THE 21-SECOND EXCITATION

Wil arrives to see *Raiders of the Lost Ark* with 21 seconds restored to it and uses his celebrity status to get into the theater, ensuring Sheldon and crew won't get seats.

THE RUSSIAN ROCKET REACTION

Wil invites Sheldon and Leonard to a party at his house. There, he presents Sheldon with an action figure to replace the one he missed as a kid. Brent Spiner promptly arrives to tear open the package.

THE STAG CONVERGENCE

Wil shows up at Howard's bachelor party. It was either that or another hot tub party at George Takei's house.

THE HABITATION CONFIGURATION

Sheldon Cooper Presents: Fun with Flags has a guest star in Wil, who does an episode about the flags of *Star Trek*.

THE DISCOVERY DISSIPATION

Wil shows up at Sheldon's apartment to cheer him up after his depression over discovering the stable super-heavy element. Wil tells him about how he too has experience getting attention for something he wishes he never did: *Star Trek*. He stays to play trains with Sheldon.

THE INDECISION AMALGAMATION

Wil agrees to meet with Penny to give her career advice. Little do they know they've *both* taken a part in *Serial Ape-ist 2*.

THE GORILLA DISSOLUTION

Wil shares a scene with Penny on the set of *Serial Ape-ist 2*. The director doesn't care about the movie at all, and when called out on it, he fires Penny *and* Wil. Wil then quickly gets an audition for *Sharknado 2*.

THE FORTIFICATION IMPLEMENTATION

Wil shows up to interview Penny for his podcast so they can talk about *Serial Ape-ist 2*.

THE SPOCK RESONANCE

Wil brings Adam Nimoy to the apartment to interview Sheldon for a documentary about Leonard Nimoy.

THE OPENING NIGHT EXCITATION

After walking into the comic book store, Wil is immediately invited to see *The Force Awakens* with the guys after Sheldon has to bow out for Amy's birthday.

THE CELEBRATION EXPERIMENTATION

Wil shows up for Sheldon's birthday party. He toasts Sheldon, saying, "Sheldon, I know that we've had our ups and downs, but I can honestly say that my life is so much more interesting because you are in it. We may have met because you are a fan of *Star Trek*. But I have become a fan of Sheldon Cooper. Live long and prosper, buddy. And happy birthday."

(THE PROTON REGENERATION)

Wil gets the role of the new Professor Proton, replacing the deceased Arthur Jeffries and drawing the Sheldon's ire.

(THE NOVELIZATION CORRELATION)

The new *Professor Proton* show launches. Sheldon is surprised that he enjoys it, until Howard guest stars on the show. When Sheldon goes to apologize to Wil and asks to be on the show, Wil invites Amy to guest star instead.

(THE BOW TIE ASYMMETRY)

Wil is scheduled to officiate Amy and Sheldon's wedding, but is replaced at the last minute by Mark Hamill.

(THE D&D VORTEX)

Wil has Sheldon and Amy on the *Professor Proton* show to talk about their super-asymmetry paper. William Shatner is also on the show, but Sheldon barfs on him. When Sheldon goes to apologize to Wil, he discovers that Wil hosts a celebrity *D&D* game with Shatner, Joe Manganiello, Kevin Smith, and Kareem Abdul-Jabbar. Leonard gets an invite, but blows it by telling Penny. Penny ends up wangling an invite to the game for herself, Amy, and Bernadette.

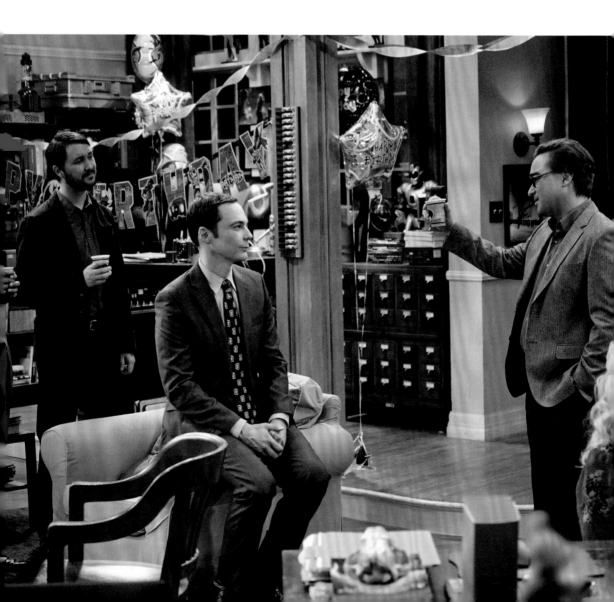

Wil Wheaton's Greatest Rivalries

Sheldon Cooper at the card tournament.
(THE CREEPY CANDY COATED COROLLARY)

Sheldon Cooper at the bowling alley.
(THE WHEATON RECURRENCE)

Sheldon Cooper at the movie theater.
(THE RAIDERS MINIMIZATION)

Amy, who keeps cutting him off as he records *Fun with Flags*.
(THE HABITATION CONFIGURATION)

Sheldon Cooper, drunk on two Long Island iced teas, goes to confront Wil for insulting Amy. He ends up just puking in Wil Wheaton's shrubs.
(THE HABITATION CONFIGURATION)

The director of *Serial Ape-ist 2* after he fires Wil for speaking up.
(THE GORILLA DISSOLUTION)

Kevin Smith, who threatens to beat Wil up on the air after inviting Penny to audition for *Clerks 3.* "I don't have a part for you, Wheaton!"
(THE FORTIFICATION IMPLEMENTATION)

The audience in the theater for *The Force Awakens* when Wil shows up to the premiere dressed as Mr. Spock and tells them to "Live long and suck it."
(THE OPENING NIGHT EXCITATION)

Sheldon Cooper, for Wil getting the part of Professor Proton.
(THE PROTON REGENERATION)

Sheldon Cooper and his attempts to get onto the new *Professor Proton* show.
(THE NOVELIZATION CORRELATION)

Sheldon and the guys trying to get a spot at Wil's celebrity *Dungeons & Dragons* night.
(THE D&D VORTEX)

The Sci-Fi Connection

SUBJECT

With an actor from STAR TREK around, references to the long-running science fiction media franchise were going to be commonplace.

Sheldon screams "Wheatonnnnn!" like William Shatner screams Khaaaaaaan! in *Star Trek II: The Wrath of Khan* (1982).
(THE CREEPY CANDY COATED COROLLARY)

As he's bowling against Wil, Sheldon performs a Vulcan mind meld with his bowling ball.
(THE WHEATON RECURRENCE)

Sheldon renames the bowling team "The Wesley Crushers."
(THE WHEATON RECURRENCE)

When Wil cuts in line at the movie theater, Sheldon quotes Jean-Luc Picard's most epic line: "The line must be drawn here! This far, no farther!"
(THE RAIDERS MINIMIZATION)

Wil tries to explain the flag of the United Federation of Planets.
(THE COHABITATION CONFIGURATION)

Wil's house number is 1701, a nod to the *USS Enterprise*'s serial number, NCC-1701-D.
(THE COHABITATION CONFIGURATION)

Wil shows up to the premiere of *The Force Awakens* dressed as Mr. Spock.
(THE OPENING NIGHT EXCITATION)

While playing *D&D* with Wil, William Shatner says he's going to go *Wrath of Khan* on the ogres.
(THE D&D VORTEX)

The Hawking Theorem

NAME: STEPHEN HAWKING

BORN: JANUARY 8, 1942

DIED: MARCH 14, 2018

OCCUPATION: THEORETICAL PHYSICIST

NICKNAMES: WHEELS, ROLLING THUNDER, HAWKMAN

"He's the wheelchair dude who invented time."—Penny, in "The Hawking Excitation"

Stephen Hawking was a legendary British physicist and former visiting professor at Caltech. The suthor of *A Brief History of Time*, Hawking was a hero to the guys, and to Sheldon Cooper in particular. Though most know Hawking as a brilliant mind, scientific theorist, and author, few knew what a sense of humor he had. He played elaborate pranks on Sheldon and Leonard, trolling them[1] for a paper they wrote. He liked the paper just fine and even found it intriguing, but having a laugh at their expense made him happy.

He's an amiable fellow and found his life intertwined with Sheldon Cooper's (and those of Sheldon's friends) in interesting ways.

Hawking passed away just over a year before he could see Sheldon and Amy win their Nobel Prize in Physics, an honor he was never able to achieve in his own life. On the other hand, he did get to make guest appearances on *Star Trek* and *The Simpsons*, which he felt were excellent places to recognize his genius.

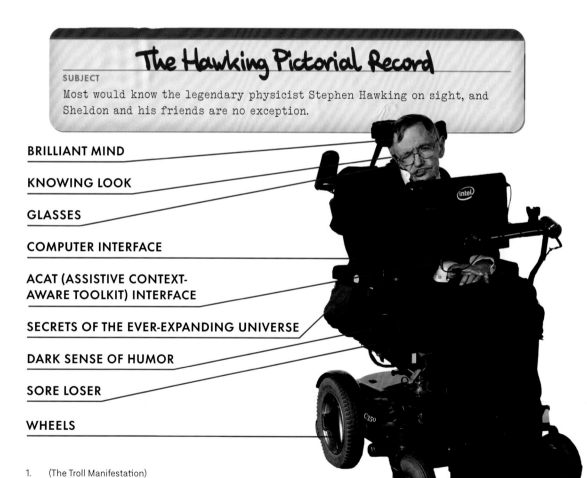

The Hawking Pictorial Record

SUBJECT

Most would know the legendary physicist Stephen Hawking on sight, and Sheldon and his friends are no exception.

BRILLIANT MIND

KNOWING LOOK

GLASSES

COMPUTER INTERFACE

ACAT (ASSISTIVE CONTEXT-AWARE TOOLKIT) INTERFACE

SECRETS OF THE EVER-EXPANDING UNIVERSE

DARK SENSE OF HUMOR

SORE LOSER

WHEELS

1. (The Troll Manifestation)

Stephen Hawking's Timeline

Stephen Hawking's first appearance. He contacts Howard's office about help with his wheelchair. Caltech designed his original wheelchair, making Howard a logical choice for help.

When Sheldon was 6 years old, he dressed up as Stephen Hawking for Halloween. He got his dad's desk chair, attached a Speak & Spell to it, and made his sister push him up and down the block. Everyone thought he was R2-D2.

Sheldon begs to meet Hawking, but Howard won't relent. Instead, he offers to show Hawking Sheldon's paper on the Higgs boson particle and says Hawking will reach out to Sheldon if he reaches the same conclusion Sheldon has.

THE HAWKING EXCITATION

In exchange for this favor, Sheldon must do a number of tasks for Howard, including cleaning all of his belt buckles, arriving at the school cafeteria in a French maid outfit, doing Howard's laundry, taking Howard's mom dress shopping, and giving Howard a compliment about his engineering work.

Howard brings home leftover pieces of Hawking's wheelchair as souvenirs.

Hawking is impressed by Sheldon's paper and wants to meet him, but only to tell Sheldon his math and conclusions are wrong. After realizing his mistake, Sheldon faints.

Sheldon: "It's an honor and a privilege to meet you, sir."
Hawking: "I know."

Sheldon challenges Hawking to a game of Words With Friends and the famous scientist accepts.

Sheldon asks Hawking if he can call him "Wheels," but Hawking isn't okay with that. He agrees to be referred to as "Rolling Thunder."

THE EXTRACT OBLITERATION

Sheldon humiliates Hawking at Words With Friends and Hawking stops playing for a few days. Howard explains that it's because Hawking is a sore loser and a big baby. "Forget the wheelchair. He should be in a stroller."

On the fourth day, Sheldon tries using a Jedi mind trick to get Hawking to resume the game.

"What do Sheldon Cooper and a black hole have in common? They both suck."—**Stephen Hawking,** in "The Extract Obliteration"

THE RELATIONSHIP DIREMPTION

Sheldon gets drunk and leaves a number of inebriated messages on Hawking's voice mail:

"Hawkman! It's your old buddy, Sheldonoscopy!"

"It's me again. I gave up string theory. You should give up black holes, and we can totally solve crimes together!"

"You know what's great? Geology. Oh! Look at this geode. That's fun to say. Gee-ode. Gee-ode . . ."

"Geeee-oooode . . . Geeee-ooooode! I kiss girls now."

"Are you mad at me? Oh no, you're mad at me. I'm so sorry!"

"Thiospinel sulfide. Thiospinel sulfide. That's even more fun than geeeee-ode . . . Hey, did you see *The LEGO Movie*?"

Hawking's response? "What a jackass."

THE TROLL MANIFESTATION

After publishing their paper on the idea that space-time could be viewed as a superfluid, Sheldon and Leonard are trolled online. They confront the online troll, only to discover that it Hawking, who really liked their paper and found the hypothesis intriguing— he just gets bored and needs to troll guys like them.

THE CELEBRATION EXPERIMENTATION

Hawking calls Sheldon via Skype to sing "Happy Birthday" to him.

Howard unveils his remote-control miniature Stephen Hawking. It talks and its eyes light up in the dark. Bernadette finds it offensive and insists that Howard call Hawking to ask him if it *is* offensive.

THE GEOLOGY ELEVATION

Hawking calls Sheldon to help talk him through his professional jealousy of Dr. Bert Kibbler. He tells Sheldon not to waste his time on jealousy, he's too brilliant. He also says the thing that gets him through not having a Nobel Prize is the knowledge that he was on *Star Trek* and *The Simpsons*.

THE PROPOSAL PROPOSAL

Sheldon goes to Stephen Hawking to ask for his blessing to marry Amy. "I think you should make her finger like Saturn, and put a ring on it," the superstar physicist tells him.

Best Cameos

SUBJECT

One of the best things about living in the greater Los Angeles area of Pasadena is the opportunity to run into all sorts of celebrities. Sheldon, Leonard, and the rest of the crew that hangs out in apartment 4A find no shortage of interesting people to meet and interact with. Sometimes, these celebrities are playing themselves, sometimes they're but players playing parts in the world of THE BIG BANG THEORY, but whichever it is, they fit right in with Sheldon's crew.

James Hong, the legendary character actor who starred in everything from *Big Trouble in Little China* (1986) and *Blade Runner* (1982) to *Kung-Fu Panda* (2008) and *Kung Fu* (1972), plays Chen, the owner of the Chinese restaurant the group frequents.

(THE DUMPLING PARADOX)

Charlie Sheen, *Platoon* (1986), taunts Raj about not being on the cover of *People* magazine.

(THE GRIFFIN EQUIVALENCY)

Octavia Spencer, who won an Academy Award for her work in *The Help* (2011) and a nomination for playing mathematician Dorothy Vaughn in *Hidden Figures* (2016), works at the DMV where Sheldon takes his driving test.

(THE EUCLID ALTERNATIVE)

Michael Trucco , who played Anders on *Battlestar Galactica* (2004), is Dave Underhill, a competing physicist working in the lab who just won a MacArthur "genius grant." He's also Penny's ex-boyfriend.

(THE BATH ITEM GIFT HYPOTHESIS)

Summer Glau, of *Firefly* (2002), and *Terminator: The Sarah Connor Chronicles* (2008), is harassed by Raj, Howard, and Leonard on the train to San Francisco.

(THE TERMINATOR DECOUPLING)

George Smoot, American astrophysicist and cosmologist who won the Nobel Prize in Physics in 2006, blows Sheldon off, asking if Dr. Cooper was smoking crack.

(THE TERMINATOR DECOUPLING)

Comedian Lewis Black plays Professor Crawley, a world-renowned entomologist sent packing by the university.

(THE JIMINY CONJECTURE)

Ira Flatow, host of NPR's *Science Friday*, audibly appears as himself to interview Sheldon. The whole thing goes awry when Barry Kripke pumps helium into Sheldon's office during the recording.

(THE VENGEANCE FORMULATION)

Katee Sackhoff from *Battlestar Galactica* (2004) and *The Mandalorian* (2019) stars in Howard's fantasy.

(THE VENGEANCE FORMULATION)

Danica McKellar, of *Wonder Years* (1988) fame and a mathematician in her own right, played Abby, Raj's date for a night.

(THE PSYCHIC VORTEX)

Yeardley Smith, the voice of Lisa Simpson, appears as Sandy, the "Menial Employee of the Month" at Los Angeles County, where Sheldon applies for a menial job so as to activate his frontal cortex to unravel a physics mystery.

(THE EINSTEIN APPROXIMATION)

Stan Lee appears as himself. He has a signing at the comic book store that Sheldon misses because he's in jail. Penny extorts his address out of Stuart and takes Sheldon to meet Stan Lee, who answers the door in silk Fantastic Four pajamas and promptly calls the police and files a restraining order against Sheldon.

(THE EXCELSIOR ACQUISITION)

Esteemed character actress Judy Greer, of *Ant-Man* (2015) and *Halloween Kills* (2021), plays Dr. Elizabeth Plimpton, a world-renowned physicist and nymphomaniac.

(THE PLIMPTON STIMULATION)

Steven Yeun, of *Walking Dead* (2010) fame, plays Sebastian, Sheldon's deranged former roommate who warns Leonard to run as he goes to

tour apartment 4A for the first time.

(THE STAIRCASE IMPLEMENTATION)

Engineer and Apple cofounder Steve Wozniak plays himself. Wozniak is Sheldon's 15th favorite technological visionary, six spots above Steve Jobs.

(THE CRUCIFEROUS VEGETABLE AMPLIFICATION)

Katee Sackhoff reprises her role as the woman of Howard's dreams, this time appearing in his bed in a *Battlestar Galactica* flight suit.

(THE HOT TROLL DEVIATION)

George Takei, Lieutenent Sulu in the original *Star Trek* (1966), appears in Howard's fantasy with Katee Sackhoff, offering to help clear up Howard's confusion in bed.

(THE HOT TROLL DEVIATION)

Renowned astrophysicist Neil deGrasse Tyson from the Hayden Planetarium in New York comes to visit Raj at Caltech. When he and Sheldon are introduced, Sheldon insults him for demoting Pluto.

(THE APOLOGY INSUFFICIENCY)

Keith Carradine from *Nashville* (1975) and *Deadwood* (2004) portrays Wyatt, Penny's father, who desperately wants her to get back together with Leonard.

(THE BOYFRIEND COMPLEXITY)

Jessica Walter, of *Arrested Development* (2003) and *Play Misty For Me* (1971) fame, plays Mrs. Latham, a wealthy donor who finds it hilarious to make smart people feel ill at ease. She offers to fund the physics lab, but wants to sleep with Leonard in return. Naturally, Leonard "takes one for the team."

(THE BENEFACTOR FACTOR)

LeVar Burton, Lieutenant Geordi La Forge from *Star Trek: The Next Generation* (1987), comes to Sheldon's apartment after Sheldon invites him via Twitter. He arrives to find Stuart, Kripke, and Zack singing "Walking on Sunshine" and leaves immediately.

(THE TOAST DERIVATION)

Brian Greene, renowned theoretical physicist, appears on the show to hawk his new book *The Hidden Reality* and talk about his ability to make science more accessible to the masses. Sheldon disapproves.

(THE HERB GARDEN GERMINATION)

Lieutenant Commander Data himself, Brent Spiner, attends a party at Wil Wheaton's house. He promptly destroys a mint-in-box action figure Wil had given Sheldon, earning him a spot on Sheldon's mortal enemies list. Leonard then buys two Data action figures from him for $30 and a promise that he'll come to Leonard's birthday party.

(THE RUSSIAN ROCKET REACTION)

Jimmy Speckerman, Leonard's high school bully, is played by Lance Barber, who went on to play Sheldon's dad on *Young Sheldon*.

(THE SPECKERMAN RECURRENCE)

Becky O'Donohue played the voice of Siri. She was a semifinalist on the fifth season of *American Idol* and was Raj's fantasy idea of the digital personal assistant.

(THE BETA TEST INITIATION)

Dr. Mike "Mass" Massimino, real-life astronaut and mechanical engineer, appears as himself by video phone to talk to Howard Wolowitz about his impending trip to the International Space Station. His mom's interruption of the call gets Howard the nickname "Froot Loops."

(THE FRIENDSHIP CONTRACTION)

Leonard Nimoy, Mr. Spock from the original *Star Trek* (1966), appears as the voice of Sheldon's Mego Spock, who comes to him in a dream to convince him to open his mint-in-box 1975 Mego *Star Trek* transporter. Sheldon does so and promptly breaks it.

(THE TRANSPORTER MALFUNCTION)

Dr. Mike "Mass" Massimino appears again, accompanying Howard into space aboard a Russian rocket.

**(THE COUNTDOWN REFLECTION &
THE DECOUPLING FLUCTUATION)**

Comedian Howie Mandel, (who was the voice of Gizmo in *Gremlins* (1984) and a number of the *Muppet Babies* (1984), plays himself, arriving at the airport side-by-side with Howard on his way home from the International Space Station. Howard thinks the press and paparazzi

at the airport are there for him, but they're really for Howie Mandel.

(THE RE-ENTRY MINIMIZATION)

Astronaut Buzz Aldrin appears in the Halloween episode as himself. Raj sends Howard a video of Aldrin handing out Milky Way candybars to kids, telling them all he went to space. He never stops telling people he's been to space, just like Howard.

(THE HOLOGRAPHIC EXCITATION)

LeVar Burton shows up at the apartment to be a guest star on *Fun with Flags*, where he talks about the flags of *Star Trek* with Sheldon.

(THE HABITATION CONFIGURATION)

Comedian Brian Posehn makes his first appearance as Dr. Bert Kibbler, a geologist at Caltech. He tells Raj's date, Lucy, she can do better.

(THE CONTRACTUAL OBLIGATION IMPLEMENTATION)

Bob Newhart, *Newhart* (1982), *The Rescuers* (1977), and *Elf* (2003), appears as the washed-up children's science show host Arthur Jeffries, who played "Professor Proton." Leonard and Sheldon hire him to come hang out at their house. His pacemaker gives out when Leonard and Sheldon tell him how much he means to them.

(THE PROTON RESURGENCE)

Bob Newhart reprises his role as Professor Proton. He meets Amy and finds out they wear the same orthopedic shoes. He emails Leonard asking if he'd take a look at his paper on nano vacuum tubes. This causes a lot of jealousy in Sheldon. He continues hitting on Penny, asking her if she has any single grandmothers.

(THE PROTON DISPLACEMENT)

After Sheldon gets jealous of Leonard and his relationship with Professor Proton, he calls in the big guns and gets Bill Nye the Science Guy to hang out with him as payback. Sheldon introduces himself to Professor Proton, who reveals he tried to sue Bill Nye for stealing his schtick. Bill Nye quickly gets a restraining order against Sheldon.

(THE PROTON DISPLACEMENT)

Ira Flatow appears in person to talk Sheldon Cooper about his discovery of the first stable super-heavy element. Sheldon blows up at him and rage-quits the interview Flatow has Sheldon and Leonard on his show again later after, Leonard disproves Sheldon's theory.

(THE DISCOVERY DISSIPATION)

Josh Peck from *Drake & Josh* (2004) plays Jesse, the owner of Capital Comics, Stuart's main competition. He's mean and Bernadette yells at him.

(THE OCCUPATION RECALIBRATION)

When James Earl Jones, the voice of Darth Vader, tweets that he'll be eating sushi at his favorite sushi place, Kaiju Sushi, Sheldon meets him there in an effort to recruit him to be a guest at the comic book convention he's organizing. He asks Sheldon to join him for dinner and nerd out about *Star Wars* with him. They go out for ice cream, on a Ferris wheel, to a strip club, to a sauna, and to karaoke. They doorbell ditch Carrie Fisher. James Earl Jones then invites them to go to Comic-Con with him.

(THE CONVENTION CONUNDRUM)

Carrie Fisher answers the door with a bat, ready to use it on James Earl Jones for doorbell ditching her.

(THE CONVENTION CONUNDRUM)

Dr. Mike "Mass" Massimino appears again, this time to talk Howard out of going back to space.

(THE TABLE POLARIZATION)

Bob Newhart reprises his role as Professor Proton, who passes away in this episode. Sheldon watches old YouTube videos of his show. He appears to Sheldon in a dream as his "Obi-Wan Kenobi" and then as a Force ghost in full Jedi robes. He wields Kenobi's lightsaber from *The Phantom Menace*. They meet on Dagobah.

(THE PROTON TRANSMOGRIFICATION)

Comedy legend Stephen Root of *Office Space* (1999) appears as Dan the man, in charge of hiring sales reps at Bernadette's pharmaceutical company. He interviews Penny for the role. He's not impressed by her, but reveals he *also* terrified of Bernadette. He hires Penny on the spot.

(THE LOCOMOTION INTERRUPTION)

Dr. Mike "Mass" Massimino joins his buddy "Froot Loops" via Skype, giving Howard advice

about throwing out a pitch at an Angels game: "Don't do it. There's no upside. If you do well, no one cares. And if you screw up, you're an idiot on YouTube forever."

(THE FIRST PITCH INSUFFICIENCY)

Oscar winner Billy Bob Thornton appears as Dr. Oliver Lorvis, who becomes infatuated with Penny after a sales call. Lorvis is a urologist to the stars and a major nerd collector. He brings the guys to his "Fortress of Solitude" and they find it to be heaven, even though he locks them in their as his prisoners.

(THE MISINTERPRETATION AGITATION)

Stephen Root returns for the Zangen company party. He drinks red wine with Bernadette and Penny, his fear of Bernadette on full display.

(THE CHAMPAGNE REFLECTION)

LeVar Burton shows up to appear on *Fun with Flags* again, on the condition that Sheldon deletes all of his contact information. When Sheldon decides *Fun with Flags* can come back, he goes to Burton's house to see if he'd like to appear on the next show.

(THE CHAMPAGNE REFLECTION)

Nathan Fillion, Captain Mal Reynolds from *Firefly* (2002), is accosted by Raj and Leonard in a deli where they argue with him about whether he's actually Nathan Fillion. He takes

an unenthusiastic picture with them.

(COMIC BOOK STORE REGENERATION)

Kevin Smith makes a voice cameo on Wil Wheaton's podcast and offers to let Penny read for *Clerks 3*.

(THE FORTIFICATION IMPLEMENTATION)

Keith Carradine reprises his role as Penny's father, Wyatt. Penny calls to tell him that she and Leonard got married and he breaks the news to her that he backed over and killed her pet pig, Moondance.

(THE BACHELOR PARTY CORROSION)

Michael Rappaport, of *Deep Blue Sea* (1999) and *Cop Land* (1997), plays Kenny, the guy willing to sell liquid helium to Leonard and Sheldon when they're trying to complete an experiment before the Swedes do.

(THE HELIUM INSUFFICIENCY)

Adam Nimoy, son of Leonard Nimoy, interviews Sheldon for a documentary on his father. Sheldon calls it a "Spockumentary."

(THE SPOCK RESONANCE)

British comedian Stephen Merchant, of *Extras* (2005) and *Logan* (2017), appears as David Gibbs, a math teacher who's dating Amy but obsessed with Sheldon.

(THE MYSTERY DATE OBSERVATION)

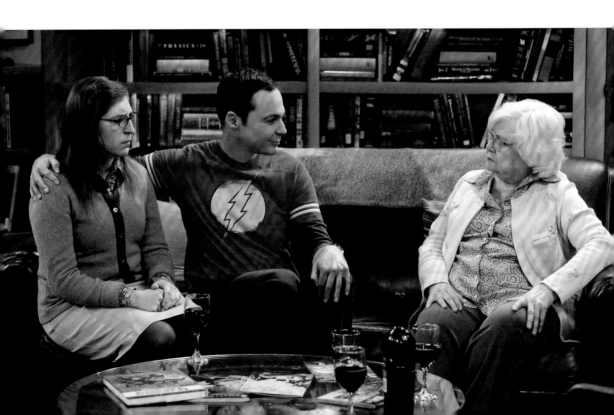

When Howard, Bernadette, Raj, and Emily volunteer at a soup kitchen for Thanksgiving, Howard ends up washing dishes with billionaire Elon Musk. Musk was on the turkey line, but got demoted for being too generous with the gravy. Howard and Musk split a piece of half-eaten pumpkin pie.

(THE PLATONIC PERMUTATION)

Amy calls Stephen Merchant's Dave to ask him on another date.

(THE EARWORM REVERBERATION)

Bob Newhart returns as the Force ghost of Arthur Jeffries. He tries to kill himself with his lightsaber when Sheldon asks for advice about having coitus with Amy.

(THE OPENING NIGHT EXCITATION)

Jane Kaczmarek, best known for her role on *Malcom in the Middle* (2000), plays Dr. Gallo, a psychiatrist Leonard sees in order to help Penny land a sale. She's read *all* of Dr. Beverly Hofstadter's work.

(THE SALES CALL SUBLIMATION)

Academy Award-nominated character actress June Squibb, of *Nebraska* (2013), *About Schmidt* (2003) *and Scent of a Woman* (1992), plays Sheldon's Meemaw and visits her grandson for a single episode.

(THE MEEMAW MATERIALIZATION)

Batman actor Adam West is easily convinced to come to Sheldon's birthday party and promptly gets into an argument with the guys about the best modern Batman, saying "Even my poodles know Bale's overrated."

(THE CELEBRATION EXPERIMENTATION)

Actor Judd Hirsch, of *Taxi* (1978) and *Independence Day* (1997), shows up as Leonard's father, Alfred Hofstadter, to attend Leonard and Penny's wedding.

(THE CONVERGENCE CONVERGENCE)

The season 10 premiere is chock-full of cameos. Judd Hirsch reprises his role as Alfred Hofstadter, who everyone assumes has now slept with Mary Cooper. Dean Norris, of *Breaking Bad* (2008) and *Terminator 2: Judgment Day* (1991), appears as Colonel Richard Williams to talk to Howard about his invention. Katey

Sagal of *Married . . . With Children* (1987) and *Futurama* (1999), plays Penny's mom alongside Keith Carradine, returning as her father. Jack McBrayer from *30 Rock* (2006) and *Wreck-It Ralph* (2012) plays Randall, Penny's drug-addicted ex-con of a brother.

(THE CONJUGAL CONJECTURE)

Television host and comedian Ellen DeGeneres tapes an episode of her show, while Sheldon and Brian Posehn's Dr. Bert Kibbler watch from the audience.

(THE GEOLOGY ELEVATION)

Christopher Lloyd, of *Back to the Future* (1985) and *Who Framed Roger Rabbit?* (1988), plays Theodore, a crazy old man who Sheldon rents his room to in order to get back at Leonard.

(THE PROPERTY DIVISION COLLISION)

Dean Norris's Colonel Richard Williams comes back to check in on Howard and Leonard's progress, but wants a new prototype theorized by Sheldon, "the kid with two shirts."

(THE EMOTION DETECTION AUTOMATION)

Dean Norris's Colonel Richard Williams breaks it to Sheldon, Howard, and Leonard that the military is taking all their research and their prototype of the quantum gyroscope, leaving them with nothing.

(THE GYROSCOPIC COLLAPSE)

George Wyner, the legendary character actor best known for his turn as Colonel Sanders in *Spaceballs* (1987), shows up as Dr. Zane, one of Amy's research colleagues at Princeton.

(THE PROPOSAL PROPOSAL)

NPR *Science Friday*'s Ira Flatow returns, this time to interview Leonard, who's supposed to talk up Caltech's physics department on the radio. Leonard doesn't do well and may well have cost the university a bunch of money.

(THE PROPOSAL PROPOSAL)

The crew goes to the grave of renowned physicist Richard Feynman for inspiration. Sheldon vomits Romulan ale all over Feynman's grave and Leonard sends an inappropriate email about how great the study of physics is to the dean of the school.

(THE RETRACTION REACTION)

Bob Newhart returns as the Force ghost of Arthur Jeffries/*Professor Proton*. He's unable to offer Sheldon any comfort after Wil Wheaton is cast as the new Professor Proton.

(THE PROTON REGENERATION)

Microsoft billionaire Bill Gates appears as himself to meet Penny. She's to show him around her workplace and forbids the guys from interfering. Leonard, Raj, and Howard stake out Gates's hotel in order to meet him.

(THE GATES EXCITATION)

Peter MacNicol, best known for his roles in *Dragonslayer* (1981), *Ghostbusters II* (1989), and *24* (2007), plays Dr. Robert Wolcott. Wolcott is a reclusive topologist who invites Sheldon to discuss physics in his secluded cabin. Sheldon brings Leonard, Howard, and Raj, which poses a problem for the reclusive scientist.

(THE RECLUSIVE POTENTIAL)

Comics superstar Neil Gaiman comes into the comic book store and Stuart doesn't even notice him. That doesn't stop Gaiman from writing a lovely review of the store and recommending his comics to people who have no idea who he is.

(THE COMET POLARIZATION)

Jerry O'Connell, Wil Wheaton's costar in *Stand By Me* (1986), guest stars as Sheldon's brother, George "Dr. Tire" Cooper. George has no interest in being friendly with his brother or attending Sheldon's wedding. The two of them reconcile their differences and George decides to come to the wedding.

(THE SIBLING REALIGNMENT)

Kathy Bates, of *Misery* (1990) and *Delores Claiborne* (2002), and the infamous magician Teller (of Penn & Teller) guest star as Amy's parents, in town for the wedding. Jerry O'Connell's George Cooper and Brian Posehn's Dr. Bert Kibbler come for the wedding as well.

(THE BOW TIE ASYMMETRY)

Mark Hamill, the legend who portrayed Luke Skywalker, loses his dog, Bark Hamill. Howard finds the dog and returns it. As a reward, Howard convinces Hamill to officiate Amy and Sheldon's wedding, replacing Wil Wheaton in the role.

(THE BOW TIE ASYMMETRY)

Teller returns as Amy's father, Larry, suspiciously staying in Amy and Sheldon's apartment. Kathy Bates joins him as Amy's mom, looking for Larry.

(THE CONJUGAL CONFIGURATION)

Neil deGrasse Tyson appears as himself once more to get into a Twitter beef with Raj after Raj takes some cheap shots at him on the local news. When Raj refuses to meet his challenge, Tyson calls up Bill Nye the Science Guy to challenge him, but Bill Nye hangs up immediately.

(THE CONJUGAL CONFIGURATION)

Keith Carradine comes back as Wyatt, Penny's father, to scold her for not wanting to have kids.

(THE PROCREATION CALCULATION)

Jerry O'Connell appears as George Cooper again via Skype to tell Leonard and the guys about Sheldon's ex–best friend, Tam Nguyen.

(THE TAM TURBULENCE)

Sheldon summons Bob Newhart's Arthur Jeffries to a diner in his dreams.

(THE PLANETARIUM COLLISION)

Sheldon asks Amy's father, played by Teller, to come by and hang out with him so he can get closer to her family. Sheldon brings Teller to the comic book store, where Howard, ironically, does magic for him and then teaches him magic as though he's an imbecile. When Amy's father wants to just hang out with Howard instead of Sheldon, Sheldon goes to bond with Amy's mother (Kathy Bates).

(THE CONSUMMATION DEVIATION)

Sean Astin, of *The Goonies* (1985), and the *Lord of the Rings* trilogy (2001-2003), and Kal Penn, of *Harold & Kumar Go to White Castle* (2004), guest star as Dr. Pemberton and Dr. Campbell, respectively, visiting scientists from Chicago. They confirm Amy and Sheldon's theory of super-asymmetry. They go on a PR tour to steal their Nobel Prize.

(THE CONFIRMATION POLARIZATION)

Keith Carradine returns as Penny's dad, Wyatt, to help her and Leonard work on their issues over Leonard's impending sperm donation to Zack.

(THE DONATION OSCILLATION)

Captain Kirk himself, William Shatner, guest stars on Wil Wheaton's *Professor Proton* show to surprise Sheldon and Amy. Sheldon is so excited and nervous, he vomits on Shatner. Wil also hosts a celebrity *D&D* game that he invites Leonard to play in. Other players include Shatner, Kevin Smith (director of *Clerks,* 1994), Joe Manganiello (*True Blood,* 2010), and Kareem Abdul-Jabbar (*Game of Death*, 1978). Then, Amy, Penny, and Bernadette wangle an invite to play in the game.

(THE D&D VORTEX)

Sean Astin and Kal Penn return as Drs. Pemberton and Campbell. They guest star on *Ellen* to try to campaign for Sheldon's Nobel Prize. The university invites Nobel Laureates to campaign for Amy and Sheldon. Amy and Sheldon send cookies to Professors George Smoot, Frances H. Arnold, and Kip Thorne, who promptly throw them in the trash.

(THE LAUREATE ACCUMULATION)

Sean Astin and Kal Penn come back as Drs. Pemberton and Campbell, hoping to broker a peace treaty between Sheldon and Amy. Amy and Sheldon bring proof of Pemberton's college plagiarism and Campbell ends up burying his partner with it, so the remaining scientists can win the Nobel together.

(THE PLAGIARISM SCHISM)

Buffy the Vampire Slayer (1997) star Sarah Michelle Gellar, playing herself, is on Raj's flight to Sweden. Raj convinces her to be his date to the Nobel award ceremony.

(THE STOCKHOLM SYNDROME)

The RPG Vortex

SUBJECT

Wil Wheaton runs a celebrity game of DUNGEONS & DRAGONS at his house every week and has a number of notable players. There's one slot, though, that he always seems to have trouble filling. First, he has Stuart sit in. Then Leonard. But they don't work out and they blab about the game. Finally, in order to annoy Sheldon, Leonard, Howard, and Raj, he invites Amy, Penny, and Bernadette to join him.

William Shatner—William Shatner is the original James T. Kirk, captain of the USS *Enterprise* on *Star Trek: The Original Series* (1966). He really wants to go *Wrath of Khan* on the ogres they're fighting.
 He really knows the difference between an owlbear and a bugbear.

Kevin Smith—Kevin Smith is the director of *Clerks* (1994) and *Chasing Amy* (1997), among other films, and made his career out of geek references and arguments, much like the ones on *The Big Bang Theory.* In an earlier episode, he offered an audition for *Clerks 3.*
 He really likes to talk his way through encounters.

Joe Manganiello—Though the girls know Joe Manganiello most from his roles in *Magic Mike* (2012) and *True Blood* (2010), Leonard would probably know him best as Flash Thompson in *Spider-Man* (2002). Having him play *Dungeons & Dragons* is no joke: Manganiello runs a celebrity *D&D* game in real life alongside folks like Tom Morello (Rage Against the Machine), Vince Vaughn (*Swingers*, 1996), and *Game of Thrones* showrunner D. B. Weiss, among others.

Kareem Abdul-Jabbar—Legendary basketball player Kareem Abdul-Jabbar is more nerdy than people would assume. As a novelist, he has written a series featuring Mycroft Holmes, Sherlock's brother. As an actor, he appeared opposite Bruce Lee in *Game of Death* (1978).
 Of Wil's group, he asks the right questions and keeps the game moving along.

BAZINGA!

THE GEEK ANOMALIES

SUBJECT

Costumes play a huge role in the lives of nerds. Whether worn for comic conventions,[1] Halloween, or more personal reasons, they're central to the identity and nerdery of those wearing them.

HALLOWEEN COSTUMES

In "The Middle Earth Paradigm," all the guys try to dress up as the Flash when they get invited to Penny's Halloween party, but they all have to go back to the drawing board.

The Flash—Sheldon, Leonard, Howard, Raj
Frodo—Leonard
Thor—Raj
Peter Pan/Robin Hood—Howard
The Doppler Effect—Sheldon

In "The Holographic Excitation," the crew heads to the comic book store for a Halloween party and the costumes are nothing short of terrific.

Papa Smurf—Howard
Smurfette—Bernadette
Sexy Cop—Penny
Albert Einstein—Leonard
Willy Wonka—Stuart
Raggedy Ann—Amy
Raggedy C-3PO—Sheldon
"Indian" Jones—Raj

The costumes in "The Imitation Perturbation" lead to some fights. When Howard dresses up as Sheldon, Sheldon isn't sure how to take it. He and Amy take things too far in retaliation when they dress up as Howard and Bernadette.

Sheldon—Howard
Doc Brown—Sheldon
Clara Clayton—Amy
Ruth Bader Ginsburg (Kooth Bader Ginsburg)—Raj
Inspector Gadget—Leonard
US Constitution and the Bill of Tights—Anu
Mary Poppins—Bernadette
Bert the Chimney Sweep—Howard (in his second costume)
A Butterfly—Stuart
Maurice "Doc" Ewing, winner of the 1960 Vetlesen Prize—Dr. Bert Kibbler
Sexy Barmaid—Penny
Bernadette—Amy (in her second costume)
Howard—Sheldon (in his second costume)

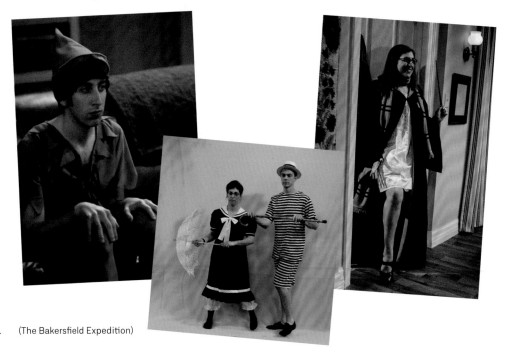

1. (The Bakersfield Expedition)

OTHER COSTUMES

In "The Codpiece Topology," the guys head to the Renaissance Fair in costume. Sheldon spends the entire time complaining about the historical inaccuracies. To fix that issue, he returns to the fair dressed as Mr. Spock and pretends to be investigating a Renaissance Fair–like planet.
Friar—Sheldon
Jester—Howard
Rogue—Raj
Knight—Leonard
Mr. Spock—Sheldon

After drinking too much coffee in "The Work Song Nanocluster," Sheldon dresses as the Flash.

After losing a bet to Stuart and Wil Wheaton in "The Wheaton Recurrence," the guys are forced to wear costumes chosen to humiliate them and parade around in the comic book store:
Batgirl—Howard
Supergirl—Leonard
Wonder Woman—Sheldon
Catwoman—Raj

In "The Justice League Recombination," the guys bring in Penny's ex-boyfriend Zack Johnson to round out their Justice League in hopes of winning the New Year's Eve costume contest. It works.
The Flash—Sheldon
Green Lantern—Leonard
Superman—Zack Johnson
Batman—Howard
Aquaman Riding a Seahorse—Raj
Wonder Woman—Penny
The Fourth Doctor—Stuart

In "The Launch Acceleration," Amy dresses in a classic *Star Trek* (1966) doctor's uniform to play "Doctor" with Sheldon.

In "The Bakersfield Expedition," Leonard, Sheldon, Howard, and Raj head to Bakersfield Comic-Con dressed in *Star Trek* costumes. They stop to take pictures in the desert, but their car is stolen on the way.
Lieutenant Commander Data—Sheldon
Commander Worf—Raj
Captain Picard—Leonard
Borg Drone—Howard

In "The Contractual Obligation Implementation," Amy, Bernadette, and Penny go to Disneyland and get princess makeovers.
Snow White—Amy
Cinderella—Bernadette
Aurora (*Sleeping Beauty*)—Penny

There were a few times that *Sheldon Cooper Presents: Fun with Flags* required the use of costumes:
Pretzel—Amy
Kangaroo—Amy
Betsy Ross—Sheldon
Old–Timey Bathing Suits—Amy and Sheldon

After Amy installs a TARDIS as the entrance to her bedroom in "The Skywalker Incursion," Sheldon dresses up as the Fourth Doctor and they do some role-playing.

In "The Viewing Party Combustion," Stuart arrives dressed as Jon Snow to watch *Game of Thrones*.

In "The Property Division Collision" Amy and Sheldon don Hogwarts robes to engage in coitus.
Hufflepuff—Amy
Gryffindor—Sheldon

When Raj wants to earn extra money in order to pay for Comic-Con tickets in "The Comic-Con Conundrum," Raj dons his old Aquaman costume and holds a sign on the street advertising Stuart's comic book store.

Sheldon's Couples Costumes

SUBJECT

In "The Holographic Excitation," Sheldon and Amy work to create a Venn diagram to decide which costumes they should don as a couple.

COUPLES I LIKE:

R2-D2 & C-3PO

HEWLETT & PACKARD

BATMAN & ROBIN

JOBS & WOZNIAK

KIRK & SPOCK

ARTHUR DENT & FORD PREFECT

THE DOCTOR & A DALEK

SALT & PEPPER

COUPLES YOU LIKE:

CINDERELLA & PRINCE CHARMING

ANTONY & CLEOPATRA

BLOSSOM & JOEY

LADY & TRAMP

ROMEO & JULIET

JACK & ROSE

DHARMA & GREG

RAGGEDY ANN & ANDY

"Couples costumes are one of the few benefits of being in a relationship."
-Sheldon Cooper, in "The Holographic Excitation"

Sheldon's Nerd Shirt Typography

THE JUSTICE LEAGUE RECOMBINATION

Sheldon wore more DC shirts featuring members of the Justice League than anything else. This pie chart shows which characters featured most prominently (hint: it was Superman) over the course of 12 seasons.

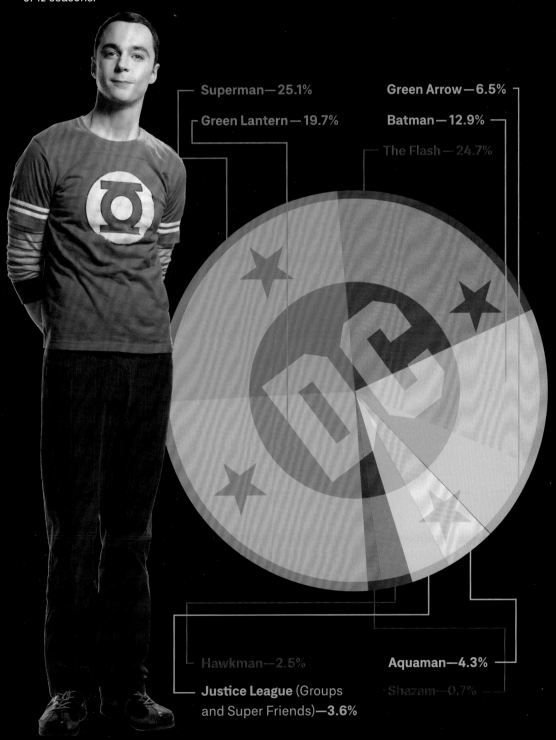

Superman—25.1%

Green Lantern—19.7%

Green Arrow—6.5%

Batman—12.9%

The Flash—24.7%

Hawkman—2.5%

Aquaman—4.3%

Justice League (Groups and Super Friends)—3.6%

Shazam—0.7%

Based on his T-shirt-wearing frequency, it would be easy to guess that the Flash is Sheldon's second favorite DC character. But add the Flash costumes he wore, and the Scarlet Speedster might even be the winner.

THE FLASH ATHLETIC STRIPE SHIRT

This shirt is one of Sheldon's favorites, featuring a distressed version of the classic Silver Age logo first worn by Barry Allen in 1956.

THE FLASH BY MICHAEL TURNER

This orange shirt has an image of the Flash drawn by comics superstar Michael Turner.

THE FLASH WITH WINGS

This logo shirt hearkens back to the Flash Jay Garrick, the original Golden Age version of the character, and his winged helmet, but married to a Silver Age costume logo.

THE FLASH POSES (x4)

This series of shirts features the Flash and his classic Silver Age logo. They feature him running and punching in a style established by Carmine Infantino.

THE FLASH EQUATION

The Silver Age Flash, Barry Allen, was created when a police scientist working in a forensics lab is struck by lightning, tapping him into the Speed Force. This mathematical equation proves it.

THE FLASH #174

Sheldon wears a blue shirt featuring the cover of *The Flash* #174, drawn by Carmine Infantino. It includes six of *The Flash*'s most dastardly villains: Captain Cold, Mirror Master, the Top, Heat Wave, Captain Boomerang, and the Pied Piper.

THE FLASH TV LOGO

Sheldon sports the Flash logo from the CW series that began in 2004.

Coming in slightly ahead of the Flash in the popularity of Sheldon's shirts is Superman, the last son of Krypton.

VITRUVIAN SUPERMAN

The Vitruvian Man was a drawing by Leonardo da Vinci, completed in the year 1490. This was da Vinci's model of the size and proportions of a normal man. Sheldon wears a shirt that honors the original, substituting the common man for the Superman.

POP-SUPERMAN

Pop artist Andy Warhol became famous for his repeating-pattern screen prints in loud colors. Sheldon wears a shirt that honors this art history with a repeating pattern of Superman logos. It's not Marilyn Monroe or Campbell's Soup cans, but it's definitely art.

KRYPTONIAN TRANSLATOR

The Kryptonian people lived imaginative lives before the explosion of their planet killed everyone, minus Kal-El. (And Kara Zor-El. And the entire bottled city of Kandor.) They had their own alphabet, too. Sheldon wears a shirt with a decoder for reading it.

CLASSIC LOGO

This iteration of the Superman logo for marketing has been around since at least the '80s. Sheldon wears it in its classic colors and in blue.

MAN OF STEEL LOGO

Sheldon wears a black version of the *Man of Steel* Superman logo.

SUPERMAN DNA

This shirt, worn a total of 12 times by Sheldon, features Superman's Kryptonian DNA.

KNEEL BEFORE ZOD

Sheldon Cooper wears this shirt representing General Zod, one of Superman's greatest foes, in "The Veracity Elasticity." This episode has Sheldon and Leonard both confront their significant others on their lying

The Green Lantern Corps and the other color corps of the emotional spectrum are an important part of the DC mythology and make up over 20 percent of Sheldon's DC shirts. Here we'll break down some of the best Green Lantern shirts from Sheldon's closet.

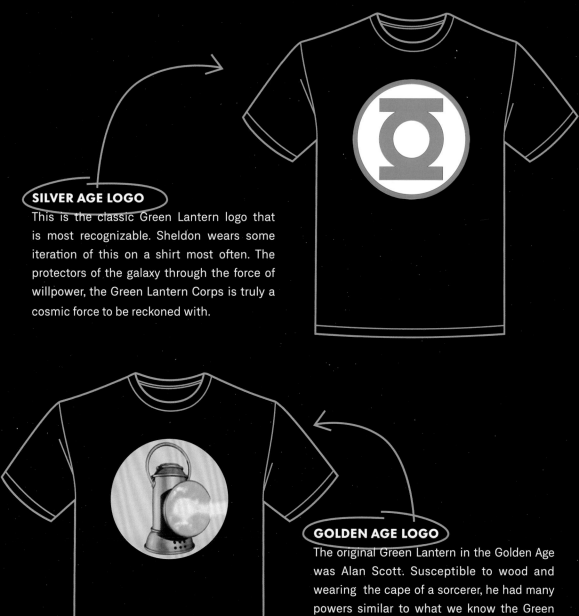

SILVER AGE LOGO

This is the classic Green Lantern logo that is most recognizable. Sheldon wears some iteration of this on a shirt most often. The protectors of the galaxy through the force of willpower, the Green Lantern Corps is truly a cosmic force to be reckoned with.

GOLDEN AGE LOGO

The original Green Lantern in the Golden Age was Alan Scott. Susceptible to wood and wearing the cape of a sorcerer, he had many powers similar to what we know the Green Lantern to be, but he evolved into what we now recognize as the Green Lantern. Sheldon first wore this classic shirt in "The Hesitation Ramification."

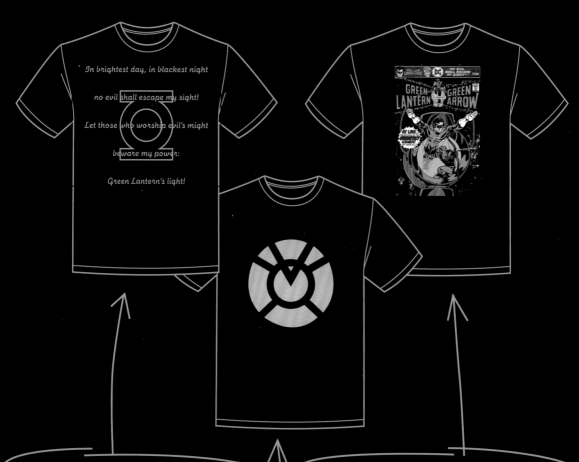

SILVER AGE WITH OAN OATH

This Silver Age iteration of the Green Lantern logo has an added twist: it has the Green Lantern oath written on it in the language of Oa, the founders of the Green Lantern Corps. It translates roughly to:

In brightest day,
in blackest night
no evil shall escape
my sight!
Let those who worship
evil's might
beware my power:
Green Lantern's light!

GREEN LANTERN & GREEN ARROW #90

Sheldon wears this shirt a few times on the show, featuring the cover of *Green Lantern #90*, written by Dennis O'Neil, which costars Green Arrow. This cover, illustrated by Mike Grell and Tatjana Wood, features Hal Jordan and Oliver Queen hunting down an alien who has crash-landed on Earth. In an interesting bit of trivia, Spock has a cameo in the Green Lantern Corps on the second page of this issue, making a Vulcan salute.

ORANGE LANTERN CORPS

The Orange Lanterns represent avarice and greed. There's only one member of the Orange Lantern Corps: Larfleeze, the greediest being in the galaxy. Sheldon wore this shirt in "The Viewing Party Combustion," where he wars with Leonard over his own avarice and will in getting what he wants with the roommate agreement.

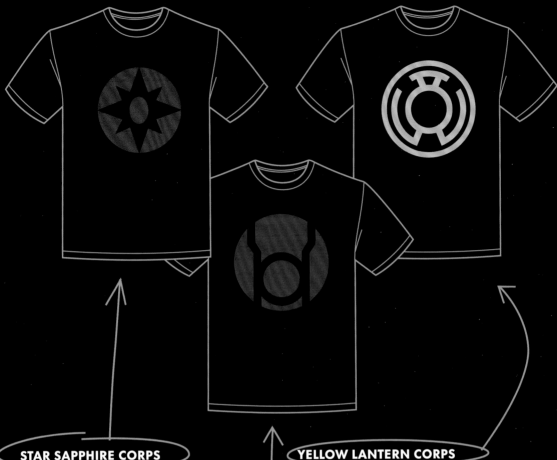

STAR SAPPHIRE CORPS

The Star Sapphires also appear on the emotional color spectrum in the world of the Green Lantern, coming in as violet. Their power is based on the emotion of love. The appearance of this shirt in "The Spaghetti Catalyst" has a significant hidden meaning. Sheldon is torn up over the custody battle between Leonard and Penny in the wake of their breakup. He decides it would be easier for love to win and the two of them to be together.

YELLOW LANTERN CORPS

Sheldon wears his Yellow Lantern/Sinestro Corps shirt on "Restock the Medicine Cabinet Day" in "The Friendship Turbulence." With the color yellow representing fear in the DC Comics world, and the direct weakness of the Green Lantern Corps, it's no wonder it appeared in an episode where Sheldon was afraid to admit that Howard going to space was hard for him.

RED LANTERN CORPS

In "The Precious Fragmentation," Sheldon wears this shirt, signifying the Red Lantern Corps. Where the Green Lanterns utilize the emotion of awillpower, the Red Lanterns utilize rage. It makes sense that Sheldon wore it in an episode he spends in angry strife with the rest of his friends over the fate of the One Ring.

THE GREEN LANTERN EQUATION

What happens when you add up a dead alien, an Oan power ring, and a cocky fighter pilot? A Green Lantern.

Batman ranks fourth in popularity in Sheldon's Justice League—based wardrobe. Here is a look at some of the coolest Bat-shirts in Sheldon's Bat-closet.

CLASSIC *BATMAN* TV LOGO

This shirt features the iconic classic *Batman* television logo, complete with a caricature of Adam West's Batman. West ends up coming to Sheldon's birthday party in "The Celebration Experimentation."

BATMAN #9

This shirt boasts the iconic cover of *Batman* #9, with Batman and Robin trapped in a police spotlight. It dates back to March 1942. The artists of this particular work were Jerry Robinson and Fred Ray.

BATMAN AND ROBIN ON THE RUN

This shirt is another patterned after the classic television show, with the trademark sound effects surrounding the Dynamic Duo. This shirt was in Sheldon's closet going back as far as "The Hamburger Postulate," but he didn't wear it that often.

THE RIDDLER

One of Sheldon's most subtle Batman shirts is the Riddler's question mark made up entirely of flying bats.

HISTORY OF BATMAN LOGOS

Sheldon wore this shirt twice, once in "The Expedition Approximation" and once in "The Paintball Scattering." It has a history of 15 different Batman logos, including Azrael, *The Dark Knight Returns*, and others.

THE DARK KNIGHT RETURNS

This shirt with a yellow Batman logo from the seminal comic book *The Dark Knight Returns* is worn by Sheldon in "The VCR Illumination." With a young Sheldon from the past coming to visit his wisdom upon an older, perhaps less-wise Sheldon, it fits thematically with the comic book source material.

BATMAN FACE OUT OF LOGOS

Sheldon wore this shirt in "The Plagiarism Schism." It features a Batman face composed entirely of Batman silhouettes, symbols, and logos.

TRAINS, WIZARDS, AND WANDS, OH MY

With Amy's influence, Sheldon starts coming out of his shell as a Harry Potter fan.

THE MARAUDERS

This hardcore logo style T-shirt features those original mischief-makers, the Marauders: Mooney, Wormtail, Padfoot, and Prongs. They created the Marauder's Map and changed the shape of the wizarding world forever with the tools that ended up in the hands of Harry Potter. Sheldon wore this shirt in "The Proton Regeneration."

THE GRYFFINDOR LION

Sheldon believes himself to be an unabashed Gryffindor, as represented by the robes he buys himself. He wears this lion shield logo of the Gryffindor, surrounded by their qualities, with pride in "The Monetary Insufficiency" and "The Imitation Perturbation."

THE HOGWARTS EXPRESS

With Sheldon's obsession with trains and nerdy pursuits, it's a wonder he didn't wear this Hogwarts Express shirt more often. Featuring a classically stylized ad for the fictional railroad, Sheldon only wore it twice, once in "The Procreation Calculation" and once in "The Conference Valuation."

HARRY'S LIGHTNING BOLT WITH SYMBOLS

Sheldon is a fan of shirts with lots of small symbols adding up to one big symbol, and his Harry Potter fandom doesn't escape this trend, either. This shirt is Harry's lightning bolt scar made up of silhouettes and symbols from the series. He wore it in "The Confirmation Polarization."

THE FANTASTIC 73

In "The Alien Parasite Hypothesis," Sheldon is convinced that the number 73 is the best number.

It's the 21st prime number, its mirror, 37, is the 12th prime number, and *it's* mirror, 21, is the product of multiplying 7 and 3.

In binary, 73 is a palindrome, 1001001.

After he breaks down why this number is his favorite, he starts sporting a shirt with the number on it in "The Re-Entry Minimization."

There's another math joke hidden in this shirt, though.

A blue shirt with a white circle and a number in the center is the uniform of the *Fantastic Four*, the family of scientists and explorers from Marvel. And what's 7 minus 3? 4. Making Sheldon's 73 shirt a *Fantastic Four* easter egg.

THE ROBOT INVASION

One of the shirts Sheldon wears features a montage of science fiction robots from across many different franchises.

- THE IRON GIANT from *The Iron Giant*
- C-3PO from *Star Wars*
- R2-D2 from *Star Wars*
- BENDER from *Futurama*
- OMNIDROID from *The Incredibles*
- A DALEK from *Doctor Who*
- THE ROBOT from *Lost in Space*
- MARIA from *Metropolis*
- HAL from *2001: A Space Odyssey*
- TWIKI from *Buck Rogers*
- A CYLON from *Battlestar Galactica*
- 7-ZARK-7 & 1 ROVER 1 from *Battle of the Planets*
- ROBBY THE ROBOT from *FORBIDDEN PLANET*
- GORT from *The Day the Earth Stood Still*
- V.I.N.CENT, MAXIMILIAN, AND B.O.B. from *The Black Hole*

THE SPACE SINGULARITY

Sheldon wore this shirt featuring a number of science fiction spaceships and vehicles.

- PROBE DROID from *Star Wars: Episode V—The Empire Strikes Back*
- THE *MILLENNIUM FALCON* from *Star Wars: Epi-sode IV—A New Hope*
- T-47 AIRSPEEDER from *Star Wars: Episode V— The Empire Strikes Back*
- ALL-TERRAIN ARMORED TRANSPORT (AT-AT) from *Star Wars: Episode V—The Empire Strikes Back*
- Y-WING from *Star Wars: Episode IV—A New Hope*
- JAWA SANDCRAWLER from *Star Wars Episode IV—A New Hope*
- THE *SLAVE I* from *Star Wars: Episode II—Attack of the Clones*
- LUKE'S LANDSPEEDER from *Star Wars: Episode IV—A New Hope*
- TIE FIGHTER from *Star Wars: Episode IV— A New Hope*
- TIE INTERCEPTOR from *Star Wars: Episode VI— Return of the Jedi*
- THE *TANTIVE IV* from *Star Wars: Episode IV— A New Hope*
- IMPERIAL STAR DESTROYER from *Star Wars: Episode IV—A New Hope*
- A-WING from *Star Wars: Episode VI—Return of the Jedi*
- A RECOGNIZER from *Tron*
- LIGHT CYCLE from *Tron*
- CYLON RAIDER from *Battlestar Galactica*
- VIPER from *Battlestar Galactica*
- DRACONIAN HATCHET FIGHTER from *Buck Rogers*
- THUNDERFIGHTER from *Buck Rogers*
- EAGLE TRANSPORTER from *Space: 1999*
- DROP SHIP from *Aliens*

Howard's Belt Buckles

SUBJECT

It's rare to see Howard without a cool belt buckle keeping his belt on and his pants up. His collection is vast and covers so many corners of geekdom, it's hard to keep track.

CLASSIC NES CONTROLLER
(PILOT)

GREEN LANTERN
(THE BIG BRAN HYPOTHESIS)

SUPERMAN
(THE HAMBURGER POSTULATE)

BATMAN
(THE COOPER-HOFSTADTER POLARIZATION)

45 RECORD ADAPTER
(THE JERUSALEM DUALITY)

SUPERMAN
(THE NERDVANA ANNIHILATION)

THE FLASH
(THE PORK CHOP INDETERMINANCY)

DARTH VADER
(THE CORNHUSKER VORTEX)

LI'L DEVIL
(THE GUITARIST AMPLIFICATION)

PAC-MAN
(THE PSYCHIC VORTEX)

BATMAN'S RED TELEPHONE
(THE BOZEMAN REACTION)

CUPCAKES
(THE EXCELSIOR ACQUISITION)

SPACE INVADERS
(THE LUNAR EXCITATION)

ATARI LOGO
(THE 21-SECOND EXCITATION)

GARGOYLE
(THE WIGGLY FINGER CATALYST)

YODA
(THE HABITATION CONFIGURATION)

JUSTICE LEAGUE
(THE BON VOYAGE REACTION)

BATMAN with a Justice League belt
(THE WORKPLACE PROXIMITY)

WONDER WOMAN (for girls' night)
(THE PROTON DISPLACEMENT)

LIGHTSABER made by Raj—
so they could have sword fights whenever they want. Howard gets Anakin Skywalker's blue lightsaber and Raj has Darth Vader's red one.
(THE PROTON DISPLACEMENT)

PONG
(THE FIRST PITCH INSUFFICIENCY)

LANNISTER LION SIGIL
(THE CELEBRATION EXPERIMENTATION)

VITRUVIAN MAN
(THE COLLABORATION CONTAMINATION)

R2-D2
(THE PROTON REGENERATION)

THE LIBERTY BELL
(THE STOCKHOLM SYNDROME)

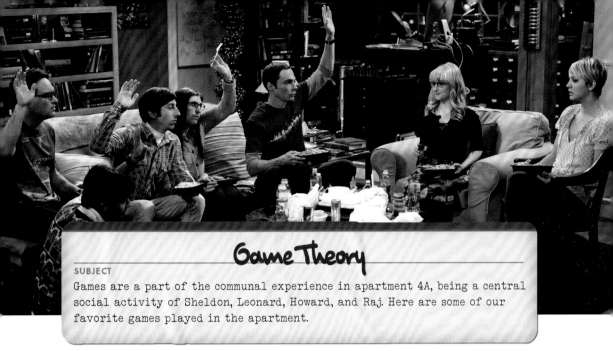

Game Theory

SUBJECT

Games are a part of the communal experience in apartment 4A, being a central social activity of Sheldon, Leonard, Howard, and Raj. Here are some of our favorite games played in the apartment.

GAME	EPISODE
Star Trek Tri-Dimensional Chess	THE PANCAKE BATTER ANOMALY
Klingon Boggle	THE PANTY PIÑATA POLARIZATION
Secret Agent Laser Obstacle Chess	THE WORK SONG NANOCLUSTER
Mystic Warlords of Ka'a	THE CREEPY CANDY COATING COROLLARY
Research Lab	THE GUITARIST AMPLIFICATION

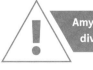 SHELDON: "The physics is theoretical, but the fun is real."
LEONARD: "We must not be playing it right."

Counterfactuals	THE ZAZZY SUBSTITUTION

A game designed by Amy and Sheldon where they postulate an alternate world that differs from theirs in one key aspect and pose questions to each other. (i)

Intergalactic Battleship	THE BOYFRIEND COMPLEXITY
Indian Monopoly	
Travel Twister	THE FLAMING SPITTOON ACQUISITION

⚠ Amy asks Bernadette and Penny to play. They could divvy up into teams. Shirts and skins. Amy calls shirts.

GAME	EPISODE
Settlers of Catan	THE SPECKERMAN RECURRENCE
Donkey Kong Jenga	THE SHINY TRINKET MANEUVER
Chess	THE WEREWOLF TRANSFORMATION

Penny beats Leonard handily

Quarters ········· THE WEEKEND VORTEX

In order to distract Amy from the rough time she's having with Sheldon, Penny plays quarters with her, not realizing Amy's a ringer. Penny gets *very* drunk, very quickly.

Pictionary ········· THE RE-ENTRY MINIMIZATION

Sheldon decides to it's boys vs. girls. Amy and Penny cream Leonard and Sheldon, who overthink *everything*.

Physics Fiesta

This is a game Sheldon *just* made up where participants answer physics questions in Spanish

Where's Waldo

Amy and Leonard take off their glasses and have to find Waldo, but the boys lose again.

Ticket to Ride	THE FISH GUTS DISPLACEMENT
Giant Jenga	THE EGG SALAD EQUIVALENCY
Axis & Allies	THE FRIENDSHIP TURBULENCE

Sheldon and Howard decide to team up, making them the Axis.

Chutes and Lawyers ········· THE MOMMY OBSERVATION

This is a game Sheldon invented. The Charles Darrow piece ends up on the floor.

GAME	EPISODE

Lord of the Rings Risk ·················· THE SPACE PROBE DISINTEGRATION

Imaginary *Lord of the Rings* Risk ······················

ℹ When the girls take Leonard and Sheldon shopping at a store with no Wi-Fi, they are forced to pretend to play *Lord of the Rings* Risk to pass the time.

Scrabble ····················· THE PERSPIRATION IMPLEMENTATION

⚠ Leonard once sprained his ankle celebrating a triple-word score with a double-letter Q in Scrabble.

Amy and Sheldon play "Eat, Fight, Befriend" with aquatic animals.

·············· THE PLATONIC PERMUTATION

LEGO, Toenail, or Pill ··············· THE SALES CALL SUBLIMATION

❓ This is a game Howard and Bernadette play when cleaning out Stuart's room. They have to identify which is sucked up by the vacuum.

Never Have I Ever ················· THE BIG BEAR PRECIPITATION

⚠ Sheldon and Amy and Leonard and Penny are in a cabin in the woods playing to pass the time while the rain foils their hike.

Campaign for North Africa: The Desert War 1940–43 ·················· THE NEONATAL NOMENCLATURE

☢ Sheldon brings what might be the most complicated and detailed game in history to play with Bernadette to pass the time while she waits to go into labor.

Forbidden Island ····················· THE CONFERENCE VALUATION

Rubik's Cube ··················· THE INSPIRATION DEPRIVATION

ℹ In a bid to keep Sheldon occupied for a while, Leonard switched stickers 2, 9, 32, and 51 on the cube. Sheldon solves that puzzle.

The Ka'a Complexity

First appearing in "The Creepy Candy Coating Corollary," the MYSTIC WARLORDS OF KA'A is one game the guys play quite a bit. They play it with each other, and in tournaments. It was at a MYSTIC WARLORDS OF KA'A tournament that Sheldon first met Wil Wheaton.

In "The Flaming Spittoon Acquisition," a *Mystic Warlords of Ka'a* expansion is released: "Wild West and Witches." Sheldon dresses up in a cowboy hat with boots and spurs to celebrate and also comments on how when they played the "Satanimals" expansion, he dressed up as the Beezlebobcat.

BASE PACK

ENCHANTED BUNNY
THE CARROT OF POWER
ZANDOR, WIZARD OF THE NORTH
POTION OF ZANCOR
SCREAMING HARPY

LESSER DEMON TURTLE
FAIRY GODMONSTER
TWO-EYED CYCLOPS
BI-POLAR BEAR
HAIRY FAIRY

SATANIMALS

HELLEPHANT

BEEZLEBOBCAT

WILD WEST AND WITCHES EXPANSION

WILD BILL WITCHKOK
FLAMING SPITTOON

ANNIE OGRELY
CREEPY TEEPEE

SUBJECT

In "The Wildebeest Implementation," Sheldon invents rules for three-player chess.

To do this, he's solved the balanced center area combat problem with five simple words: transitional quadrilateral to triangular tessellation.

Then he invented two new pieces: the Serpent and the Old Woman. The Serpent poisons pieces, which will die after two more turns unless the Old Woman can get there in time to suck out the poison. After successfully sucking out the poison, she becomes the Grand Empress, which combines the power of the Knight, Queen, and Serpent.

He considers adding a third piece, Prince Joey, the king's feebleminded but well-meaning cousin. Every time Prince Joey moves, there's a 1-in-5 chance he'll kill himself.

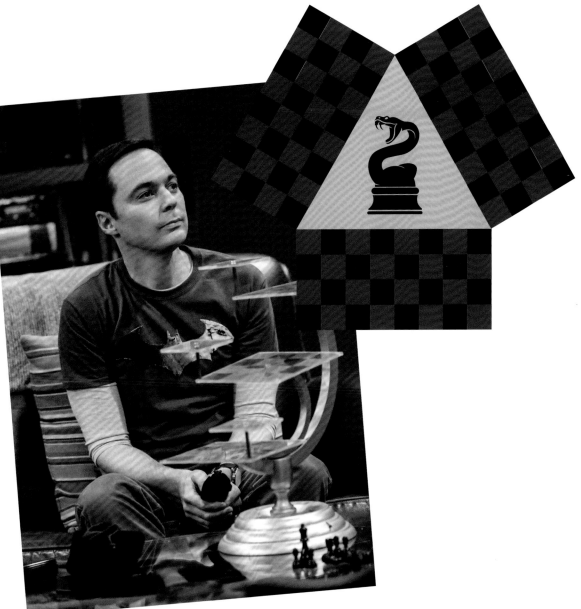

The Tabletop Role-Playing Game Catalyst

After Sheldon, Leonard, Howard, and Raj play DUNGEONS & DRAGONS in "The Wiggly Finger Catalyst," the game became a mainstay on the show. And it's no wonder. It's been a mainstay of geek culture for at least five decades. Their style of play is a little more scripted than most groups, but no less charming. Here's a look at the highlights from their best sessions.

In their first official *D&D* session on the show, Sheldon acts as the Dungeon Master. It is a standard old-school dungeon crawl that has Howard joke his way through ogres. They find a dragon in the second room. Howard asks if that's a little on the nose.

"When you play *Chutes and Ladders*," Sheldon says, "do you complain about all the chutes and ladders?"

(THE WIGGLY FINGER CATALYST)

Leonard DMs a game that leads the guys through a holiday-themed adventure on a race to save Santa Claus. Sheldon ends up murdering Santa Claus in the game.

(THE SANTA SIMULATION)

Howard is the Dungeon Master and does a number of celebrity impressions, including Nicolas Cage and Al Pacino. When their trip to Las Vegas is canceled, Penny and Bernadette join the game. Howard finishes the game strong, featuring a dragon with the voice of Christopher Walken.

(THE LOVE SPELL POTENTIAL)

Sheldon DMs Bernadette through a single-player one-shot. She takes on the persona of Bernatrix, a warrior queen who is strong, beautiful, and tall.

(THE FERMENTATION BIFURCATION)

The Rock-Paper-Scissors Expansion

Rock-Paper-Scissors-Lizard-Spock was created by internet pioneer Sam Kass as an improvement on the classic game. It adds two more layers of complexity, making it more difficult to end the game in a stalemate. Sheldon first introduces this to the group in "The Lizard-Spock Expansion." The rules are simple:

SCISSORS CUT PAPER

LIZARD POISONS SPOCK

LIZARD EATS PAPER

PAPER COVERS ROCK

SPOCK SMASHES SCISSORS

PAPER DISPROVES SPOCK

ROCK CRUSHES LIZARD

SCISSORS DECAPITATE LIZARD

SPOCK VAPORIZES ROCK

ROCK CRUSHES SCISSORS

The Video Game Simulation

The array of video games played by the folks in apartment 4A is vast.

DANCE DANCE REVOLUTION
(THE BIG BRAN HYPOTHESIS)

WORLD OF WARCRAFT
(THE FUZZY BOOTS COROLLARY)

HALO 3
(THE DUMPLING PARADOX)

WII SPORTS BOXING
(THE PORK CHOP INDETERMINACY)

TRESSLING—(Tetris and Arm Wrestling)
(THE PEANUT REACTION)

SUPER MARIO 64
(THE CODPIECE TOPOLOGY)

AGE OF CONAN
(THE BARBARIAN SUBLIMATION)

WII SPORTS BOWLING
(THE BATH ITEM GIFT HYPOTHESIS)

ROCK BAND
(Red Hot Chili Peppers, "Under the Bridge")
(THE MATERNAL CAPACITANCE)

ZORK
(THE HOFSTADTER ISOTOPE)

MARIO KART WII
(THE GORILLA EXPERIMENT)

ROCK BAND
(The Guess Who, "American Woman")
(THE PSYCHIC VORTEX)

WII FISHING
(THE BOYFRIEND COMPLEXITY)

WII ARCHERY
(THE HERB GARDEN GERMINATION)

RED DEAD REDEMPTION
(THE SHINY TRINKET MANEUVER)

STAR WARS: THE OLD REPUBLIC
(THE WEEKEND VORTEX)

STAR WARS KINECT
(THE EXTRACT OBLITERATION)

WORDS WITH FRIENDS
(with Stephen Hawking)
(THE EXTRACT OBLITERATION)

BATMAN: ARKHAM ASYLUM
(THE WORKPLACE PROXIMITY)

BATMAN: ARKHAM CITY
(THE DISCOVERY DISSIPATION)

WII SKIING
(THE COOPER EXTRACTION)

KINECT BASEBALL
(THE FIRST PITCH INSUFFICIENCY)

SHADOW OF THE COLOSSUS
(THE EXPEDITION APPROXIMATION)

DONKEY KONG ARCADE
JAWS ARCADE
CENTIPEDE ARCADE
(THE MISINTERPRETATION AGITATION)

HEADS UP!
Sheldon guesses the clue "Tesla" when Amy
says it's a poor man's Sheldon Cooper.
(THE SEPTUM DEVIATION)

VR NATURE SIMULATOR
Sheldon tries to spend time in the wilderness.
(THE BIG BEAR PRECIPITATION)

OVERWATCH
(THE COGNITION REGENERATION)

GRAND THEFT AUTO
Sheldon obeys traffic signals, even though he's in a
stolen car with a dead sex worker in his truck.
(THE MONETARY INSUFFICIENCY)

FORTNITE
(THE CITATION NEGATION)

Buttons, Howard's catlike companion in the MMORPG he plays, has been with him since he hit level 10.

(PILOT)

Howard uses FrOOtLOOpS11 as his screen name, a reference to his astronaut nickname.

(THE CITATION NEGATION)

Raj uses JohnWilliams as his screen name. "Because I always score."

(THE GATES EXCITATION)

Penny plays the *Age of Conan* MMORPG with the screen name Queen Penelope.

(THE BARBARIAN SUBLIMATION)

Sheldon plays a Night Elf Rogue in *World of Warcraft*.

(THE FUZZY BOOTS COROLLARY)

Howard once snuck onto Sheldon's *World of Warcraft* account and changed the name of Sheldon's level-80 warlock from Sheldor to Smeldor.

(THE APOLOGY INSUFFICIENCY)

Leonard once had a multi-day *World of Warcraft* binge with Howard and Raj that ended with the cops. Someone called them because of the smell.

(THE WORKPLACE VORTEX)

The guys ask Penny if she wants to join them for a Superman movie marathon. Penny isn't sure how many there are, but says she likes the one where Superman catches Lois Lane from falling. Sheldon explains the physics of how that's impossible and would have killed Lois while Penny sneaks away.

(THE BIG BRAN HYPOTHESIS)

Sheldon uses the phrase "Great Caesar's ghost" which is the favored exclamation of Perry White, the editor of the *Daily Planet*, the paper Clark Kent works for.

(THE BIG BRAN HYPOTHESIS)

In a paper, Sheldon includes a footnote that likens mirror-symmetry with the Flash playing tennis with himself.

(THE COOPER-NOWITZKI THEOREM)

When Sheldon congratulates Penny on involving his mother to get him through a problem, he reminds her that "With great power comes great responsibility," which is ripped straight from Spider-Man comics and films.

(THE PANTY PIÑATA POLARIZATION)

Leonard often uses Superman's given Kryptonian name, Kal-El, as a password.

(THE WHITE ASPARAGUS TRIANGULATION)

Sheldon saves up for when science develops an affordable technology that will allow him to fuse his skeleton with adamantium like Wolverine.

(THE FINANCIAL PERMEABILITY)

Sheldon hides cash in a Green Lantern statue.

(THE FINANCIAL PERMEABILITY)

Sheldon posits that Dick Grayson is the only logical replacement for Bruce Wayne, should he give up the cape and cowl. Stuart says it could only be the second Robin, Jason Todd, despite his death. Or his appearance as Red Hood.

(THE HOFSTADTER ISOTOPE)

Sheldon and Stuart argue about the canonization of Joe Chill as the killer of Batman's parents.

(THE HOFSTADTER ISOTOPE)

Howard bets his copy of *Fantastic Four* #48 (first appearance of Silver Surfer) against Sheldon's *The Flash* #123, (the classic "Flash of Two Worlds" issue) that Sheldon has not correctly identified a snowy tree cricket.

(THE JIMINY CONJECTURE)

Leonard suggests that Sheldon get back at Kripke for ruining his NPR interview the same way the Joker got back at Batman for putting him in Arkham Asylum—by poisoning Gotham City's water supply. After Sheldon sets a trap in Kripke's lab, Raj says fondly that Sheldon reminds him of a young Lex Luthor.

(THE VENGEANCE FORMULATION)

Raj gives Sheldon his limited edition Green Lantern Power Battery in trade for hanging out with him. A girl recognizes it and fans out over it. Raj then gives Sheldon his Incredible Hulk hands, signed by Stan Lee, tin exchange for Sheldon agreeing to hang out with Abby and Martha again.

(THE PSYCHIC VORTEX)

Sheldon believes Superman cleans his uniform by flying to the sun in a bid to incinerate contaminate matter, leaving the invulnerable Kryptonian fabric unharmed and daisy fresh.

(THE BATH ITEM GIFT HYPOTHESIS)

Leonard can't decide whether he wants Stan Lee to autograph his *Journey Into Mystery* #83 or his *Fantastic Four* #5 (first appearance of Doctor Doom).

Sheldon plans on having Stan Lee sign his latest issue of *Batman*, even though Lee had nothing to do with Batman.

Raj spends the episode naming all of the alliterative Marvel names that Stan Lee came up with and how irritating he finds it.

(THE EXCELSIOR ACQUISITION)

> **"If they took all the money they spent trying to make a decent Hulk movie, they could probably just make an actual Hulk."**
> —Leonard, in "The Desperation Emanation"

Zack Johnson, Penny's former boyfriend, is an expert in *Archie* comics, explaining the universe to the guys at the comic book store.

(THE JUSTICE LEAGUE RECOMBINATION)

When Raj suggests that Aquaman sucks fish pee, Sheldon reminds him that Aquaman can use his telepathic powers to tell the fish to do their business elsewhere.

(THE JUSTICE LEAGUE RECOMBINATION)

Raj thinks Scooter is the Aquaman of the Muppet Babies.

(THE JUSTICE LEAGUE RECOMBINATION)

> **"Excuse me. You have the great Sheldon Cooper in your lab and you're gonna make him do the dishes? That's like having the Incredible Hulk open a pickle jar."**
> —Sheldon, in "The Vacation Solution"

"When I look in your eyes, and you're looking back in mine, everything feels not quite normal. Because I feel stronger and weaker at the same time, I feel excited and at the same time terrified. The truth is I don't know what I feel, except I know what kind of man I want to be."

—**Sheldon** to Amy, quoting Spider-Man (2002)
(THE DATE NIGHT VARIABLE)

When showing Penny his work with electromagnets, Leonard tells Penny that when he plays with it, he sometimes pretends he's the Marvel super-villain Magneto.

(THE HOLOGRAPHIC EXCITATION)

After Howard gets Sheldon's parking space, Sheldon steals Howard's $500 replica Iron Man helmet and wears it to do his work.

(THE PARKING SPOT ESCALATION)

The '60s *Spider-Man* theme song is Sheldon's third favorite cartoon theme song. Right after *Inspector Gadget* and *Teenage Mutant Ninja Turtles*.

(THE FISH GUTS DISPLACEMENT)

Penny, Amy, and Bernadette decide they want to learn why the guys are so into comic books, so they go to Stuart for recommendations. He recommends *Fables* #1 to them. They end up with some *Thor* comics and argue about the rules of Mjolnir like a bunch of nerds.

(THE BAKERSFIELD EXPEDITION)

Sheldon and Leonard catch up on some *Walking Dead*, and Sheldon spoils the fact that Lori dies. Leonard also has the fact that Dumbledore and Dobby the house elf die spoiled for him.

(THE SPOILER ALERT SEGMENTATION)

Sheldon feels like serving on a committee at the university is beneath him and a waste of his talents. "Like asking the Human Torch to heat up your frozen burrito."

(THE CONTRACTUAL OBLIGATION IMPLEMENTATION)

Howard is dismayed by the *Superior Spider-Man* story arc, which sees Dr. Otto Octavius's mind put into the body of Spider-Man. Raj was quite enjoying it, though, saying that it combines all the fun of Spider-Man with the body switching shenanigans of *Freaky Friday* (1976 and 2003). The original story was written by Dan Slott and illustrated by Ryan Stegman, Humberto Ramos, and Giuseppe Camuncoli. *The Big Bang Theory* cast cameoed in issue 28 of *Superior Spider-Man* later the next year.

(THE DECEPTION VERIFICATION)

Bernadette spends a day going to different comic book stores trying to replace Howard's copy of Frank Miller's *The Dark Knight Returns* #1 after mangling it with her curling iron. Graded at a 9.8, that issue has been sold for as high as $1,500.

(THE OCCUPATION RECALIBRATION)

The guys panic trying to get tickets for San Diego Comic-Con.

(THE CONVENTION CONUNDRUM)

When hanging out at Dr. Lorvis's house, Leonard wears Cerebro and Sheldon wears Magneto's helmet as they face off playing a game.

(THE MISINTERPRETATION AGITATION)

When getting dressed in tuxedos for the fake prom the girls are throwing, Leonard tells Sheldon that he could have gotten a clip-on bow tie.
Sheldon: "Bruce Wayne doesn't wear a clip-on."
Leonard: "Bruce Wayne doesn't make his roommate tie it for him."
Sheldon: "His name is Alfred, and yes, he does."

(THE PROM EQUIVALENCY)

Sheldon said that if he ever needed to hire a lawyer, he would *not* hire She-Hulk.

(THE CLEAN ROOM INFILTRATION)

Raj and Howard talk about *Archie versus Predator*, the classic four-issue *Archie* miniseries by Alex de Campi and Fernando Ruiz, released in 2015.

(THE 2003 APPROXIMATION)

After watching a trailer for *Batman v Superman: Dawn of Justice*, Amy posits that it's dumb that Batman would fight Superman.

(THE EMPATHY OPTIMIZATION)

While hitting on her at the comic book store, Raj talks to Claire about Fiona Staples and Brian K. Vaughan's cult comic book hit *Saga*.

(THE MEEMAW MATERIALIZATION)

Sheldon: "I have a question about Batman. Batman is a man who dresses up like a bat. Man-Bat is a part man part bat hybrid. Now, if Man-Bat dressed up as a man to fight crime, would he be Man-Batman?" After this, the guys descend into lunacy on the question.

(THE VIEWING PARTY COMBUSTION)

Exhausted from too many late nights working on a project for the air force, Sheldon hallucinates the Flash. The Flash tries to get him to drink an energy drink full of caffeine, saying that *all* superheroes use performance-enhancing drugs, even the Hulk, who's on steroids. "You know why Batman wanders around getting into fights? Scotch."

(THE DEPENDENCE TRANSCENDENCE)

Sheldon relates to his trouble with Amy and her colleagues through the lens of the Avengers: "Iron Man doesn't get mad that he's not in an *Iron Man* movie. He gives the audience a thrill and he goes away, and that should have been me tonight. I should have been the delightful cameo in your movie."

(THE PROPOSAL PROPOSAL)

Sheldon says he wants to put Aquaman on his hold so he could say he was into it before it was cool.

(THE CELEBRATION REVERBERATION)

Howard is really into *Jughead: The Hunger*, an *Archie* comics series that casts Jughead as a werewolf. "Werewolf Jughead is not your dad's jughead…"

(THE CELEBRATION REVERBERATION)

Leonard: Why do I have to be Robin?
Sheldon: If you have to ask, you're Robin.

(THE ATHENAEUM ALLOCATION)

Sheldon likens the comic book store to his own version of Wakanda, and its popularity is like an invasion.

(THE COMET POLARIZATION)

Sheldon and Denise are both excited about Dan Slott's run on *Iron Man* because he's their favorite *Spider-Man* writer, too.

(THE COMET POLARIZATION)

> "If Bruce Banner is driving a rental car and turns into the Hulk, do you think he's covered? Or does he need to add the Hulk as an additional driver?"
>
> —Raj, in "The Reclusive Potential"

In order to raise money for a science experiment, Sheldon tries selling a number of valuable comics to Stuart, including a complete run of Todd McFarlane's *Spawn* and *Giant Size X-Men* #1.

(THE MONETARY INSUFFICIENCY)

When Denise and Stuart discuss moving in together, Stuart says he wants to do that more than Galactus wants to devour worlds. Denise wants it more than the Thing likes to clobber. More than Hulk wants to smash and more than Batman wants to ignore the due process of law.

(THE MONETARY INSUFFICIENCY)

Sheldon's Favorite Mutants

SUBJECT
The X-Men were a group of mutants with special abilities, shunned by the world for being different and special. It's no wonder a prodigy like Sheldon Cooper would easily relate to them. In "The Bad Fish Paradigm," he reveals his favorite X-Men, in order. Sheldon felt a special kinship with the brilliant mind of Professor X, even once creating his own supergroup with his friends that he dubbed "the C-Men."

1. **Professor X**
2. **Nightcrawler**
3. **Wolverine**
4. **Cyclops**
5. **Iceman**
6. **Storm**
7. **Angel**
8. **Beast**

It's impossible to be around people like Sheldon, Leonard, Howard, and Raj and expect not to have STAR WARS and STAR TREK references all over the place.

Penny: Do or do not, there is no try.
Leonard: Did you just quote *Star Wars*?
Penny: I believe I quoted *The Empire Strikes Back*.
(THE WHEATON RECURRENCE)

Sheldon threatens to "Vulcan nerve pinch" Leonard at the physics conference.
(THE COOPER-HOFSTADTER POLARIZATION)

Sheldon posits that in *Star Trek*–style transporters, the original matter would need to be destroyed and the transporter would create a new version of that person.
(THE JERUSALEM DUALITY)

Sheldon is convinced to compete in a physics bowl tournament with Leonard, Howard, and Raj after Leonard quotes Spock's dying words to him: "The needs of the many outweigh the needs of the few. Or the one."
(THE BAT JAR CONJECTURE)

When Sheldon arrives to compete in the physics bowl, his team is dressed in modified original series *Star Trek* uniforms, with Sheldon in command gold and his recruited team cast as redshirts.
(THE BAT JAR CONJECTURE)

Sheldon dresses as Spock and pretends to be on an away mission on an Earth-like planet in order to reconcile the historical anachronisms of the Renaissance Fair.
(THE CODPIECE TOPOLOGY)

Sheldon and Raj argue about which is the worst *Star Trek* film, *Star Trek: The Motion Picture* or *Star Trek V: The Final Frontier*.
(THE LIZARD-SPOCK EXPANSION)

Sheldon invokes Starfleet General Order 104, section A, in order to deem Leonard unfit for command in his relationship and tries to relieve him of command.
(THE WHITE ASPARAGUS TRIANGULATION)

For Christmas, Penny gives Sheldon a napkin signed by Leonard Nimoy, which he also used to wipe his mouth.
(THE BATH ITEM GIFT HYPOTHESIS)

After shooting Penny with a paintball, Sheldon quotes the old Klingon proverb "Revenge is a dish best served cold."
(THE CUSHION SATURATION)

Sheldon has worked on perfecting the mimicry of Admiral Ackbar's iconic line from *Star Wars: Episode VI—Return of the Jedi*: "It's a trap!"
(THE DEAD HOOKER JUXTAPOSITION)

Raj compares C-3PO to Sheldon.
(THE HOFSTADTER ISOTOPE)

Sheldon assumes Leonard must be physically ill when he shuts offa TV airing of "Trials and Tribble-ations" when it's on TV, the classic crossover episode between *Star Trek: Deep Space Nine* and the original *Star Trek* series.
(THE HOFSTADTER ISOTOPE)

To motivate the team as they train for an expedition to the North Pole, Leonard invokes the story of Han and Luke's survival on Hoth.
(THE MONOPOLAR EXPEDITION)

Sheldon tries to Force choke the guys.
(THE ELECTRIC CAN OPENER FLUCTUATION)

Sheldon: "Sheldon's Log. Stardate 63345.3. While my colleagues are off observing the Leonid meteor shower, I have remained behind to complete my paper on the decays of highly excited massive string states. Although the research is going well, I do miss the warmth of human companionship."
(THE ADHESIVE DUCK DEFICIENCY)

Leonard has an X-wing poster in his bedroom that reads "Defend and protect."
(THE BOZEMAN REACTION)

Raj enters the comic book store to the "Imperial March" playing through the speaker in his shirt.

(THE EXCELSIOR ACQUISITION)

After Sheldon builds himself a robotic avatar to interact with the world, to the annoyance of everyone, Howard suggests taking him to Tatooine to sell him to Jawas. Which was a joke he stole from Raj.

(THE CRUCIFEROUS VEGETABLE AMPLIFICATION)

Sheldon never identified with the Rebel Alliance. Despite their tendency to build Death Stars, Sheldon's always been more of an Empire man.

(THE ZAZZY SUBSTITUTION)

After sleeping with Raj's sister, Leonard cops to being the Darth Vader of Pasadena. Sheldon disagrees, positing that he's too short to be Darth Vader. At best, Leonard's more of a turn-coat Ewok.

(THE IRISH PUB FORMULATION)

In a guilt-ridden dream about betraying Howard to the FBI, Sheldon is convinced he really is in a dream when Leonard points out the Gorn sitting on the couch in Sheldon's spot, reading *Gorn* magazine.

(THE APOLOGY INSUFFICENCY)

Sheldon and Leonard waited in line for 14 hours to see *Star Trek: Nemesis*.

(THE 21-SECOND EXCITATION)

After Sheldon suggests that Amy use the Vulcan technique of Kolinahr to rise above her base sexual urges, she suggests that it's absurd to rely on the advice of cheap science fiction. Rather than give in to his rage, Sheldon uses Kolinahr to remain her friend.

(THE ALIEN PARASITE HYPOTHESIS)

While they're not dating, Leonard calls the space in bed between himself and Penny the Neutral Zone, after the space between the United Federation of Planets and the Romulan Empire in *Star Trek*. "Of course, sometimes the Federation and the Romulans would enter the Neutral Zone to negotiate a temporary truce."

(THE LOVE CAR DISPLACEMENT)

When caravanning up to Big Sur for a conference, Sheldon gives himself the moniker Red Leader and Howard the moniker Red Five. During the Death Star attack in *Star Wars: Episode IV—A New Hope*, Red Leader was Garven Dreis, who was killed after an unsuccessful attempt at the perilous trench run. Red Five is Luke Skywalker's call sign.

(THE LOVE CAR DISPLACEMENT)

Sheldon adapts a *Star Trek* fan-fiction novella he wrote when he was 10 into a one-act play that he believes will rival Tennessee Williams. It's a self-insert story with Sheldon cast as Gary Stu, who travels to the 23rd century. Penny plays Spock and Sheldon plays Mary Cooper.

(THE THESPIAN CATALYST)

Sheldon brings a Klingon bat'leth to confront Todd Zarnecki, the kid who stole all of Sheldor the Barbarian's stuff in *World of Warcraft*. Todd Zarnecki steals the bat'leth from Sheldon.

(THE ZARNECKI INCURSION)

There's a painting of bounty hunters including Boba Fett, Dengar, and Greedo behind the bathroom door in the apartment.

(THE HERB GARDEN GERMINATION)

When Sheldon tries to coerce Leonard into signing a new and improved roommate agreement, Sheldon initiates a self-destruct sequence for the apartment, just like Captain Kirk in the original *Star Trek* series episode "Let That Be Your Last Battlefield."

His self-destruct sequence, Code 1-1 A-2B, matches Destruct Sequence 2 for *Constitution*-class starships. Instead of a self-destruct, he threatens to send blackmail evidence of Priya and Leonard's relationships to her parents.

(THE AGREEMENT DISSECTION)

Sheldon decides Leonard going to Wil Wheaton's party is a betrayal as large as turning R2-D2 and C-3PO over to the Empire.

(THE RUSSIAN ROCKET REACTION)

As part of their pre-Halloween hijinks, Howard and Raj create a series of haunted house clichés to scare Sheldon, but none really work. He explains that he's too smart for them to scare him. But when Sheldon turns around and sees

the puppet of Balok (worn by Leonard) from the original *Star Trek* series episode "The Corbomite Maneuver" staring back at him, he screams and faints.

(THE GOOD GUY FLUCTUATION)

Sheldon is upset that he has to cuddle with Amy instead of building his LEGO Death Star.

(THE ISOLATION PERMUTATION)

Sheldon, Howard, and Raj gather to watch *Star Wars: Episode IV—A New Hope* on Blu-ray, but Sheldon's rivalry with a bird delays them. Howard laments that if they don't move quickly, George Lucas will change it again before they can watch.

(THE ORNITHOPHOBIA DIFFUSION)

In order to deal with a menacing blue jay, Sheldon dons a Boba Fett helmet and arms himself with a broom, but instead of shooing the bird away, it flies inside and lands on Sheldon's spot.

(THE ORNITHOPHOBIA DIFFUSION)

Stuart has a nightcap at the comic book store: coffee liqueur in a Chewbacca mug. He calls it a sad-tini. Stuart gives Raj his own sad-tini in a Yoda mug.

(THE DATE NIGHT VARIABLE)

"The Imperial March" is Sheldon's "I'm unhappy and about to destroy the planet" music.

(THE COOPER KRIPKE INVERSION)

Leonard has an idea for a *Star Wars*–themed coffee shop called "Brewbaccas."

(THE CLOSURE ALTERNATIVE)

Sheldon pretends everyone he meets is a character from *Star Trek*, which explains why he calls Leonard "Unnamed Crewman in a Red Shirt" and Raj "Uhura."

(THE BON VOYAGE REACTION)

Sheldon: "Last week you told Leonard he couldn't wear his Wookiee jacket out in public."
Penny: "That's different. I'm not going to the mall with someone dressed like a dumb space bear."

(THE WORKPLACE PROXIMITY)

When Amy tells Sheldon that she missed him while he was in Texas, Sheldon replies with Han

Solo's classic "I know."

(THE COOPER EXTRACTION)

Howard sends in an audition tape for the new *Star Wars* film, quoting Luke Skywalker in *Star Wars: Episode VI—Return of the Jedi* warning the rest of the crew that Vader is on the Forest Moon of Endor.

(THE HESITATION RAMIFICATION)

Penny teaches Sheldon yoga, but he only agreed to do it because he thought she said "Yoda."

(THE OCCUPATION RECALIBRATION)

The guys are excited to celebrate *Star Wars* day on May the Fourth. Penny asks if it's like *Star Wars* Christmas and Howard explains that that is Wookiee Life Day. They're not able to celebrate because they have to attend the funeral of Arthur Jeffries, Professor Proton himself.

(THE PROTON TRANSMOGRIFICATION)

Raj offers to make Penny breakfast, saying, "Admiral Ackbar's Snack Bar is open for business." All while wearing a *Star Wars* apron and *Star Wars* T-shirt. When Penny heads out, Raj offers to put together some Attack of the Scones for her to take with her.

(THE PROTON TRANSMOGRIFICATION)

Sheldon rightfully explains to Raj and Howard how absurd the "Machete order" is and why *Star Wars: Episode I—The Phantom Menace* is a vital part of the *Star Wars* mythos.

(THE PROTON TRANSMOGRIFICATION)

Sheldon plays the *Star Trek* theme song on his nose to cheer Amy up.

(THE COLONIZATION APPLICATION)

Leonard and Sheldon decide to drive by Skywalker Ranch on their way to a talk in Berkeley. They get to the gate but Sheldon leaps out of the car and races in, starting a security hunt for him. The guard gets on his radio and calls out a Code AA-23. AA-23 was Princess Leia's detention block on the Death Star in *A New Hope*. They arrest Sheldon and Leonard and put them in Skywalker Ranch jail.

(THE SKYWALKER INCURSION)

After being interviewed by Adam Nimoy for a documentary on Spock and blowing up about

his breakup with Amy, Sheldon watches the first episode of *Star Trek: The Original Series,* "Where No Man Has Gone Before."

(THE SPOCK RESONANCE)

It is a period of great tension. Our heroes, Leonard, Sheldon, Wolowitz, and Koothrappali know that tickets to the Star Wars movie are about to be available for pre-sale. If they fail in their mission and can't see it on opening night Sheldon has sworn that they will never hear the end of it for the rest of their lives . . . They believe him.

(THE OPENING CRAWL OF "THE OPENING NIGHT EXCITATION")

When Leonard and Sheldon catch Amy and Penny in a lie, they discuss it in flawless Klingon.

(THE VERACITY ELASTICITY)

Amy tries lulling Sheldon to sleep with the *Star Trek* theme. It doesn't work. He suggests *2001: A Space Odyssey* (1968) as an alternative.

(THE VERACITY ELASTICITY)

Sheldon refers to Cinnamon as an attack tribble.

(THE ESCAPE HATCH IDENTIFICATION)

Sheldon buys a whole bunch of Romulan ale at Comic-Con and offers some to Leonard, who asks, "Isn't that just vodka with blue dye in it?"

(THE RETRACTION REACTION)

Sheldon suggests to Amy that R2-D2 projecting a hologram should serve as their wedding invitations.

(THE CONFIDENCE EROSION)

Howard tries to invoke the "Let the Wookiee Win" defense when asking Sheldon and Amy to apologize to Bernadette.

(THE IMITATION PERTURBATION)

Leonard's Keepsake Congruence

SUBJECT

Leonard is one of the biggest collectors on the show and has some impressive keepsakes in his collection.

2,600+ COMIC BOOKS
(THE BIG BRAN HYPOTHESIS)

LUKE SKYWALKER'S *RETURN OF THE JEDI* LIGHTSABER REPLICA
(THE BIG BRAN HYPOTHESIS)

REPLICA OF THE BOTTLED CITY OF KANDOR
(THE COOPER-HOFSTADTER POLARIZATION)

ORIGINAL SERIES *BATTLESTAR GALACTICA* FLIGHT SUIT
(THE COOPER-HOFSTADTER POLARIZATION)

BAT-SIGNAL
(THE PANCAKE BATTER ANOMALY)

DARTH VADER VOICE CHANGER
(THE NERDVANA ANNIHILATION)

JOURNEY INTO MYSTERY #83, the first appearance of Thor
(THE EXCELSIOR ACQUISITION)

FANTASTIC FOUR #5, THE FIRST APPEARANCE OF DR. DOOM
(THE EXCELSIOR ACQUISITION)

TWO *STAR TREK: THE ORIGINAL SERIES* UNIFORMS. (everyday and dress)
(THE PRESTIDIGITATION APPROXIMATION)

CARICATURE PORTRAIT OF HIMSELF DRESSED AS LION-O FROM *THUNDERCATS,* sketched by Jim Lee at ComiCon
(THE GOOD GUY FLUCTUATION)

STAR TREK: THE NEXT GENERATION PHASER REPLICA
(THE SPOILER ALERT SEGMENTATION)

MR. SPOCK CUCKOO CLOCK
(THE PROPERTY DIVISION COLLISION)

Comic Book Cartography

SUBJECT

The Comic Center of Pasadena is the water cooler of culture for Sheldon, Leonard, Howard, Raj, Stuart, and everyone else who ends up there.[1]

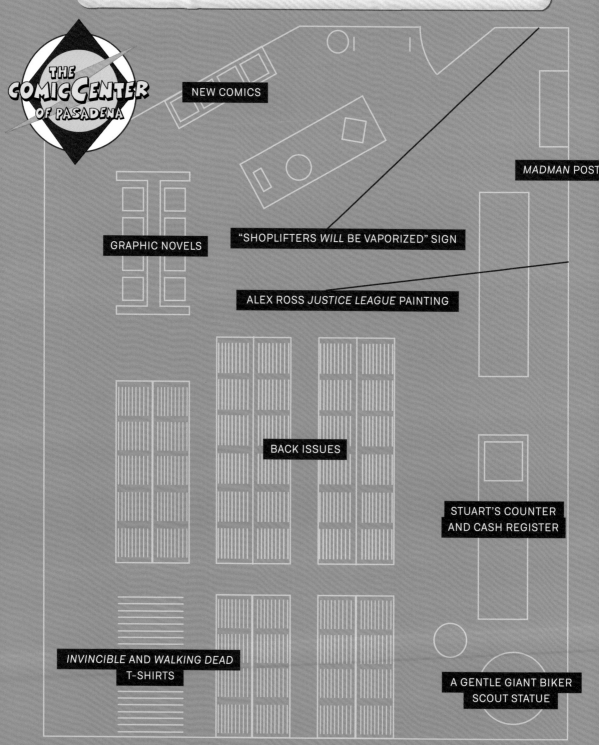

THE COMIC CENTER OF PASADENA

NEW COMICS

MADMAN POST

GRAPHIC NOVELS

"SHOPLIFTERS *WILL* BE VAPORIZED" SIGN

ALEX ROSS *JUSTICE LEAGUE* PAINTING

BACK ISSUES

STUART'S COUNTER AND CASH REGISTER

INVINCIBLE AND *WALKING DEAD* T-SHIRTS

A GENTLE GIANT BIKER SCOUT STATUE

1. Even Neil Gaiman, who no one seems to recognize, despite him repeatedly suggesting his own comics to patrons in (The Comet Polarization.)

(THE TANGIBLE AFFECTION PROOF)

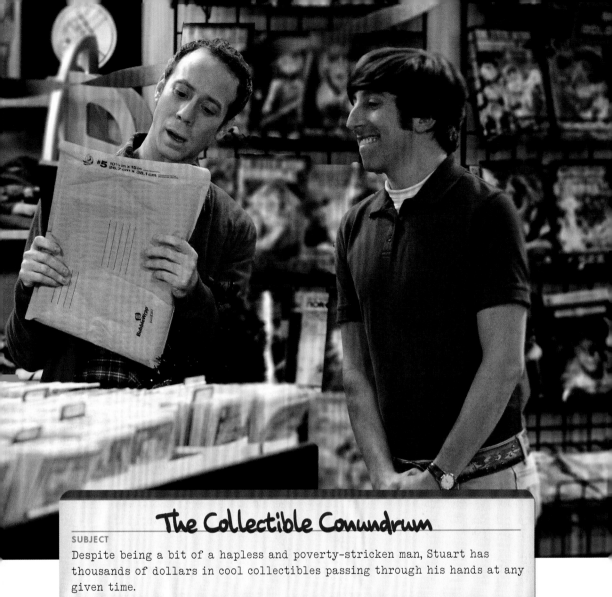

The Collectible Conundrum

SUBJECT

Despite being a bit of a hapless and poverty-stricken man, Stuart has
thousands of dollars in cool collectibles passing through his hands at any
given time.

LONGCLAW, JON SNOW'S SWORD
(THE RUSSIAN ROCKET REACTION)

IRON MAN HELMET SIGNED
BY ROBERT DOWNEY JR.
(THE RUSSIAN ROCKET REACTION)

BATMAN #612, "HUSH: PART FIVE"
Jim Lee alternate pencil cover
(THE RUSSIAN ROCKET REACTION)

NEXT MEN #21
The first appearance of Hellboy
(THE GOOD GUY FLUCTUATION)

EXCALIBUR REPLICA
(THE WEEKEND VORTEX)

BATMAN UTILITY BELT
that could conceivably be used by a 93-
year-old woman for storing her pills
(THE WEEKEND VORTEX)

TWO MINT-IN-BOX 1975
MEGO *STAR TREK* TRANSPORTERS
(THE TRANSPORTER MALFUNCTION)

REPLICA OF BILBO'S SWORD, STING

REPLICA RORSCHACH MASK
FROM *THE WATCHMEN*

SUPERMAN'S CAPE
(THE TANGIBLE AFFECTION PROOF)

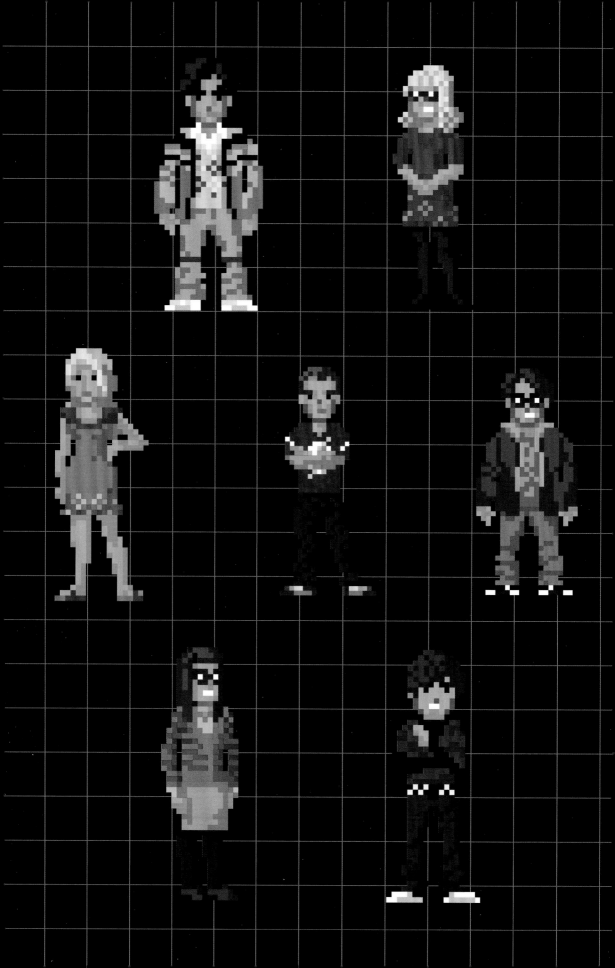

THE MINUTIA PROTOCOLS

SUBJECT

The gang from apartment 4A have watched a LOT of movies, and it's astonishing how many they've seen and reference in the course of their interactions with one another.

When Leonard accidentally wins an auction for the original screen-used time machine from the 1960 film *The Time Machine*, trouble ensues when the guys try to split custody of the prop and it causes problems with Penny.

(THE NERDVANA ANNIHILATION)

In order to get Leonard out of the house for his surprise party, Howard invites him to see a new final cut of *Blade Runner* (1982) at the Landmark Nuart Theatre with 8 seconds of new footage.

(THE PEANUT REACTION)

Sheldon re-creates Humphrey Bogart's classic line about Ingrid Bergman in *Casablanca* (1942), but for Leslie Winkle and with more venom: "Of all the overrated physicists, in all the labs, in all the world, why does it have to be Leslie Winkle?"

(THE CODPIECE TOPOLOGY)

In "The Maternal Capacitance," Raj paraphrases Robert Duvall's iconic line from *Apocalypse Now* (1979): "I love the smell of paintballs in the morning."

When new neighbors move in upstairs, a freaked-out Sheldon impersonates Carol Anne's creepy "They're heeere . . ." from *Poltergeist* (1982)

(THE DEAD HOOKER JUXTAPOSITION)

Raj and Howard both quote Vince Vaughn's "Vegas, baby!" from *Swingers* (1996).

(THE VEGAS RENORMALIZATION)

When a flaw is revealed in Howard's space toilet en route to the International Space Station, the guys have to figure out how to fix it using only the items already aboard the station, just like in *Apollo 13* (1995).

(THE CLASSIFIED MATERIALS TURBULENCE)

Ice Station Zebra (1968) and *John Carpenter's The Thing* (1982) are the movies Howard suggests they watch in the North Pole during their expedition.

(THE MONOPOLAR EXPEDITION)

The guys watch *Gremlins* (1984) and Sheldon complains about how hard it is for people in the film to follow the rules.

(THE PIRATE SOLUTION)

The guys all go to see the new digital restoration of *Time Bandits* (1981), the mind-bending Terry Gilliam fantasy classic.

(THE GUITARIST AMPLIFICATION)

While Leonard tries to console Sheldon after Kripke's helium prank, Raj steps in with a reference from *The Wizard of Oz* (1939), saying, "We represent the Lollipop Guild and we want you!" in a high-pitched voice.

(THE VENGEANCE FORMULATION)

Sheldon, Leonard, and Penny watch the 1966 classic *How the Grinch Stole Christmas*, directed by animation legend Chuck Jones. Sheldon identifies with the Grinch as relatable, up to the point that he gives in to social convention and returns the presents.

(THE MATERNAL CONGRUENCE)

When the crew follows a person they think is Adam West to a yard sale, they buy a box full of junk. Inside is a slime-stained final shooting draft of *Ghostbusters 2* (1989), an Indiana Jones connect-the-dots book, and the One Ring from the *Lord of the Rings* trilogy (2001–2003).

(THE PRECIOUS FRAGMENTATION)

Sheldon refers to *A Beautiful Mind* (2001) as "a feel-good romp if there ever was one."

(THE DESPERATION EMANATION)

Sheldon tells a dressed-up Leonard that he looks like as if one of the plants from *Invasion of the Body Snatchers* (1956, 1978) duplicated him in every way, except with an absurd amount of hair gel.

(THE DESPERATION EMANATION)

Sheldon, Leonard, Howard, and Raj are excited to see a 35mm print of *Raiders of the Lost Ark*

(1981) but aren't able to because Wil Wheaton and his lackeys take the last seats. Rather than leave defeated, Sheldon steals the film canisters and is chased down the street by the entire theater to the *Indiana Jones* theme song by John Williams.

(THE 21-SECOND EXCITATION)

Sheldon sacrifices himself in paintball, re-creating the slow motion death scene of Willem Dafoe in *Platoon* (1986).

(THE SKANK REFLEX ANALYSIS)

In a scene right out of Quentin Tarantino's *Pulp Fiction* (1994), Howard collapses on the ground from his heart condition and Bernadette tells Sheldon he's going to have to inject Howard with adrenaline. She's not strong enough to break through his breastplate with the syringe. Sheldon jabs Howard, but finds it was all an elaborate prank.

(THE GOOD GUY FLUCTUATION)

Howard quotes *2001: A Space Odyssey* (1968) after he tells the group he's going to learn how to poop in space: "Open the podbay doors, HAL . . ."

(THE FRIENDSHIP CONTRACTION)

Penny and Bernadette introduce Amy to *Grease* (1977). Amy was forbidden to watch it because her mother thought it would encourage her to join a gang.

(THE ROTHMAN DISINTEGRATION)

Howard asks Bernadette if she'd be willing to learn the big number from *Dirty Dancing* (1987) for the dance at their wedding. He casts himself as Jennifer Grey and Bernadette as Patrick Swayze. Raj has the same fantasy when planning a romantic date for Penny and Leonard.

(THE LAUNCH ACCELERATION)

When signing off on the webcam aboard the International Space Station, Howard tells Bernadette, "To infinity and beyond," which is Buzz Lightyear's motto in *Toy Story* (1995).

(THE DATE NIGHT VARIABLE)

When it's Sheldon's turn to reveal his story of what might have been in the letter Howard's father wrote him, he tells Howard it was a map to the lost treasure of One-Eyed Willy, which was the plot of *The Goonies* (1985).

(THE CLOSET RECONFIGURATION)

In *Who Framed Roger Rabbit?* (1988), no toon can resist the lure of finishing "Shave and a haircut." Amy uses it to prove her point that Sheldon struggles with closure. Because he's a cartoon.

(THE CLOSET RECONFIGURATION)

Obsessed with the release of the Kraken, Sheldon watches *Clash of the Titans* (1981) before bed while Leonard is out to see on a scientific research mission. This gives him terrible nightmares.

(THE HOFSTADTER INSUFFICIENCY)

Sheldon shows Amy *Raiders of the Lost Ark* (1981) for the first time. She mistakenly believes she's found a story problem with the film and convinces Sheldon of such for a time.

(THE RAIDERS MINIMIZATION)

After Howard and Bernadette have a fight, he's forced to sleep over at Raj's house and they watch *The Princess Bride* (1987), a classic of fantasy, action, and romance. Howard asks Raj to stop talking and Raj responds with "As you wish." Westley's way of saying "I love you" in the film.

(THE WORKPLACE PROXIMITY)

When Raj is asked to help plan a romantic evening for Penny to give Leonard, he suggests she get a giant boombox to hold in the air like in *Say Anything* (1989).

(THE ROMANCE RESONANCE)

When Raj and Cinnamon stay at apartment 4A, Sheldon is nervous about being there. Leonard tells him to relax, Cinnamon is in her crate, but Sheldon cites the disaster at *Jurassic Park* (1993) and what havoc the dinosaurs wrought there.

(THE DISCOVER DISSIPATION)

When Sheldon goes out of town for Christmas, Leonard says Sheldon's rules of decorating the tree are out the window, describing it as Thunderdome, a reference to *Mad Max: Beyond Thunderdome* (1985).

(THE COOPER EXTRACTION)

Bernadette brings over *It's a Wonderful Life* (1946) for everyone to watch for Christmas. The conversation turns to Sheldon and how he's the

hub for all their relationships. They proceed to relate stories about what their relationships would be like without Sheldon.

(THE COOPER EXTRACTION)

When it's revealed during Raj's murder mystery dinner that someone came back from 20 years in the future to murder Stuart, Leonard accuses Raj of basing the entire dinner on the story from *The Terminator* (1984)

(THE MOMMY OBSERVATION)

Penny accuses Leonard of being a crybaby, citing his tears at *Toy Story 3* (2010) as proof. He reminds her that the toys were holding hands in a furnace, completely warranting the tears.

(THE PROTON TRANSMOGRIFICATION)

When Sheldon, Leonard, Howard, and Raj decide to go on a science retreat, it's suggested they go to a cabin in the woods, but Sheldon cites the film *Cabin in the Woods* (2011) as a reason that's absurd. Then, when Leonard suggests they go to a hotel instead, Sheldon cites *The Shining* (1980) as a reason that's absurd. When Raj suggests a house on the lake, Sheldon cites *The Lake House* (2006) as a reason that's absurd. When Leonard asks if he'd try a beach house, naturally Sheldon cites *Jaws* (1975).

(THE FOCUS ATTENUATION)

At their retreat to change the world, Sheldon, Leonard, Howard, and Raj comb through *Back to the Future II* (1989) looking for technology to invent. Leonard and Sheldon break down the time paradoxes in the film. The night degenerates into them doing no work and watching *Ghostbusters* (1984).

(THE FOCUS ATTENUATION)

Raj remarks that ever since he saw *Pretty in Pink* (1986) he wanted to go to an American prom, but then he saw *Carrie* (1976) and that changed his mind. But *Never Been Kissed* (1999) changed his mind once more.

(THE PROM EQUIVALENCY)

Penny likens the camera up in Leonard's sinuses to the scary boat ride in *Willy Wonka and the Chocolate Factory* (1971).

(THE SEPTUM DEVIATION)

When Howard, Raj, and Leonard are tasked with cleaning out the office of a deceased colleague named Roger Abbot, Howard mentions that his name sounds just like the titular character in the classic noir masterpiece *Who Framed Roger Rabbit?* (1988).

(THE CHAMPAGNE REFLECTION)

When Raj asks Howard to go with him to a Hindu temple, Howard worries that it will be all like *Indiana Jones and the Temple of Doom* (1984): "Some bald guy with horns isn't going to rip my heart out?" Raj assures Howard that the film, classic though it may be, is" an imperialist fantasy that makes the followers of a beautiful and peaceful religion look like a bunch of bloodthirsty barbarians."

(THE SPACE PROBE DISINTEGRATION)

While Leonard and Raj work on a method for contacting aliens for NASA, they talk about the failures of the Golden Record on NASA's Voyager because it would require aliens to build a record player. Raj points out that E.T. from *E.T.: The Extra-Terrestrial* (1981) was smart enough to build a communications device out of a Speak & Spell and an umbrella.

(THE COMMUNICATION DETERIORATION)

When they look for a way to get some exercise, Sheldon, Leonard, Howard, and Raj join Barry Kripke's fencing club. When Kripke tells them it won't be like *Star Wars* (1977), Howard tells them he hopes it will be more like *The Princess Bride* (1987). They quote Inigo Montoya's speech repeatedly in the voice of numerous characters, including Puss in Boots and Darth Vader.

(THE PERSPIRATION IMPLEMENTATION)

Leonard accuses Penny of having a "weird brother-sister-Elliott-E.T. relationship" with Sheldon, a reference to *E.T.: The Extra-Terrestrial* (1981). He refers to his own relationship to Sheldon as more like Leonard being the little girl from *Poltergeist* (1981) and Sheldon as the creepy thing in the TV.

(THE VIEWING PARTY COMBUSTION)

When Raj lords his status as godfather to Halley Wolowitz over Stuart, Stuart apologizes, saying he didn't mean to offend "Don Corleone," a reference to Francis Ford Coppola's legendary film *The Godfather* (1972).

(THE COHABITATION EXPERIMENTATION)

Penny doesn't want to see another video of Raj and Cinnamon "Lady-and-the-Tramping" some spaghetti, a reference to the classic Disney cartoon *Lady and the Tramp* (1955), where the two dogs eat along the same strand of spaghetti until they kiss.

(THE ESCAPE HATCH IDENTIFICATION)

Stuck on a tight deadline to design an input manifold for his project with Amy, Howard hopes he can pass off a copy of Doc Brown's drawing of a flux capacitor from *Back to the Future* (1985).

(THE NEONATAL NOMENCLATURE)

When Stuart gets a bad spray tan to impress Denise on a date, Howard makes a number of Oompa Loompa jokes, all references to the 1971 classic *Willy Wonka and the Chocolate Factory*.

(THE WEDDING GIFT WORMHOLE)

Raj mentions the anniversary of *Halloween* (1978) and Leonard mentions the fact that the original costume of Michael Myers was an altered Captain Kirk mask. They try to show Sheldon the movie but he has Amy come in, angry, forbidding it.

(THE IMITATION PERTURBATION)

Sheldon explains to Amy's father, Larry, that the title of *Lethal Weapon* (1989) is actually redundant, since most weapons are automatically lethal.

(THE CONSUMMATION DEVIATION)

The Origins of Bazinga!

BAZINGA bəˈzɪŋguh / exclamation, informal
An exclamatory interjection announcing that an exact or perfect conclusion to a problem has been found, or celebrating a perfectly timed joke, prank, or lie.

EXAMPLES OF BAZINGA! IN POPULAR PARLANCE

> "You actually had it right in the first place. Once again, you've fallen for one of my classic pranks. Bazinga."
> —Sheldon (The Monopolar Expedition)

Sheldon: Leonard, you may be right. It appears that Penny secretly wants you in her life in a very intimate and carnal fashion.
Leonard: You really think so?
Sheldon: Of course not. Even in my sleep-deprived state, I've managed to pull off another one of my classic pranks. Bazinga!

(THE MONOPOLAR EXPEDITION)

> "Obviously, waitressing at the Cheesecake Factory is a complex socioeconomic activity that requires a great deal of analysis and planning. Bazinga!"
> —Sheldon (The Gothowitz Deviation)

Sheldon: You know, I've always wanted to go to a goth nightclub.
Howard: Really?
Sheldon: Bazinga! None of you ever see my practical jokes coming, do you?

(THE GOTHOWITZ DEVIATION)

Sheldon: There's just no pleasing you, is there, Leonard? You weren't happy with my previous approach to dealing with her, so I decided to employ operant conditioning techniques, building on the work of Thorndike and B. F. Skinner. By this time next week, I believe I can have her jumping out of a pool, balancing a beach ball on her nose.
Leonard: No, this has to stop now.
Sheldon: I'm not suggesting we really make her jump out of a pool. I thought the "bazinga" was implied.

(THE GOTHOWITZ DEVIATION)

Sheldon: So, that's what you wear to an interview?
Raj: Come on, dude, we've been friends for years.
Sheldon: Oh, pulling strings, are we?
Raj: Sheldon, for God's sakes, don't make me beg.

Sheldon: Bazinga! You've fallen victim to another one of my classic practical jokes. I'm your boss now. You may want to laugh at that.

(THE PIRATE SOLUTION)

Sheldon: Your shoes are delightful. Where did you get them?
Howard: What?
Sheldon: Bazinga. I don't care.

(THE GORILLA EXPERIMENT)

"All right, you people ready to have some fun? You have a basic understanding of differential calculus and at least one year of algebraic topology? Well, then here come the jokes. Why did the chicken cross the Möbius strip? To get to the same side. Bazinga! . . . All right, a neutron walks into a bar and asks, how much for a drink? The bartender says, for you, no charge."
—Sheldon (The Pants Alternative)

Sheldon: A, I rarely kid. And B, when I do kid, you will know it by my use of the word Bazinga.
Howard: So you're saying the two of you are going to be sleeping in the same bed?
Sheldon: Yes . . . "bazinga."

(THE PLIMPTON STIMULATION)

Sheldon: With skin as fair as mine, moon burn is a real possibility.
Howard: That's a bazinga, right?
Sheldon: One of my best, don't you think?

(THE LUNAR EXCITATION)

"Amy, I find myself wondering if we should actually engage in coitus at least one time in our relationship . . . Bazinga."
—Sheldon, in (The Desperation Emanation)

"Howard, you are a good friend. And I wish you nothing but happiness. Bazinga, I don't!"
—Sheldon (The Stag Convergence)

Sheldon: Well, Amy enjoys knitting her own sweaters, so I was thinking of getting her an all-expense-paid trip to the Wisconsin Sheep and Wool Festival.
Penny: Sorry. I was waiting for the "bazinga."

(THE OPENING NIGHT EXCITATION)

/ The Trivia Randomization Table
10 RANDOMIZE TIMER
20 FOR I=BBT TRIVIA
30 PRINT RND;
40 NEXT I
RUN
/

At the start of the show, Sheldon is pleased to have 212 friends on MySpace, none of whom he'd ever met.
(PILOT)

Leonard uses Darth Vader No-More-Tears shampoo and Luke Skywalker No-More-Tears conditioner.
(PILOT)

Howard maintains a blog.
(PILOT)

Raj is terrified of both insects and women, leading Sheldon to posit that ladybugs must leave Raj catatonic.
(THE JIMINY CONJECTURE)

Amy shares Sheldon's aversion to soiled hosiery.
(THE LUNAR EXCITATION)

Sheldon organizes his cereal numerically by fiber content.
(THE BIG BRAN HYPOTHESIS)

Leonard plays the cello.
(THE HAMBURGER POSTULATE)

Amy believes that she and Sheldon have the genetic potential to produce the first in a line of intellectually superior, benign overlords to guide humanity to a brighter tomorrow.
(THE ROBOTIC MANIPULATION)

Sheldon keeps his toothbrush in a plexiglass case under a UV light.
(THE DUMPLING PARADOX)

Sheldon has carried an honorary Justice League of America membership card, signed by Batman, since he was 5.
(THE GRASSHOPPER EXPERIMENT)

Amy finds Leonard to be a festival of humdrum chitchat.
(THE ZAZZY SUBSTITUTION)

Penny has a "Don't knock before 11 o'clock or I'll punch you in the throat" rule.
(THE WORK SONG NANOCLUSTER)

Raj would rather swim buck-naked across the Ganges with a paper cut on his nipple and and die a slow, agonizing death from a viral infection than work with Sheldon.
(THE HOT TROLL DEVIATION)

Sheldon's watch is linked to the Atomic Clock in Boulder, Colorado.
(THE LOOBENFIELD DECAY)

Leonard celebrates Columbus Day by watching The Goonies, Gremlins, and Young Sherlock Holmes, all written by Chris Columbus.
(THE PIRATE SOLUTION)

Penny handles all of the spiders in apartment 4A.
(THE DEAD HOOKER JUXTAPOSITION)

Leonard mixes pancake batter in Sheldon's urine sample measuring cup.
(THE PANCAKE BATTER ANOMALY)

Amy finds the idea of being cast in the role of bad girl oddly titillating.
(THE ZAZZY SUBSTITUTION)

Raj once prayed to the Hindu god Urvashi in hopes that Howard's bowels would loosen and his penis would droop like a willow tree.
(THE LARGE HADRON COLLISION)

When Sheldon tries to deceive anyone, he has "more tics than a Lyme disease research facility."
(THE BAD FISH PARADIGM)

Halle Berry is Sheldon's fifth favorite Catwoman.
(THE BAD FISH PARADIGM)

Howard has a poster of Halle Berry above his bed.
(THE BAD FISH PARADIGM)

Howard postulates that Sheldon Cooper will one day eat an enormous amount of Thai food and, through mitosis, split into two Sheldons.
(THE COOPER-NOWITZKI THEOREM)

Sheldon claims to be the genetically superior Homo Novus and is "too evolved" to drive.
(THE EUCLID ALTERNATIVE)

Howard may have discovered life on Mars after crashing the Mars Rover in a ditch to impress a woman, but has to delete the data that would allow him to take credit.
(THE LIZARD-SPOCK EXPANSION)

According to Sheldon, Penny's biggest achievement is memorizing the Cheesecake Factory menu.
(THE MATERNAL CONGRUENCE)

Sheldon is willing to be a house pet to a race of super-intelligent aliens if given the chance.
(THE FINANCIAL PERMEABILITY)

The Miller's Tale by Chaucer is the dirtiest story Amy knows.
(THE 21-SECOND EXCITATION)

Leonard was on the debate team in high school.
(THE PRESTIDIGITATION APPROXIMATION)

Sheldon's Meemaw calls him Moon Pie because he's nummy-nummy and she could just eat him up.
(THE TERMINATOR DECOUPLING)

Penny was inducted as a member of the Corn Queen's court in her home state of Nebraska.
(THE PANTS ALTERNATIVE)

Sheldon would rather have a blowfly lay eggs and hatch larvae in his auditory canal than go to Las Vegas.
(THE VEGAS RENORMALIZATION)

Howard sells his sperm for extra money.
(THE CLASSIFIED MATERIALS TURBULENCE)

Sheldon subscribes to the "Many Worlds" theory which posits an infinite number of Sheldons in an infinite number of universes and is positive that none of those Sheldons dance. The math suggests that in a few of those universes, he's a clown made of cotton candy.
(THE GOTHOWITZ DEVIATION)

Howard can't look at pickled herring without being aroused and ashamed.
(THE ADHESIVE DUCK DEFICIENCY)

Sheldon celebrates Sir Isaac Newton's birthday on December 25 rather than Christmas.
(THE MATERNAL CONGRUENCE)

According to Sheldon, Penny doesn't understand the critical role gasoline plays in the internal combustion engine.
(THE PLIMPTON STIMULATION)

Sheldon believes that when the robots rise up, ATMs will lead the charge.
(THE EXCELSIOR ACQUISITION)

Sheldon feels most at home in the Sim city he designed, Sheldonopolis.
(THE PANTS ALTERNATIVE)

Sheldon familiarizes himself with female emotional crises by studying the comic strip Cathy.
(THE WHEATON RECURRENCE)

Penny characterizes the approximately 171–193 men she's dated as "a few."

According to Sheldon's math, Penny has had approximately 31 sexual partners, which she says isn't even the close to the real number.
(THE ROBOTIC MANIPULATION)

Howard is not considered a friend by Sheldon, but a treasured acquaintance.
(THE BOZEMAN REACTION)

Sheldon plays the recorder, just like Captain Picard.
(THE CRUCIFEROUS VEGETABLE AMPLIFICATION)

According to Raj, if Sheldon were a superhero, he'd be Captain Arrogant and his superpower would be arrogance. Sheldon disagrees, preferring the more zazzy "Dr. Arroganto."
(THE HOT TROLL DEVIATION)

Sometimes, his movements are so lifelike, Leonard forgets that Sheldon is not a real boy.
(THE HOT TROLL DEVIATION)

Raj once gave Sheldon a Snoopy snow cone maker as a Thanksgiving Day present.
(THE IRISH PUB FORMULATION)

Amy once invented a boyfriend to get her family off her back. "Armen the miniature horse breeder."
(THE WEEKEND VORTEX)

Sheldon never viewed Michael Jackson's "Thriller" video in its entirety because he finds the notion

of zombies dancing in choreographed synchronicity implausible. Also, it's scary.
(THE 21-SECOND EXCITATION)

Howard once convinced Raj that foreigners give Americans presents on Thanksgiving and that he should wash all of their clothes on Fourth of July.
(THE IRISH PUB FORMULATION)

Sheldon assumes girls' nights are all about talking about rainbows, unicorns, and menstrual cramps.
(THE AGREEMENT DISSECTION)

Amy stops wearing lip gloss because Sheldon thinks it made her lips look too slippery.
(THE SPOILER ALERT SEGMENTATION)

After getting kicked off Leonard's app-making team, Sheldon helps Penny develop her app to identify where to buy cute shoes she sees on other people.
(THE BUS PANTS UTILIZATION)

Sheldon advocates eugenics.
(THE INFESTATION HYPOTHESIS)

Amy has a fondness for Marmaduke.
(THE APOLOGY INSUFFICIENCY)

Sheldon achieved one of his lesser dreams and became a notary public.
(THE WIGGLY FINGER CATALYST)

"If I had a death ray, I wouldn't be living here. I'd be in my lair enjoying the money the people of Earth gave me for not using my death ray."
(SHELDON IN "THE ORNITHOPHOBIA DIFFUSION)

Howard refuses to pay fines when books Sheldon lends him are overdue.
(THE APOLOGY INSUFFICIENCY)

Under the effects of dental anesthesia for a deep gum cleaning, Sheldon once thought he got onto a bus, but actually ended up on a booze cruise to Mexico.

(THE FRIENDSHIP CONTRACTION)
A hummingbird is Raj's first choice for an ankle tattoo. Or a dolphin. He goes back and forth.
(THE ORNITHOPHOBIA DIFFUSION)

When she was six, Amy wanted to marry the

gorilla from GOOD NIGHT, GORILLA.
(THE COLLABORATION FLUCTUATION)

There's only one mind-expanding drug Sheldon enjoys: school.
(THE LAUNCH ACCELERATION)

When he first came to America, Raj thought gossip only happened around a water cooler, so he spent his first month hanging out by the water cooler at Caltech. The only gossip he heard was about the creepy guy hanging out by the water cooler.
(THE VACATION SOLUTION)

Penny was a bully in high school.
(THE SPECKERMAN RECURRENCE)

Narrowly beating out Pepto Bismol, Strawberry Quik is Sheldon's favorite pink fluid.
(THE LAUNCH ACCELERATION)

Since she's the one who has to track him down on every IKEA trip, Penny thinks she'd be really good at hunting Sheldon for sport.
(THE RECLUSIVE POTENTIAL)

Sheldon loves swordfish. They are fish with a sword for a nose. And the hammerhead shark. Another fish with a tool on its head.
(THE DECOUPLING FLUCTUATION)

Raj once paid a kid on eBay $25 for a handcrafted Harry Potter wand and received nothing but an ordinary stick in return.
(THE ROTHMAN DISINTEGRATION)

Leonard says that Penny's heels make him feel like he's "out for a walk with his mommy."
(THE BETA TEST INITIATION)

Sheldon hates the concept of brunch and can't stand being at a table where one person is having an omelette and another is having a sandwich.
(THE BAKERSFIELD EXPEDITION)

Howard fits in the booster seats at the Cheesecake Factory.
(THE WIGGLY FINGER CATALYST)

In lieu of her power bill, Penny once sent the power company a Starbucks gift card, an apology note, and photos of her.
(THE SPOILER ALERT SEGMENTATION)

Sheldon believes that in order for science to advance, people should have chips implanted in their skulls that explode when they say something stupid."
(THE TENURE TURBULENCE)

Penny once cleaned the bathroom with Sheldon's toothbrush.
(THE BIG BEAR PRECIPITATION)

Sweden is home to Sheldon's favorite muppet and second favorite meatball.
(THE WORKPLACE VORTEX)

Sheldon finds pretending to be an alien a valuable coping mechanism. The first time he did it, it was to see Penny in a play. She had no idea that Commander Umfrumf of Ceti Alpha Three was in the audience.
(THE PROM EQUIVALENCY)

Penny likens Sheldon and Leonard to Bert and Ernie. "You guys even teach me stuff about words and numbers."
(THE SPOILER ALERT SEGMENTATION)

Raj's birthday is the alarm code for the Wolowitz house.
(THE DEPENDENCE TRANSCENDENCE)

Howard learned to pick locks in high school when he thought he could be a magician and escape artist like Harry Houdini.
(THE 43 PECULIARITY)

Because his car gets such terrible gas mileage, Raj sponsors a penguin at the LA Zoo.
(THE COMIC-CON CONUNDRUM)

Sheldon sees prime numbers as red. Twin primes appear pink and smell like gasoline.
(THE SALES CALL SUBLIMATION)

Dr. Boots Hofstadter was the name of the family cat when Leonard was living at home.
(THE 43 PECULIARITY)

Raj posts videos of himself flossing on Instagram.
(THE LONG DISTANCE DISSONANCE)

Sheldon is both flattered and hurt when people tell him he looks like Jack Skellington from The Nightmare Before Christmas (1993).
(THE VERACITY ELASTICITY)

Raj once wrote a fanfic mashup called Captain Marvelous Mrs. Maisel.
(THE D&D VORTEX)

Penny can drink a beer underwater.
(THE SCAVENGER VORTEX)

Sheldon has a commercial fishing license.
(THE EXPLOSION IMPLOSION)

Raj once had a plush doll of Rocket Raccoon from Guardians of the Galaxy, but Cinnamon licked it raw.
(THE COLLABORATION CONTAMINATION)

Sheldon's favorite food is pizza: a circle made of triangles in a square box.
(THE SOLO OSCILLATION)

Raj bathes with his dog. Not in a weird way, but not in a normal way, either. They both wear swimsuits.
(THE TAM TURBULENCE)

Once, when all the knives were dirty, Howard cut a bagel with his keys.
(THE DISCOVERY DISSIPATION)

Penny once got Leonard a watch for his birthday with money she took out of his wallet.
(THE ANYTHING CAN HAPPEN RECURRENCE)

Sheldon is the pope of a planet he invented in hyperspace.
(THE TENANT DISASSOCIATION)

Raj cries every time Hugh Jackman sings.
(THE TAM TURBULENCE)

Leonard confesses to Sheldon that he likes Star Wars: Episode I The Phantom Menace.
(THE RETRACTION REACTION)

Sheldon assigns numbers to his friends. Penny is "Friend #4".
(THE INSPIRATION DEPRIVATION)

Thanks to Penny's influence, Leonard only wears his superhero underwear on Fridays and his birthday.
(THE MATERNAL CONCLUSION)

* * *

END

THE
APARTMENT
ANALYSIS

The Apartment Aptitude

SUBJECT

Everything in THE BIG BANG THEORY revolves around apartment 4A. It's where the crew all eat, play, and even engage in more personal extracurricular activities.

Sheldon's spot: Sheldon's favorite spot is chosen for its ideal proximity to the radiator in the winter and the ideal cross-breeze in the summer. It's also angled to his preferences in relation to the television so as to not discourage conversation or create a parallax effect with the screen.

The couch was purchased for $100 from people moving out on the first floor, replacing the pair of lawn chairs Sheldon had for common furniture.

(THE STAIRCASE IMPLEMENTATION)

Periodic Table of Elements Shower Curtain
Two-Man Earthquake Survival Kit

(THE DUMPLING PARADOX)

Leonard's spot
Raj's spot on the floor
Howard's spot
The Batman cookie jar
Sheldon's whiteboard
Leonard's whiteboard
Replica Green Lantern lantern
***Halo* helmet lamp**

(THE CUSHION SATURATION)

Cylon toaster

(THE CORNHUSKER VORTEX)

Dartboard behind the front door
One time they played darts, but Leonard broke a window.

(THE ITCHY BRAIN SIMULATION)

Bowl for keys

(THE VEGAS RENORMALIZATION)

Herman Miller Aeron chair at the desk

(THE GUITARIST AMPLIFICATION)

Sheldon's desk on the left, Leonard's on the right

(THE DESPERATION EMANATION)

Luminous paint with safety arrows pointing to the nearest egress

(THE ROOMMATE TRANSMOGRIFICATION)

Library card catalog
Longclaw

(THE FRIENDSHIP CONTRACTION)

Closet with the "junk box"

(THE ITCHY BRAIN SIMULATION)

Wall safe behind the whiteboard and a safe on the floor

(THE SPOCK RESONANCE)

Physics and Dungeons & Dragons books on the shelf

(THE PROPERTY DIVISION COLLISION)

Thermostat
Sheldon can control it with an app, even after he moves out.

(THE MATRIMONIAL METRIC)

Sheldon's attempt at building the genetic code of a super race—**the ball tower**

(THE STOCKHOLM SYNDROME)

New dining room table, which is removed after a single episode.

(THE TABLE POLARIZATION)

Sheldon once tried to declare the apartment a sovereign nation, complete with its own currency.

(THE TOAST DERIVATION)

Sheldon brings back the original apartment layout, complete with **folding lawn chairs.**

(THE 2003 APPROXIMATION)

The elevator is finally repaired.

(THE CHANGE CONSTANT)

The Burgled Apartment Situation

SUBJECT

In "The Bozeman Reaction," thieves break into the apartment and steal a whole lot of stuff.

TV

TWO LAPTOPS

FOUR EXTERNAL HARD DRIVES

PS2

PS3

XBOX

XBOX360

CLASSIC NINTENDO

SUPER NINTENDO

NINTENDO 64

WII

VIDEO GAMES:

Halo
Halo 2
Halo 3
Call of Duty
Call of Duty 2
Call of Duty 3
Rock Band
Rock Band 2

Final Fantasy 1-9
The Legend of Zelda
The Legend of Zelda: The Ocarina of Time
The Legend of Zelda: Twilight Princess
Super Mario Brothers
Super Mario Galaxy
Mario and Sonic at the Winter Olympics
Ms. Pac-Man

The Apartment Anomalies

SUBJECT

Leonard and Sheldon shared apartment 4A for years, though eventually Penny moves in when Sheldon moves out. There are a lot of things to know in order to live there.

Managed by the 2311 North Los Robles Corporation.
(THE FINANCIAL PERMEABILITY)

Referred to by Sheldon as his "Fortress of Solitude" when he has the place to himself while his friends are in Las Vegas.
(THE VEGAS RENORMALIZATION)

The elevator has been broken since Leonard blew it up after improperly mixing rocket fuel for Howard's three-stage model rocket engine.
(THE STAIRCASE IMPLEMENTATION)

WiFi password: Pennyisafreeloader
(THE THESPIAN CATALYST)

WiFi password: Pennygetyourownwifi
(THE ROOMMATE TRANSMOGRIFICATION)

WiFi password: Pennyalreadyeatsourfood-shecanpayforwifi
(THE SPECKERMAN RECURRENCE)

The Apartment Accumulation

All the people who've called apartment 4A home, even for a night:

Leonard and Sheldon are the chief occupants of apartment 4A.

(PILOT)

Sheldon moves out briefly after no longer wanting to keep Penny's secret about never graduating from community college.

(THE BAD FISH PARADIGM)

Dr. Stephanie Barnett moves in with Leonard, but moves out quickly.

(THE VARTABEDIAN CONUNDRUM)

Penny's ex-boyfriend Justin, a visiting guitarist, crashes on the couch. He was going to stay with Penny, but Leonard was jealous.

(THE GUITAIRIST AMPLIFICATION)

Penny sleeps over and becomes a regular overnight guest in the apartment.

(THE BOZEMEN REACTION)

Penny and Leonard break up and she no longer sleeps in the apartment.

(THE WHEATON RECURRENCE)

Dr. Elizabeth Plimpton stays in the apartment for two days.

(THE PLIMPTON STIMULATION)

Penny stays the night to sleep with Leonard. To Sheldon's dismay, his noise-canceling headphones aren't as effective as he'd like.

(THE LUNAR EXCITATION)

Leonard sneaks Priya Koothrappali into his room and sleeps with her.

(THE IRISH PUB FORMATION)

Howard crashes at the apartment after he and his mother have a fight.

(THE COHABITATION FORMULATION)

Priya Koothrappali becomes a regular fixture in Leonard's bedroom.

(THE HERB GARDEN GERMINATION)

Raj sleeps over at the apartment.

(THE ROOMMATE TRANSMOGRIFICATION)

Leonard's high school bully, Jimmy Speckerman, crashes on the couch to sleep off his inebriation.

(THE SPECKERMAN RECURRENCE)

Raj and his Yorkie, Cinnamon, stay at the apartment after Howard and Bernadette kick him out for making them insecure about "half-assing" their marriage.

(THE DISCOVERY DISSIPATION)

Penny sleeps over frequently.

(THE RELATIONSHIP DIREMPTION)

Penny partially moves in. Sheldon doesn't like the idea of Leonard moving out, so he and Penny split their time between the apartments.

(THE SPOCK RESONANCE)

A pipe bursts in Amy's apartment and she's forced to stay with Sheldon for as many as five weeks. Penny ends up offering her apartment for Sheldon and Amy to have a trial run of living together.

(THE COHABITATION EXPERIMENTATION)

Sheldon and Amy move into Penny's apartment, leaving Leonard and Penny the primary occupants of apartment 4A.

(THE PROPERTY DIVISION COLLISION)

Theodore, played by Christopher Lloyd, rents Sheldon's room for a dollar a night for most of a month.

(THE PROPERTY DIVISION COLLISION)

Raj moves into Sheldon's old room in an effort to cut down on costs. Sheldon is outraged by this, but doesn't stand in the way.
Raj quickly moves out.

(THE GATES EXCITATION)

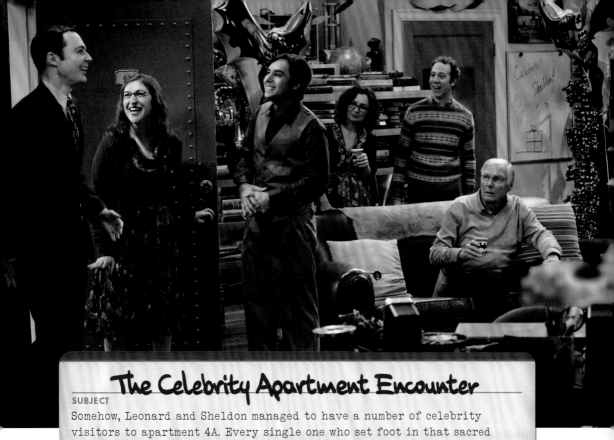

The Celebrity Apartment Encounter

SUBJECT

Somehow, Leonard and Sheldon managed to have a number of celebrity visitors to apartment 4A. Every single one who set foot in that sacred space, whether cameoing as themselves or playing a part, would never forget the experience.

LeVar Burton comes to the apartment after Leonard invites him to hang out with his new friends via Twitter.

(THE TOAST DERIVATION)

Wil Wheaton comes to the apartment to record a guest spot on *Sheldon Cooper Presents: Fun with Flags*.

(THE HABITATION CONFIGURATION)

Bob Newhart's "Professor Proton" comes and hangs out at the apartment.

(THE PROTON DISPLACEMENT)

Billy Bob Thornton's Dr. Oliver Lorvis hangs out with the guys at the apartment.

(THE MISINTERPRETATION ALIGNMENT)

LeVar Burton visits the apartment to appear on the final episode of *Fun with Flags*.

(THE CHAMPAGNE REFLECTION)

Michael Rappaport's Kenneth Fitzgerald, the helium thief, comes over to have a beer and watch *Ernest Goes to Jail* (1990).

(THE HELIUM INSUFFICIENCY)

Adam Nimoy, Leonard Nimoy's son, interviews Sheldon for a documentary about his father at the apartment. Wil Wheaton tags along.

(THE SPOCK RESONANCE)

Academy Award–nominated character actor June Squibb, playing Sheldon's Meemaw, visits the apartment.

(THE MEEMAW MATERIALIZATION)

Christopher Lloyd ends up in the apartment as Theodore, a guy Sheldon tries renting a room to in order to get back at Leonard for his disrespect of the roommate flag.

(THE PROPERTY DIVISION COLLISION)

Brian Posehn's Dr. Bert Kibbler visits the apartment to show off his new date and have dinner with the crew.

(THE SEPARATION AGITATION)

THE ROOMMATE AGREEMENT

1. THE COOPER-NOWITZKI THEOREM

(A.) The Skynet Clause only applies if Leonard needs to help Sheldon destroy an artificial intelligence he created that is taking over the Earth.

(B.) The Body Snatchers Clause requires Leonard to help Sheldon destroy someone they know replaced with an alien pod.

(C.) The Godzilla Clause requires the destruction of Tokyo to be invoked.

2. THE COOPER-NOWITZKI THEOREM)

(A.) Any deviations in the television watching schedule, with exceptions for breaking news, need to be pre-approved at their weekly roommate meeting.

(B.) Roommate meetings adhere to mock-parliamentary procedure.

3. THE PANTY PIÑATA POLARIZATION

(A.) Article I, Section III allows for emergency meetings to be called.

4. THE VARTABEDIAN CONUNDRUM

(A.) Cohabitation rider. A "girlfriend" shall be deemed "living with" Leonard when she has stayed over for A) ten consecutive nights, or B) more than nine nights in a three-week period, or C), all the weekends in a given month plus three weeknights. Once invoked, each of them gets their own refrigerator shelf and the door becomes communal food. Apartment vacuuming will be increased from two to three times a week to accommodate the increased accumulation of dead skin cells. The bathroom schedule shifts.

(B.) In the roommate agreement, Leonard names Sheldon his sidekick in the event he gains superpowers.

(C.) Leonard agrees to not now or ever intend play a percussive or brass instrument in the apartment.

5. THE FRIENDSHIP ALGORITHM

(A.) Whistling is strictly prohibited.

6. THE MONOPOLAR EXPEDITION

(A.) Leonard is forbidden from disappointing Sheldon.

7. THE JIMINY CONJECTURE

(A.) Sheldon has unilateral control of the thermostat ever since the sweaty night of '06.

8. THE LARGE HADRON COLLISION

(A.) The Friendship Rider in Appendix C: Future Commit-ments, number 37: in the event one friend is ever invited to visit the large Hadron Collider, now under construction in Switzerland, he shall invite the other friend to accompany him.

(B.) Contains contingencies for what happens if Sheldon or Leonard wins a McArthur Grant.

(C.) Contains contingencies for what happens if Sheldon or Leonard is bitten by a zombie, including a clause that Leonard can't kill Sheldon, even if he turns.

(D.) Since it seemed too far-fetched at the time of signing, there are no clauses in the agreement about either party getting a girlfriend.

(E.) Sheldon is required to ask at least once a day how Leonard is doing, even though he simply doesn't care.

(F.) Sheldon is not allowed to stage spontaneous biohazard drills after 10:00 pm.

(G.) Sheldon is forbidden from mastering Tuvan throat singing.

(H.) Sheldon has a friendship clause that obligates him to take Leonard swimming at Bill Gates' house, should he be invited.

9. THE PLIMPTON STIMULATION

(A.) Sheldon is required to give official 24-hours' notice in writing that a non-related female will be spending two or more nights in the apartment.

(B.) Pets are banned with the exception of service animals such as seeing eye dogs and, one day, cybernetically enhanced helper monkeys.

(C.) Roommates agree that Friday nights will be reserved for watching Joss Whedon's brilliant new series Firefly.

10. THE STAIRCASE IMPLEMENTATION

(A.) Section 9: Miscellany—The apartment's flag is a gold lion rampant on a field of azure. It is never to be flown upside down unless the apartment is in distress.

(B.) If either roommate invents time travel, they agree to make their first stop their first meeting where they hash out the roommate agreement.

(C.) Section 8—visitors, subsection B—females, paragraph 4: coitus. Roommates shall give each other 12 hours notice of impending coitus.

(D.) Leonard is entitled to allocate 50% of the cubic footage of the common areas as long as Sheldon is notified by email.

11. THE CRUCIFEROUS VEGETABLE AMPLIFICATION

(A.) All ties will be settled by Sheldon.

12. THE IRISH PUB FORMULATION

(A.) Section 74.C lists the various obligations and duties of the parties in the event one of them becomes a robot.